Raskolnikov's Rebirth

Psychology and the Understanding
of Good and Evil

Raskolnikov's Rebirth

Psychology and the Understanding
of Good and Evil

İLHAM DİLMAN

OPEN COURT

Chicago and La Salle

To order books from Open Court, call toll-free 1-800-815-2280.

Cover illustration: Los in flames, from *The Book of Urizen* by William Blake.

Open Court Publishing Company is a division of Carus Publishing Company.

Copyright © 2000 by Carus Publishing Company

First printing 2000

Printed and bound in the United States of America.

Library of Congress Cataloging-in-Publication Data

Dilman, İlham.
 Raskolnikov's rebirth : psychology and the understanding of
 good and evil / İlham Dilman.
 p. cm.
 Includes bibliographical references (p.) and index.
 ISBN 0-8126-9416-3 (paper : alk. paper)
 1. Ethics. 2. Good and evil. 3. Psychology, Religious 4.
Psychoanalysis. 5. Freud, Sigmund, 1856–1939. I. Title.
BF47.D55 2000
150'.1—dc21 00-027436
 CIP

The kind of psychology which Freudian theories represent leaves out the soul and is suited to people who believe that they have no spiritual needs or aspirations. In this matter both the doctor and the patient deceive themselves . . . Those theories—e.g. of sexuality—and Freud's therapy are hostile to spiritual values, [they are part of] a psychology without a soul . . .

<div align="right">C.G. Jung, Modern Man in Search of a Soul</div>

. . . the word 'psychology' is a Janus-faced word, a word that faces in two opposite directions . . . The first direction, and which I would claim is the original meaning of the word, occurs in phrases such as this. We might say of a great novelist such as Tolstoy or . . . George Eliot, that they show profound psychological insight into the characters they depict . . . In general . . . it is the great novelists, dramatists, biographers, historians, that are the real psychologists . . . A psychology which is concerned with the scientific study of universal types [such as the one] studied in a university faculty of psychology . . . necessary to obtain a degree in that subject . . ., whatever progress it makes . . . will never replace . . . a psychology which has insight into individual characters, as a more accurate, a more scientific, a more efficient discipline.

<div align="right">Dr M. O'C. Drury, The Danger of Words</div>

I still find it a very strange thing that the case histories I describe read like short stories and lack, so to speak, the serious imprint of science . . . In the study of hysteria . . . an exhaustive account of mental processes, of the kind we are accustomed to having from imaginative writers, enables me to obtain insight into the origin of hysteria.

<div align="right">Sigmund Freud, The Study of Hysteria</div>

Brief Contents

Detailed Contents

Preface

Raskolnikov's Rebirth is concerned with the contribution psychology, the discipline, can make to an understanding of good and evil and of a person's relation to his morality. It argues that experimental, scientific psychology can make no contribution to such an understanding. In a sense analogous to the one in which we may describe a person as having no soul, such a psychology has no soul. It is blind to the kind of life in which human beings have a soul.

This book contrasts experimental psychology with what it calls a 'thoughtful' psychology which gives place to reflection on human life—a life which offers the possibility of autonomy to human beings, a life in which human beings find their individuality. I am interested in psycho-analysis because it has the potential of being a thoughtful psychology. Jung called Freud's psychology 'a psychology without a soul'. This book tries to show how Freud's perceptions, which were clouded by his scientism and his concentration on 'psycho-pathology', could nevertheless inspire a move towards a more thoughtful psychology. To this end I critically examine the contribution of a few later psycho-analysts to an understanding of a person's relation to good and evil and also to an understanding of religious belief. The book closes with a chapter on Dostoyevsky's Raskolnikov because in *Crime and Punishment* we have a profound appreciation of the relation of a person, a character in the novel, to good and evil, what it means to be alienated from goodness, and of the radical change he undergoes in his mode of being as he is reintegrated with goodness. In such reintegration Raskolnikov finds his soul, the soul he has lost in his alienation from goodness. Dostoevsky describes this as 'Raskolnikov's rebirth'.

For psychology, as a discipline, likewise to find its soul it has to turn from experimentation to reflection, from the general to the individual. Dostoevsky, in his novels, shows himself to be such a thoughtful psychologist.

İLHAM DİLMAN
January 2000

Acknowledgements

Chapter 1, 'Science and Psychology', was read to the Royal Institute of Philosophy in London in November 1995 as part of a series of lectures, arranged by its director Professor Anthony O'Hear. The series was edited by Professor O'Hear and published by Cambridge University Press as *Verstehen and Human Understanding*. Chapter 5 on Happiness is a modified and expanded version of a shorter paper on the same topic published in the *Journal of Medical Ethics*, 1982. Chapter 6, 'Psycho-analysis and Ethics: The Self in its Relation to Good and Evil', was read at the Tenth Inter-Nordic Philosophy Symposium on 'Ethics and Understanding' in Turku, Finland, in August 1993 and has been published in the Proceedings of that Conference by Macmillan edited by Professor L. Alanen under the title *Commonality and Particularity in Ethics*. Chaptr 7, 'Good and Evil: Love and Ego-centricity', is a shorter version of a paper that will be published by Macmillan in a book of essays in honour of Professor D.Z. Phillips entitled *The Possibilities of Sense*, edited by Professor John H. Whittaker. Chapter 8, 'Love and Hate: Are they Opposites?', has also appeared in my book *Love: Its Forms, Dimensions, and Paradoxes*, published by Macmillan in 1998. Chapter 9, 'Must Psycho-Analysis Explain Religion Away?', was read at a Conference in Claremont, California, arranged by Professor D.Z. Phillips. It was edited by Professor Phillips and published in the Proceedings of that conference by Macmillan under the title *Can Religion be Explained Away?* I thank the respective editors and publishers for permission to include these writings in *Raskolnikov's Rebirth*.

I would like to thank Helen Baldwin for her invaluable assistance in preparing the typescript of this book.

Summary of the Book's Argument

The book begins by asking: What is knowledge of human beings and can it be acquired by scientific methods? Thus Chapter 1 is a critique of experimental psychology. It argues that, insofar as psychology is a discipline aiming to understand people as individuals, it cannot be an experimental science. Insofar as it persists in its scientific pretensions, however, it cannot contribute to an understanding of individual behaviour and motivation. That is not to say that there are not questions within psychology, in a broad sense, that are amenable to experimental study. There are. But they are concerned with the *constants* behind individual behaviour in its variations. These are, however, on the peripheries of psychology as a study of individual human beings. Psychology as a discipline belongs to the humanities and has many more affinities with the arts than with the sciences. Section 1.2 considers a few examples from experimental psychology to substantiate its criticisms.

Chapter 2 extends the critique of experimental, scientific psychology into its study of moral behaviour. Considering a variety of examples reviewed in Derek Wright's *The Psychology of Moral Behaviour*, I argue that, inevitably, the psychological explanations offered by scientific psychologists are all of false or corrupt forms of moral behaviour and that in *this* sense there is no such thing as 'the psychology of moral behaviour'. The reason is that it is not a person's psychology which determines and explains his moral behaviour when it is genuine; it is *he* who determines it in the autonomy he has acquired in coming to own a morality. The question 'what makes a person moral?' calls for reflection and clarity on what is meant or understood by morality. When such clarity is

achieved it becomes plain that this is not a psychological question like 'What makes a person delinquent?'

The important distinction which a study of moral behaviour needs to be clear about is the distinction between what is genuine and what is false here—between genuine altruism and concern for others, for instance, and its false and corrupt varieties. The psychologism of an unreflective, experimental study of moral behaviour militates against such clarity. Consequently, in its very way of conceptualizing and thinking about moral behaviour when concerned to find a psychological explanation, it turns such behaviour into one of its false or corrupt varieties.

In any case it is in his *mode of being* that a person is moral; it is that which gives his behaviour its moral character. Experimental psychology seems to have no recognition of this. Where a person's mode of being finds expression in his behaviour, it is seen as such when taken together with what comes before it and what comes after, that is as part of what unfolds in the course of time and in the surroundings of his life. Experimental psychology ignores this and, indeed, it has to; it could not be an experimental science if it did not.

It is not an accident, therefore, that academic, scientific psychology totally misunderstands the relation between an individual's psychology and his genuinely moral behaviour. Chapter 3 argues that a *thoughtful* psychologist needs to learn to think about human life, to appreciate what is radically distinctive about human existence, and to understand the place of morality in human life. He will then come to see that psychology cannot tell us what the *determinants* of moral behaviour are; for they are not psychological but moral. This is not to say that it does not have a contribution to make to our understanding of moral behaviour—the subject matter of this book. It does. For every person has a psychology, of course, including the genuinely moral person—the person whose morality comes from *him* and not from his psychology.

Such a person's psychology is not a 'determining' psychology but an 'enabling' one. It does not determine his behaviour, but promotes a mode of being in which he has the space for growth—a space in which he can grow to be himself. It is a psychology, therefore, which *permits* him to be himself in his morality so that his moral behaviour comes from him and is not the outcome of his psychology. It does so by virtue of its lack of narcissism, ego-

centricity, and defensiveness. It *enables* him thus to come to have moral convictions and to act in accordance with his commitments in the light of his moral judgements in particular situations. It *enables* him to develop positive capacities, such as trust, forgiveness, concern for others, self-respect and courage, which are at once moral and psychological capacities enabling him to come to himself and act with autonomy, to be the author of his actions instead of the slave of requirements to which he conforms for one reason or another.

There can be no autonomy without genuine moral convictions and so commitments. I argue in Chapter 3 that a person comes to have such convictions through moral learning. The morality he thus learns works through his psychology to transform it. So transformed, his psychology, having become an enabling psychology, makes it possible for him to own his morality and to find autonomy in owning it.

Such a person's psychology, therefore, and his morality are the two sides of the same coin: they stand to one another in the same relation as the duck and the rabbit in the Jastrow figure, except that they are in dynamic interaction with one another. They are thus at one with each other in the way that, where a person has the courage of his convictions, his courage and his convictions are at one: the courage is an expression of the genuineness and strength of his convictions and his convictions are a source of his courage.

Chapter 3 also argues that moral learning involves growth of the self towards greater autonomy and contact with the 'outer world'—the person's social environment and other people in their independent existence. This means turning outward, away from a self-centred orientation, away from a vision fixed by patterns from the past impermeable to the present. This involves overcoming affective obstacles to a genuine consideration of others. Moral learning, therefore, is largely an education of the emotions in the course of which the self is so transformed as to come to own its morality. In the mode of being a person thus acquires, he comes to be integrated with his values. The terms in which his psychology, transformed through such integration, is to be characterized are inevitably and at the same time moral terms.

What I called a 'determining psychology', in contrast, is the kind of psychology at the root of Freud's psychological determinism. For, freed from its scientism, Freud's determinism is his con-

ception of the psychological bondage of the individual. Such bondage is the slavery of the divided self, as portrayed by Freud in his picture of the tripartite divisions of the personality, to a part of itself. But these divisions are not immutable, they can be healed. Since the person is ultimately responsible for these divisions he can be liberated from such bondage to a part of himself, divided from the rest, by its integration through his acceptance of responsibility for it.

Chapters 3 and 4 argue that in this process of integration the parts of the divided self are transformed and that an important part of such transformation is coming to own one's morality—the integration of the super-ego. There is thus no sharp line between moral learning and the transformation of the self in a genuine psychotherapy. In either case the morality thus owned stops being a 'repressive' and 'negative' force in human life and becomes a 'constructive force' essential to individual autonomy and the consideration of others within its parameters—though these parameters may of course vary from one morality to another.

Chapter 4 raises the specific question of how self-knowledge can bring about the kind of change which psycho-analytic therapy seeks to help the analysand to come to in himself. It is thus concerned with the connection between self-knowledge and the changes in a person that come about with the healing of his inner divisions.

What is distinctive about Chapter 4 is its analysis of the concepts of self and self-knowledge. It argues that self-knowledge is not knowledge *about* oneself, that coming to self-knowledge is learning to *be* oneself. Learning to be oneself is coming to be aware of those things in oneself, fears and defences for instance, which stand in the way of one's coming together, conflicts which divide one, so that one has a chance to come to terms with them and in the process move towards greater unity and autonomy.

It is natural to wonder why or how it is that self-knowledge leads to change in the direction of greater autonomy. The puzzle comes from thinking of self-knowledge as knowledge about oneself—about what one is like. Whereas coming to self-knowledge is very much more a reclaiming of what one disowns and the way it changes in being reclaimed as well as the way one changes in oneself as what is reclaimed changes. The detailed discussion of this in

Chapter 4 develops ideas which are employed later in the book, in discussions of the self in its relation to good and evil.

Chapter 5 begins by asking 'What is happiness?' and goes on to argue that a person's outer circumstances are not sufficient to make him happy. He must also have certain capacities and through their exercise contribute to his own happiness—without, however, having it as his object. What is in question are the person's capacity to enjoy things, to take an interest in people, his ability to appreciate what is good and beautiful, to feel gratitude, to forgive. In their exercise he is active, he puts himself out and makes a contribution to the life he shares with others. That is why unless a person is able to forget himself and stop thinking about his happiness he cannot find happiness. He has also to be able to bear pain, grief, distress and disappointment without feeling sorry for himself, complaining, or going to pieces. That is, he has to be able to keep a sense of proportion, have humour, patience, courage in the face of adversity, and trust. These are personal qualities, moral virtues, which presuppose that the person has outgrown his ego-centricity and found himself—the topic of the following chapter.

I agree with Freud that life is inherently problematic and contains pain and disappointment. A person who insulates himself from these becomes smug and what happiness he may find in his life then becomes shallow. To so insulate oneself is an expression of personal weakness. Thus an ability to be happy presupposes an openness to life, and one cannot be open to the pleasures of life without at the same time being open to its pains. In that sense happiness cannot be made secure and any misguided attempt to make it so is destructive of it. It takes stability of personality to face the insecurity of happiness.

Freud thinks of morality as primarily a force of repression preventing people from being themselves. Its benefits in terms of social cohesion are external to it and one who can voluntarily submit to its discipline would be acting out of rational enlightenment. Freud's view thus lacks a recognition of the integral way in which morality belongs to human life and has a *positive* role to play in the life of the individual when he makes it his own and in the process comes to himself. An appreciation of this is to be found in Jung, in Melanie Klein and some of her followers, and in Winnicott and

Erich Fromm. Chapter 6 is concerned to appreciate their contri-
bution to this topic *critically*.

One of their claims is that there is a morality that is inherent
in us. Chapter 6 argues that what they have in mind is our capac-
ity for love, concern for others, trust and good will—a capacity we
come to in our development towards maturity when that develop-
ment is not arrested. In the course of such development the love
we are capable of is purged of its ego-centricity.

But the line between what is 'inherent' in our nature and what
comes from outside is not easy to draw. Section 6.2 argues that
much of our nature is the result of nurture, while equally it is part
of our nature that makes nurture possible. What may be said to be
'inherent' in us are thus the *seeds* of our morality. But what kind of
morality these grow into depends on the *soil* in which they grow
and the kind of watering they receive—that is the culture and
moral environment in which the individual grows as a child and
the care and attention he receives during his formative years. Thus
the kind of moral values which the individual makes his own
comes to him from *outside*, from the life into which he is initiated.
But this does not make our morality into something that is
'implanted' into us as Freud thinks. For in what we thus learn we
acquire our very *being*.

In the child, however, is also to be found what Freud attributed
to human nature—what makes for selfishness, self-centredness,
and hedonism: thus the *duality* of human nature which gives the
human soul its *bi-polarity*. But equally important are the forms of
significance that become available to the child in the course of his
mastery of language, his education, and his development. What
belongs to human nature and what belongs to the culture in which
the individual develops are thus complementary and inseparable.

The next question raised in Chapter 6 is the relation between
morality and human life. Morality, of one kind or another, belongs
to human life and is integral to it. It is an important part of what
makes human life the kind of life it is. A person who lacks all moral
concern will participate in that life only in a *limited* way. This limi-
tation will mark his personality; in fact it will constitute an arrest in
his development. It will also mark the world in which he lives. Such
a person will be unable to enter into and make personal sense of
part of the world in which the rest of his fellow human beings live.
I characterize such a person as ego-centric and claim that his con-

tact with others and what he can receive from them is limited by what he is able to give them.

Section 6.3 is a critique of the idea that there is only *one* kind of authentic morality and that it is the one which has an objective basis in our humanity. Freud had rejected morality because he could find no basis for it in human nature. Fromm and Money-Kyrle share Freud's presupposition that, unless such a basis could be found, morality would be something external, artificial, arbitrary, and therefore something deceptive. They argue that a basis can indeed be found for the values of psycho-analysis: 'humanistic ethics'. Section 6.3 argues that this is a mistake: our humanity is not the source of the values of humanistic ethics; rather it is such an ethics that is the source of our humanity. But this does not make such a morality into a 'mere product' of our culture and so into something artificial. It is no more artificial than our language.

A morality is not authentic or inauthentic as such, in abstraction from the people who observe it in one way or another. The authenticity of a morality is a matter of each individual's relation to it, not a matter of its relation to something independent and 'objective'. It is the *individual's* morality that is authentic or not. When it is authentic then there is nothing arbitrary about his allegiance to it. For then his allegiance is neither a form of conformity nor a reaction-formation against tendencies in him arbitrarily prohibited. Rather it comes from what the individual sees in the values of the morality in question and what they mean to him.

Both Money-Kyrle and Erich Fromm have maintained that maturity, autonomy, being oneself, or authentic and moral goodness in the humanistic sense coincide. Section 6.5 is an examination of this claim and an attempt to see what truth can be extracted from it. It argues that though an evil person can be behind his evil acts, in the life which sanctions those actions he cannot come to himself, be himself. This is a controversial claim and the bulk of 6.5 is a defence of it. On the other side of the coin, I argue that, in gaining greater accessibility to goodness, a person achieves greater coherence of self.

The concluding section claims that goodness, in the sense that has been under discussion, is not the property of any one culture and that, in that sense, it has a certain universality.

Chapter 7 is a continuation of the discussion of the previous chapter, develops the ideas put forward there and defends them.

It begins with a reconsideration of the question whether we can identify a human nature, the same nature in all human beings, in different cultures.

Various conditions, physical and other, shape men's lives. Lives so shaped are the soil in which different values are thrown up and grow, and these in turn contribute to the shaping of men's lives. The relationship is a two-way one. The conditions and the way men respond and adapt to them may be spoken of as the *roots* of the different moralities to be found among men.

The individual is born into a life in which he is shaped by increasing degrees of active participation on his part. Through such participation, in turn, he contributes to the life he shares with others, shapes his own life and himself changes in the process. What life he is born into and grows up in is an accident, but what he makes of himself in that life is not.

Section 7.1 focuses on two constants or universals which go into the make-up of *human nature*: the will to survive in inhospitable or threatening circumstances, with its aggressive energy that can be put into creative uses; and the capacity to love, feel, and care for others. These can combine in all sorts of ways. I refer to them as 'constants' in the sense that they cut across different cultures; but though they do, they presuppose one form of culture or another to be part of human nature. Human nature can only exist within a human culture, even though it transcends any particular culture.

These two constants of human nature, however, can change in the course of the development of the individual or its arrest. The will to survive, for instance, can assume a selfish aspect and act as a magnet for the person's ego-centric impulses and emotions. This would arrest the child's growth out of his early ego-centricity. As such, in the adult, it is disposed to enter into the service of evil.

Section 7.2 is a discussion of ego-centricity and its special significance in moralities of love. It constitutes an alienation from goodness. Section 7.3 explores goodness and evil in moralities of love. Section 7.4 looks at the sense in which good and evil are 'universal' and considers objections to the way this has been presented in the preceding chapter. Section 7.5 defends my claim that evil desiccates life of its sense for the person who embraces it and prevents the person from coming to himself. (This is the controversial view I put forward in Chapter 6.) In 7.5 I defend it against the fol-

lowing objection: the good man is equally alienated from evil and his life is equally limited. What counts as a limitation or impoverishment is relative to the speaker's perspective and there is nothing self-stultifying about what is a limitation from a perspective which a person does not share. For it to be self-stultifying he must *himself* consider the life he wants to live to be limiting and so feel deprived of something he wants, values and cares for while living that life. Hence, the objection goes, there cannot be anything self-stultifying about indifference to the good and non-engagement with it.

Section 7.5 looks at the ego-centric person who is self-sufficient and successful. It agrees that there need be no tension in such a person, no conflict between what he wants and pursues and what those pursuits exclude, since he doesn't know what he misses and, therefore, cannot want it. It remains true, however, that in feeding his ego such a person starves himself and that this increases the hunger he feels in his ego. He is thus driven by the ultimate unattainability of what he craves for and the way this increases his craving. Thus driven, his pursuits stand in the way of his growth and his flourishing in the sense of his coming to himself. There may be no inner conflict in him but Socrates's simile of trying to fill a leaky vessel with a sieve is an apt description of his case.

I consider the objection that doing so may not be anything frustrating to such a person; it may constitute for him part of the activity of life which exhilarates him, while 'growth of the self' may mean nothing to him. It is true that from the ego's perspective adopted by such a man what I call 'growth of the self' is invisible to him and so he cannot himself find his pursuits stultifying. My judgement that it is nevertheless self-stultifying is made from the perspective in which Tolstoy thought of Ivan Ilytch as self-deceived and Socrates called Archelaus an unhappy man. The self which I claim to be stultified by the pursuit of evil is thus the same as the one deceived in Tolstoy's story and the one pitied in Archelaus by Socrates.

I consider this objection further when I ask whether evil is self-alienating. To this end I consider the notions of development, arrest, authenticity, maturity and contact, against the charge that they are 'systematically ambiguous' and that this does damage to my claim. Professor D.Z. Phillips, from whom the objections I consider in this chapter come, said that the limitation I claimed for

evil is relative to the point of view or perspective from which we describe a way of living. I argue, in contrast, for an *asymmetry* between good and evil which takes the sting out of this objection. I conclude that the good man's life is not limited and impoverished by what he turns away from in the sense in which the evil man's life is impoverished by what he is alienated from.

Chapter 8 examines the way in which in the affective moral development of a person the love of which he becomes capable acquires a moral dimension—one that is internal to the kind of love this is. It is in this form that love and goodness are the two sides of the same coin. The development of the person, moral and psychological at once, is the purification of his love from all forms of ego-centricity. The possibility of such development is inherent to love, whereas it is logically alien to our concept of hatred. It is in this sense that love and hatred do not exist in the same logical space to be even each other's opposites.

I considered (in Chapter 6) the revisions of Freud's views of morality which have been made within psychoanalysis. Erich Fromm claimed that Freud's views depicted a form which morality does often take among people, a form in which it is repressive and prevents people from coming to themselves. But morality does not have to take that form. Freud's views of religion suffer from the same drawbacks. In them Freud depicts what Christianity does sometimes come to mean to people, the kind of God at least some worship. But in his rationalism he cannot see an alternative to this. As in Chapter 6, here in Chapter 9 I consider an alternative offered by a later psycho-analyst, Rycroft. I am sympathetic to what he offers, but I expose its limitation. More importantly, I claim that psycho-analysis, though Freud's brain-child, is not confined to Freud's views of morality and religion: those views are not endemic to psycho-analysis.

So Chapter 9 asks: what can psycho-analysis make of religion and can it help a religious patient with his spiritual problems? After a brief consideration of Freud's conception of religion and the God he rejects, Chapter 9 summarizes, expands on, and attempts to clarify Rycroft's conception of God, the God Rycroft, as a trained analyst, can personally make sense of. This God, Rycroft argues, is not an object, not a metaphysical God. It is a spiritual God, and belief in such a God is an affirmation of love on the part of the believer—a selfless love of others. Coming to such a

love is a transformation in oneself which coincides with the individual's development towards greater unity of self, maturity, and autonomy. Hence such a belief is dramatically opposed to a belief in an infantile father-figure as depicted by Freud. It is, therefore, an expression of a psychology not susceptible of analysis. So we have here an idea we have come across in earlier considerations of Erich Fromm and Kleinian analysts, namely that spirituality requires emotional maturity and unity of self. It can only be achieved hand in glove with such a psychological transformation from a 'determining' to an 'enabling' psychology—a topic further pursued in Chapter 10.

In 9.3 I consider the question: How far does Rycroft succeed in putting his God in a pivotal position in spiritual life? Though sympathetic to what he says, which I try to present in the best possible light, I argue that in distancing himself from the language of Christianity and its theology, much of which in his mind calls for a metaphysical interpretation which he rightly rejects, he gives us a somewhat attenuated and psychologized God. He loses sight, to some extent, of the connections, made by the language from which he distances himself, between the love affirmed in belief in a Christian God and the various things in the life and culture of the believer. The result is that he finds himself confined to expressing these connections in psychological terms: integrity, wholeness of self, psychological health, and insight. In this connection I consider briefly Plato's identification of spiritual health with goodness.

Rycroft holds that belief in the God he can make sense of cannot be explained in psychological terms. I made the same claim about goodness. Yet certainly, as great literary writers, among them Dostoyevsky, well appreciate, the spiritual cannot exist in limbo from the psychological. They interpenetrate one another; but how? I make some short comments about this.

If, as Rycroft says, his God is immune to psychoanalytic interpretation, is there anything a psychoanalyst can do to help a patient with his religious, spiritual problems? I consider this question briefly in 9.4, through a consideration of the example of father Zossima in Dostoyevsky's *The Brothers Karamazov* exercising his healing powers on a peasant woman, a devout religious believer, who is in the throes of an arrest of life after the death of her child.

In 9.5 I argue that though there cannot be psychological explanations of genuine religious beliefs there can be historical questions which can be asked about individual religious beliefs and particular religions in particular periods. However, to say that a particular God belongs to a religion and that any religion is part of a culture and in that sense its product, in other words the product of complex historical, sociological, and physico-geographical circumstances, is not to say or imply that God is a human creation. God is no more an invention than our language and our moral values are. I distinguish between a religious claim made by a believer as part of the expression of his faith, such as 'There is only one God', and one made by a sociologist or anthropologist, such as 'There are many different gods.' These two statements do not contradict one another; there is no conflict between them.

The book, I have said, is concerned with the interrelations between the self and the soul, psychology and morality. It concludes with a discussion of Dostoyevsky's character Raskolnikov in *Crime and Punishment*, because the novel is vibrant with insight into this relation. Thus in Chapter 10 I let the novel speak for itself as much as possible. I find there a clear vision of what I have tried to work out in the present book, in particular how much a person's spiritual and psychological problems form an *organic whole* so that coming to terms with one set of problems is coming to terms with the other set and *vice versa*.

Graphically the theme of *Crime and Punishment* is the loss of the life of the soul when evil is allowed to enter the soul, and its resurrection and the person's return to autonomy when he consents to mourn and pay for this evil in accepting responsibility for it in punishment. The novel follows the way the evil that Raskolnikov allows to enter his soul with the murder he commits joins hands with his defences against the fear of becoming a non-entity. For that, given his psychology, is what admitting his guilt is tantamount to for Raskolnikov: it is a form of total submission. In defiance he is somebody—he counts, at least in his own eyes—whereas in submission he is nothing. That is how, we are shown, the evil he has allied himself with was meant to serve him. He, in turn, serves that evil by preventing goodness from taking hold of his soul. It is a perfect pact, mutually beneficial—consolidating the hold of evil in his soul and beneficial to Raskolnikov's ego, but detrimental to his soul.

Psychologically the crime he has committed is an attempt to regain the autonomy he has surrendered to spite his mother who has been pushing her morality down his throat. But autonomy cannot be regained without coming together and making peace with oneself. Raskolnikov comes to realise this after much suffering. He has violated the morality in which he was raised. He has to pay for this in remorse and repentance before he can make that morality his own, is reintegrated with goodness, and finds the wholeness and autonomy that have been eluding him.

To do so he has to give up his defences and appear in the dependency in which he feels exposed and vulnerable. This parallels what often happens in a psycho-analysis. In Raskolnikov the defences in question have been taken over by evil; in that evil he puts up a barrier against goodness. Only through remorse can Raskolnikov re-admit goodness into his life. Only then can he find himself and his soul—finding himself in finding his soul, and his soul in finding himself. This was precisely the theme of Chapter 6.

Thus, it is psychological needs that turn Raskolnikov to evil; but it is not his psychology that later turns him to goodness in the same way. Rather the changes in his psychology, as he works through the conflicts in which good and evil are at war with one another in him, allow him, for the first time, to turn to goodness without any reservation. It is because he wanted something for himself that he had turned to evil. But in turning to goodness a person wants nothing for himself; otherwise whatever he is turning to would not be goodness. Turning to goodness—like generosity, gratitude, forgiveness, and trust—is gratuitous. Its explanation is in terms of what a person sees in goodness, not in terms of his psychology—of what it does for him. This is another of the themes that have been prominent in the book.

Almost all the themes of this book come up again in this last chapter on Dostoyevsky's Raskolnikov, providing a good illustration of the philosophical claims worked out and defended in the previous chapters.

1 Science and Psychology

1.1 SCIENTIFIC METHOD AND UNDERSTANDING HUMAN BEINGS

I want to ask: What is knowledge of human beings and can it be acquired by experimental methods?

It is a widespread assumption in academic psychology that the methods which have been applied with great success in the physical sciences are applicable to investigations in other areas and hence to psychological investigation. The history of experimental psychology is the history of the adjustments psychologists have made to their subject to be able to apply the experimental method of the sciences to it. In the process of trimming the head to fit the cap on it they have emasculated psychology.

The knowledge they seek in this way—which is the only kind of knowledge they recognize—is impersonal, general, inductive, theoretical. It is to be applied to particular cases so as to obtain an understanding of individual people and help them to deal more efficiently with such problems as difficulties in learning at school, stress at work, problems of maladjustment, unhappiness in relationships, and so forth. This is the orthodox view.

Thus, in his *Psychology: The Science of Mental Life*, George Miller says that advance in a science is measured in terms of theory and of practical results: 'scientific knowledge provides a foundation for technological advances, for the solution of practical problems that arise in the daily affairs of ordinary people' (p. 16). This foundation, he tells us, is to be found in the understanding it seeks of 'what people are *really* like' (p. 17). 'Like all sciences, psychology has influenced our lives at both levels. It has given us technical

tricks and it has changed our conception of human nature' (p. 17). He mentions psychological testing as one example of the fruits of scientific knowledge in psychology:

> They [psychological testers] began to test aptitudes, to classify interests, to evaluate achievements. Now they can pigeonhole your personality, assess your emotional stability, your masculinity, your imagination, executive potential, chances of marital bliss, conformity to an employer's stereotype, or ability to operate a turret lathe. Whatever you plan to do, there seems to be a psychological test you should take first. (p. 19)

Now the idea that a person's emotional stability or his chances at making a happy marriage can be assessed by a psychological test, in the way that his ability to operate a turret lathe can be so assessed, shows a thoughtless attitude towards life and, I believe, has done immense harm. One cannot come to know a person in this way, nor can one assess his chances at making a happy marriage by any kind of litmus test.

First of all it takes time to come to know a person and, even then, one can at best only guess how he will come up in the face of a new challenge. Besides, there are so many imponderables where something like a marriage is concerned that the most one can do is to make a tentative guess, adding the proviso: 'if he is lucky', 'if things go well for him'. (a) There is a place for chance in life, contingencies that are not predictable, and (b) a person, however set in his ways he may be, may always meet an old contingency in a new way.

So let me ask, what is knowledge of human beings? How does it enter into our understanding of ourselves and others as individuals? Can it be acquired by scientific observation, and does it have the kind of generality, precision, and objectivity characteristic of science? Wittgenstein asks: can one learn this knowledge? Let me quote his very brief answer:

> Yes; some can. Not, however, by taking a course in it, but through 'experience'. —Can someone else be a man's teacher in this? Certainly. From time to time he gives him the right *tip*. —This is what 'learning' and 'teaching' are like here. —What one acquires here is not a technique; one learns correct judgements. There are also rules, but they do not form a system, and only experienced people can apply them right. Unlike calculating-rules. (*PI*, p. 227)

The experience which Wittgenstein has in mind is the kind one has in living one's own life. It refers to one's dealings with people in their variety in different situations, meeting with their co-operation as well as obstruction, their gratitude and their resentment, finding communion with them and at other times feeling at a loss and out of one's depth. The point is that we acquire whatever knowledge we have of mankind in *living our life*, engaging with others and suffering life's adversities. The more open we are in ourselves—that means open to hurt, grief, criticisms, as well as to the pleasures of give and take—the more we are capable of learning from others and about life. By contrast the psychologist's laboratory is an ivory tower.

Obviously observation plays an important part here, but it belongs to our dealings with people, it is part of our participation in life's activities in the course of which we meet others. It is to be contrasted with the detached observation we have in the sciences, where observation is a skill and one trained observer is as good as another. There the observation is part of his expertise, here it comes from the individual and it is as much in his responses as it is in his eyes. What is important is that it should be first-hand—not skilled. A skill is acquired by training; being genuine in one's responses is what a person comes to in his growth.

It is in learning to be oneself, in learning to live one's own life that one comes to know people. As one comes to know people as individuals, one becomes alive to their differences and acquires an understanding of people—what Wittgenstein calls 'judgement'. This is not confined to the intellect; the understanding is an intimate part of the person. That is why psychology, in what Dr Drury in his book *The Danger of Words* characterizes as 'its original meaning', is not an *academic* subject. Drury says that in this sense 'it is the great novelists, dramatists, biographers, historians, that are the real psychologists' (1973, p. 41).

So the knowledge and understanding that makes a psychologist a psychologist in *this* sense is picked up in the course of living one's life and keeping one's eyes open and one's wits about. As Wittgenstein says, some can learn this knowledge; not, however by taking a course in it. For there is no general method for acquiring it and it engages the person in himself as an individual. It is not the kind of knowledge which is open to all who are intellectually qualified. It calls for personal qualities.

For this reason observation and objectivity do not mean here what they mean in the sciences. There, as I said, observation has to be dispassionate; the observer has to be detached from what he observes. There is only one point of view from which he observes it: that of the science in which he has been trained. In contrast, the human beings whom the psychologist is concerned to understand have themselves a point of view on what they are doing and on the situation in which they act. The observant person is the one who can enter into the other's point of view, appreciate how he sees things, what things mean to him, what considerations carry weight with him. Only in this way can he understand the other's conduct—his decisions, reactions, fears, and desires. He has to speak the other's language, share the life of that language with him, live in the same world. I am referring to the human world in which the identity of what forms part of it (situations, events, relations) is determined by forms of significance which have their source in the language and culture of those who live in it. There is nothing like this in the world of physics, nor in the life and behaviour of animals—in the natural sciences.

I said that the observant person in psychology is a participant in the world of the person he observes; he is not detached from it. Does that mean that there is no such thing as objectivity here? The answer is: it depends on what one means by 'objectivity'. Certainly there is a difference between biassed and unbiassed observation. The psychologist has to make sure that his personal likes and dislikes do not bias his appreciation. On the other hand this does not mean that he has to be indifferent to those he is trying to understand. If he were, he could not respond, enter into their point of view. So the attitude he has to develop is not one of detached interest but of concern and fellow-feeling.

In this respect he is to be contrasted with the scientific observer who is, as it were, a human instrument. What he observes constitute data for his science. His training qualifies him as such an instrument and he is objective precisely in his impersonality. The psychologist's understanding, on the other hand, does not grow from data in this sense, but from what he grasps in his responses to people 'in the traffic of human life'—to use an expression from Wittgenstein. The scientist's detachment would, therefore, disqualify him from grasping what he grasps in such responses. What is important is that he should be free in his

responses from seeing things only in relation to himself. This is what constitutes bias in psychology. For it prevents the psychologist from seeing what people respond to and the considerations that weigh with them from within their point of view. It would thus stand in the way of a proper understanding of their conduct.

I contrasted scientific data which can be recorded and collected with an instrument with human conduct. Data are self-contained units abstracted from the flow of events—positions of a star, the acidity of chemical solutions, the changing voltages of an electric current. Human conduct, by contrast, is an integral part of the life of an individual person, with a particular history, participating in the life of the culture to which he belongs. It can only be identified and characterized, as I said, in the traffic of human life; not in abstraction from it. That is why the most interesting questions of psychology are not amenable to experimental investigation. For an experiment is something one can repeat. The environment in which it is repeated in the laboratory is tightly controlled. It must remain the same from one performance of an experiment to another performance of it. Otherwise it would be impossible to compare results. What is thus included in or excluded from this environment makes a causal difference to the result obtained. That is the focus of interest in the experiments: what are the factors that affect the result? But the same result must be conceivable in different circumstances; otherwise we could not say whether this or that factor in those circumstances do or do not affect the result in question.

With what psychology is interested in it is mostly otherwise. The remark that a man utters, for instance, will have a different significance in different circumstances; it will no longer be what it is—an insult, a word of praise, an encouragement. In different surroundings the same gesture, movement, or even action will manifest very different feelings, qualities of mind and character. Indeed, words which are an expression of gratitude in one person's mouth may turn into an expression of irony or condescension in another person's mouth. To know what they express or mean you have to know the person who means them thus or thus. Here we have a serious logical limit to experimentation in psychology.

On the other side of the same coin, most of the states and qualities of mind and character that are relevant to what interests us in

people have diverse manifestations. Consequently the words we use to refer to and describe them—'gratitude', 'arrogance', 'intelligence', and so forth—cover 'many manifestations of life'. As Wittgenstein puts it: the phenomena which constitute these manifestations are 'widely scattered' (*Zettel* §110). There is nothing to be abstracted from them all, from the diverse manifestations of love or intelligence for instance, such that we can say 'this is its essential nature'. If we abstract or construct such an 'essence' or general character in the name of science we shall leave out much that is of vital interest to us. This is one reason why there can be no unified theory of love or of learning, for example, and why their presentation belongs to literature. It is also one reason why we should take intelligence and other psychological tests with a pinch of salt. Dr Drury tells us how, when he was in the army, a man who was found by intelligence tests to have the mental age of a boy of twelve and a half displayed much native intelligence in the job Drury appointed him to do. Manifestations of intelligence are 'widely scattered'; we can even say that intelligence is not one thing.

What the psychologist is concerned to discern and understand in human conduct are expressions of the human soul—verbal and other—that is of individual human beings. Here it is important to remember that human beings can be themselves in what they say and do, and as such accessible to others, and they can also withdraw, put up a front, hide their feelings and intentions from others. They are capable of lying and pretence. There is nothing like this in the animal world or the world of physics, nothing like this which the physicist or the ethologist needs to take into account in his observations. For much of what the psychologist needs to understand he has to come to know people as individuals. This necessarily takes time and is not a matter of observing how they behave, as it were, through a one-way screen. He has to be receptive to others and the people he is interested in have to be open and be themselves *with him*. I emphasize the 'with him' for this is part of a two-way interaction. The scientist observes the phenomena he studies; the psychologist has to be able to talk to people and listen to what they have to say. Obviously he knows this, but the gloss that is put on this in psychology badly misrepresents what is in question. In introspective psychology what a person reveals about himself in what he tells others, including the psychologist, is

treated as information provided by self-observation. The idea is that he observes in himself what no one else can observe. Thus the psychologist observes him and what he cannot observe is relayed to him by the subject of his experiments. As William James puts it: 'when psychology is treated as a natural science "states of mind" are taken for granted as data immediately given in experience' (1948, p. 462). It is such data which the subject is supposed to report to the psychologist, the experimenter.

The behaviourist rightly rejects the idea of introspection as a form of observation directed to some private inner landscape. He treats what the person says about himself as part of his behaviour. In doing so, however, he misses something distinctive about human beings, namely that there are some things which we can find out about people only if they choose to disclose them to us— thoughts, feelings, wishes and memories which we may never know of unless they tell us. They have a privileged access to those not by introspection, but simply by virtue of these thoughts, memories, and wishes being *theirs*. That is, people have the capacity to tell others what they think, remember, intend to do, if they want to, because they can talk. It is this simple but important fact which psychologists have had great difficulty in recognizing—I mean in seeing it for what it is.

I have argued that the kind of knowledge we expect to find in psychology 'in its original meaning', namely what I referred to as 'knowledge of human beings' or 'knowledge of the human soul', is not inductive knowledge. It does not have the generality of scientific laws. Wittgenstein, we have seen, speaks of what one who learns such knowledge acquires as 'judgement'—in the sense in which we may say of someone that 'he has judgement'. Its generality, therefore, lies in the way one who comes to it comes to a new perspective on life. Through it one's understanding of individuals is deepened. It is thus the generality of a perspective to which one is related personally. It is as such that it enters my dealings with and responses to people in particular situations and my judgements about their conduct.

Yet the orthodox view in academic psychology is that psychological knowledge is arrived at inductively, by generalizing what one observes in particular cases. This can then be applied to new cases. I have already quoted George Miller to this effect: 'scientific knowledge provides a foundation for technological advances, for

the solution of practical problems that arise in the daily affairs of ordinary people.' A classic statement of this view is found in John Stuart Mill's 'On the Logic of the Moral [meaning 'mental'] Sciences', in *A System of Logic*, Book VI:

> Human beings do not all feel and act alike in the same circumstances; but it is possible to determine what makes one person, in a given position, feel or act in one way, another in another . . . In other words, mankind has not one universal character, but there exist universal laws of the formation of character. (p. 41)

Here is a different conception of what I learn and the way it bears on and comes into motion in each new case I meet. I quote the last paragraph of John Wisdom's 'Paradox and Discovery' in a collection of his essays by the same title:

> It is, I believe, extremely difficult to breed lions. But there was at one time at the Dublin zoo a keeper by the name of Mr Flood who bred many lion cubs without losing one. Asked the secret of his success, Mr Flood replied, 'Understanding lions'. Asked in what consists the understanding of lions, he replied, 'Every lion is different'. It is not to be thought that Mr Flood, in seeking to understand an individual lion, did not bring to bear his great experience with other lions. Only he remained free to see each lion for itself. (p. 138)

This is in stark contrast with George Miller's claim that 'psychology ... has given us technical tricks', for instance mental tests, by means of which 'now they [the psychologists who apply them] can pigeonhole your personality, assess your emotional stability, etc.' It is precisely such pigeonholing which, Wisdom tells us, Mr Flood avoided in his understanding of lions.

Clearly the kind of understanding Mr Flood had of his lions has greater affinity to what artists give us of what they present in their works than the one scientists give us of the phenomena they study. For the scientist is interested in general properties or common characteristics to determine common reactions. Artists, on the other hand, are interested in seeing things in their differences, to capture them in their uniqueness. Wisdom thus underlines the child-like character which Mr Flood preserved in his view of his lions, however wide his experience had been in breeding many lion cubs: 'We need to be at once like someone who has seen much and forgotten nothing (he says), and also like one who is seeing

everything for the first time' (pp. 137–38).

This is precisely the quality of vision one finds in a good painting, biography, or novel. Thus Marion Milner, a Kleinian psychoanalyst who in her youth sought to find herself and also to paint, writes of the way things revealed themselves to her when she could detach herself from her self-preoccupations:

> I was lying, weary and bored with myself, on a cliff over the Mediterranean, I had said 'I want nothing', and immediately the landscape dropped its picture-postcard garishness and shone with a gleam from the first day of creation, even the dusty weeds on the roadside. (1952, p. 107)

This is what Wisdom describes as 'seeing everything for the first time'. It is the opposite of what Miller tells us the scientific psychologist does: 'pigeonhole your personality.'

When someone's personality is pigeonholed one may at best come to know what is vulgarly called 'what makes him tick'. This may be useful information for someone interested in pulling his strings, in using him. But it is very far from understanding him and it is a delusion to think that this is all there is to him. In any case, the idea that everyone has strings that can be pulled is as crass a notion as that everyone has a price and can be bought. Someone who pigeonholes people does not see them with open eyes and in their depth; he makes cardboard cut-outs of them. Furthermore the contact he makes in his interactions with them is bound to be superficial, for he doesn't permit them to be themselves.

Let me add that human beings cannot be confined to what they are like—even where a psychologist can pull their strings. For a person—and this is where a person differs from a lion, even when seen as an individual lion—can himself be aware of what he is like and has himself a point of view on it. He is the person he is in the kind of relation he stands to it. He may be dissatisfied with himself, be troubled about the way he is, consider himself a failure, be defiant in the way he is; he may accept it, or he may acquiesce in it. Thus, in the last case, if he is greedy for instance, he will be so in the mode of a greedy puppy. Even in such a case, though, he can take cognizance of the way he is and take responsibility for it: endorse or repudiate it. Here we can say nothing general: this dimension of life which is distinctive of human existence necessarily eludes any scientific psychology—that is any psychology which is concerned with general or common characteristics

from which to draw inferences in particular cases in the way Mill suggests.

Yet psychologists, in thinking of themselves as scientists, lose sight of this. They say, for instance, that they wish to understand the way the mind works and go on chasing after laws that govern the mind's workings. But there is no such thing as 'the way the mind works'. We may, of course, perfectly legitimately, wonder about the way a particular person's mind works. Here we are try-ing to figure him out as an individual: Why, for instance, is he so quick to take offence? Why does he reject people's friendly over-tures so readily? Why does he like to ruffle people's feathers? What does he get out of being offensive to people? There is no general theory which will help us arrive at answers to such questions. We shall only arrive at answers here by coming to know the person in question. This involves talking to him and finding out about his past life and present circumstances, his thoughts and feelings about different things, his interests, convictions and his plans and hopes for the future. We shall make sense of all this, of course, in the light of our experience of people over a period of time.

This is precisely the kind of research that goes into writing a biography; it is the kind of thing a novelist brings before his mind imaginatively in constructing a character. What the biographer or novelist makes of this material, the way he arranges it to give us insight into the person or character presented, depends on his tal-ent, imagination, and knowledge of the human soul—in the sense I have tried to elucidate. He looks at and makes us see the person and character he presents 'from *within*', that is from within the person's or character's point of view, using his art to this effect. He makes us see the world in which the person or character moves, through his, the character's, eyes, contrasting it with the way those he interacts with see it.

Such a focus is *historical* rather than inductive. The question, 'What led up to it?', say to a bout of depression, a dispute between him and a fellow character, or a permanent feature of character he has developed from early childhood on, is not directed at formu-lating hypotheses about repeatable causal sequences. It seeks rather to gather an individual story which helps us to make sense of what the writer makes us see—for instance disappointments of the person with himself, contradictions within his character, fail-ures incommensurable with his talents. I suggest that this is the

only way to understand people as individuals and that is why I think that psychology in what Drury calls 'its original sense' belongs to the humanities rather than, as we are taught to think in universities, to the sciences.

Let me make it clear that I do not wish to deny that there are questions that fall within the purview of psychology, in a broad sense, that are amenable to experimental study. They concern, as Charles Taylor puts it, 'the infastructural conditions for the exercise' of those capacities which are necessary to human conduct—such as attention, perception, memory, voluntary movements, and the functioning of the neurological systems that come into play in the exercise of these capacities. They are concerned with the *constants* behind individual behaviour in its variations. As both Drury and Taylor point out, these phenomena, which are amenable to experimental, scientific study, are on the psycho-physical or psycho-neurological boundary of psychology, that is on its peripheries. I doubt that *their* study has any light to throw on individual behaviour.

If we consider the analogy of the infrastructure of a city—its sewer-system, road network, electricity, water works—this point would become plain. One takes these to be in place and in good working order when one tries to understand the life of the city—its people's occupations and preoccupations, the way its institutions run and are interconnected. If the roads were to get blocked, the sewers, electricity, telephone exchanges and water works were to stop functioning, the life of the city would grind to a halt. That is not to say, however, that one can understand that life in the way one understands how its telephone network or sewer system works.

The trouble with academic, experimental psychology is that, deceived by the pretensions of science, it does not recognize its own limitations. As Wittgenstein puts it at the end of *Philosophical Investigations*:

> The confusion and barrenness of psychology is not to be explained by calling it a 'young science'; its state is not comparable with that of physics, for instance, in its beginnings . . . For in psychology there are experimental methods and conceptual confusion.
>
> The existence of the experimental methods makes us think we have the means of solving the problems which trouble us; though problem and method pass one another by. (II, §xiv)

1.2 EXPERIMENTAL PSYCHOLOGY: SOME EXAMPLES AND THEIR CRITIQUE

I have argued that insofar as psychology is a study that aims at understanding people as individuals it cannot be an experimental science. Insofar as it persists in being an experimental science it cannot contribute to an understanding of individual behaviour and motivation. I want now to give a few examples to illustrate the disaster that experimental psychology has been in this respect.

In its early stages it is understandable that in their experiments psychologists should have confused experimental and conceptual questions. I am thinking of Wundt in the 1880s and the introspective analysis he carried out of consciousness by putting experimental subjects in certain situations and asking them questions to be answered by introspection, questions about what they detect within the field of their consciousness. Wittgenstein described this as a dead-end in philosophy insofar as it was used to answer conceptual questions. We find the same procedure employed by the Würzburg School carrying out experiments on the nature of thought and the will. Of course there is such a thing as what one may call an analysis of consciousness, I mean of the moment-to-moment shifting contents of what a person experiences; but not as a means to answering conceptual questions. It would be of interest to psychology; but it is best carried out by a novelist like Virginia Woolf in her novel *To the Lighthouse*. Here Wundt's 'introspective experiments' are worthless; what we need is an imaginative study, not an experimental one.

Introspective psychology, where introspection is supposed to be what observation is to physics, not surprisingly, turned out to be barren and misguided. But behaviourism which developed in reaction to it and took its place fared no better. It was worse than confused; it was also crude. It developed a picture of human beings, of their abilities and motivation, that was a grotesque caricature. I have tried to illustrate this in my discussion of B.F. Skinner's work in my book *Mind, Brain, and Behaviour* and I will not repeat now what I said there.

However, I do not think that what has replaced behaviourism fares any better. Much of it is little more than the old wine of introspectionist psychology in new computerized bottles. I shall give two or three examples, with my comments. They come from a

book of papers given at a conference between philosophers and psychologist entitled *The Self: Psychological and Philosophical Issues.* In it there is a paper by a cognitivist critic of behaviourism, Paul Secord, criticizing the kind of behaviouristic account of reflexive behaviour put forward in a paper on self-deception by Willard Day in the same volume. Day had opposed, I think rightly, the idea that an evasive response to an unwelcome suspicion about oneself, such as we find in self-deception, must be mediated by an intervening state of recognition. For knowledge or recognition is not a *state of mind.* In this way, he thought, his account escaped 'the paradox of self-deception', namely that the person who deceives himself must both recognize something about himself and, at the same time, insofar as he is deceived, not know that very same thing. With this I am not now concerned. But Day concludes, in a typically behaviouristic fashion, that since the kind of behaviour we have in self-deception cannot be understood in terms of conflicting states of mind, it is to be understood in terms of 'contingencies involving negative reinforcement'.

Secord, in turn, is critical of this. He considers the case of self-control another instance of reflexive behaviour and argues that we cannot hope to understand it without referring to 'cognitive processes'. He is right to criticize the ideal of operant behaviourism which puts the emphasis on external, environmental causes as the main source of human behaviour. But his idea of intermediate 'cognitive processes' simply puts the clock back and the misconceptions that go with it mar his own positive account. He replaces the behaviourist idea of 'environmental contingencies' reinforcing behaviour with what he calls 'self-intervention' and 'self-direction', and what he says in his account of the self-restraint, which he says they involve, is thoroughly muddled.

The very gist of what he says is that in restraining and controlling oneself one resorts to commitment: 'Commitment helps people to carry out their intentions' in the teeth of their inclination to the contrary. The idea is that a person manages to avoid sinning by embracing a religion, he manages to keep his promise by committing himself for the future. He asks: Why are promises kept? He answers: Because once they are made they are costly to break.

This may be true in a particular case. But then the person in question is not really committed: he keeps his promise only because he is afraid of the consequences. The fact that he has

given his word to do something carries little weight with him. This is the only kind of case where there is a *psychological answer*, and the question answered is *not* 'Why do people keep their promises?' but 'Why did he do what he said he would do when honouring the word he gave matters so little to him?' The general question 'Why do people keep their promises?' makes no sense; it is a confused attempt to ask a conceptual question: 'What is it about a promise that makes it binding? In what sense is it binding? What is involved in committing oneself, in undertaking to do something?'. These are questions best left to philosophers and insofar as a psychologist thinks he can answer them in psychological terms he can only introduce muddle and confusion. Thus in the different cases he considers Secord systematically distorts genuinely conceptual points and gives what one may call a 'corrupt' account of what it is for a person to commit himself to a course of action.

What needs to be understood is that my promise, my commitment to do what I give my word to do, is not something that *ensures* that I keep it. For the relation between the promise and the action promised is *internal.* To say that it involves a 'constraint' only means that when I give my word to do something I cannot do just anything I like. If I may be said to have 'given up certain options' that only means that if I told someone I would meet him for tea at a certain time then I cannot go to the cinema instead at that time. This is part of what it *means* to say 'I shall meet you for tea'. If I go to the cinema instead because I feel like it then I could hardly be said to have *meant* what I said. My point is that 'meaning what one says', 'committing oneself for the future'—this is not a matter of what goes on in one's mind, a 'cognitive process', at the time one speaks.

I give this as an example of how little experimental psychologists know what they are talking about and how far experimental psychology remains trapped in long-standing misconceptions. It is true that psychology had, for a long time, remained under the shadow of philosophy. But when it 'liberated' itself from philosophy's armchair in the name of science it took the wrong turning and lost its way, and it also was left in the grip of conceptual confusions which kept it going through the same motions over and over again. Of course psychology is not an armchair study; but that does not make it an experimental science. There are other alternatives, and I have argued that psychology derives its insight into

the individual from the psychologist's 'experience of life'. But that is very different from experimenting in a laboratory. So I am not saying that psychology should have kept in the shadow of philosophy. All the same its dissociation from philosophy in the training of psychologists has been a loss. The criticism of philosophy would have kept it from going off the rails and it would have been, on the whole, a civilizing influence.

I say this because experimental psychology has really become brash: its language is often barbaric and its view of man is shallow. It has lost its understanding of what it means to be a human being and of the kind of world in which human beings live. It thinks of the human world in terms of stimuli which human beings invariably take as reward or punishment. Human motivation is thus on the whole reduced to the carrot and the stick. Skinner quotes Hamlet who exclaimed of man: 'How like a god!' He contrasts Shakespeare with Pavlov who said of man: 'How like a dog!' Skinner then adds that from Shakespeare to Pavlov psychology has taken a step forward by bringing man 'within range of a scientific analysis' (Skinner 1971, p. 196). This is precisely what I mean by psychology's wedding to science having had a decivilizing effect on psychology. In his book *Walden Two* Skinner portrays his vision of the heights of human life, to be achieved by 'behavioural engineering', using 'operant conditioning' as its main tool. In my book on Skinner I compared Skinner's spokesman Frazier in *Walden Two* with Dostoyevsky's Grand Inquisitor in *The Brothers Karamazov*. The big difference between them, I said, is that the Grand Inquisitor knows the higher things he has forgone for the sake of a childlike happiness for men, knows what it means to be free and to bear responsibility for one's actions, whereas Frazier does not (Dilman 1988, p. 60).

In his *New Introductory Lectures on Psycho-Analysis* Freud said that 'psycho-analysis was met by illuminating criticisms to the effect that man is not merely a sexual being but has nobler and higher feelings' (p. 82). He agreed and added: 'for us the super-ego . . . is as much as we have been able to apprehend psychologically of what people call the "higher" things in human life' (p. 95). Freud's conception of moral conscience was flawed—as I argued in my book *Freud and Human Nature*—much in the way that Secord's conception of moral commitment is equally flawed. Skinner's conception of the heights of human life is flawed in much the same way.

All this is inevitable when psychologists attempt to give 'psychologistic' accounts of what Freud called the higher things in human life—art, morality, and religion. This does harm to their understanding of the individual as well. For it blinds them to forms of the individual's relation to these things that are not self-interested, so that the 'high' is made 'low'.

I now want to elaborate on this further by considering the following experimental research Kenneth Gergen conducted with Stanley Morse on the way other people affect a person's conception of himself, that is his identity and the worth he has in his own eyes:

> Participants in this research were students at the University of Michigan who answered an advertisement for part-time jobs in the Institute for Social Research. When each applicant arrived for the preliminary screening, he was seated in a room by himself and asked to complete a number of self-rating forms, including a battery of approximately thirty self-evaluation items fully designed by Coppersmith to tap basic levels of self-esteem. After each applicant had completed the various measures, the secretary entered the room, bringing with her another 'applicant' for the job who was, in fact, a collaborator. For some forty applicants, the collaborator was obviously very desirable as a potential employee. He wore a dark business suit and carried an attaché case which he opened to remove several sharpened pencils, at the same time revealing copies of books on statistics and philosophy. The remaining applicants were exposed to a dramatically different experience. Here the competitor entered wearing a smelly sweatshirt, torn trousers and no socks; he appeared generally dazed by the procedure and tossed onto the table a worn copy of a cheap paperback novel. After several minutes of silent exposure to the newcomer, the applicant was given additional forms to complete, including a second battery of items assessing levels of self-esteem. (Mischel 1977, p. 152)

The experimenters tell us that the results of this study show 'that the mere presence of the other person was sufficient to alter the manner in which the applicants conceptualized their own self-worth' and that this has 'far reaching implications'. They take it to provide experimental support for Gergen's view that there is no self over and above what others see in one, no self-esteem independent of the value which others bestow on one and of the way one measures up to others in the light of these values. This is the a highly dubious conceptual claim that the self in each individual human being is a 'social construction', and it calls for philosophical criticism.

I should have thought it elementary for any real psychologist worth his salt that only a person lacking a secure sense of self or identity would thus feel undermined or reassured in his self-confidence by the presence of others who appear impressive or insignificant to them. In any case, why assume that the subjects, however selected, would all react in the same way to what is presented to them by the psychologists? There is, surely, a difference between a sense of self that is genuinely secure in its own identity, that is one in which one knows and accepts who one is and feels no need to apologize for it, and one in which one's sense of inner security is in need of constant external bolstering—by other people's opinions, by favourable comparisons with others, and by artificially constructed identities, such as those that find expression in trendiness, the disporting of badges, or slavish conformity. Only in these latter cases is there some sense in talking of the self as a *construction*—'personal' when it is defensive and 'social' when it arises out of mindless conformity. When a person is real and himself there is nothing in who he is, 'his self', that is a 'construction'.

Certainly a person comes to himself, finds an identity in which he is himself, in his relations to other people, the practices, activities, interests, and values he shares with them. But whether or not the self he comes to is genuine depends on the form which these relations take. It seems that Gergen and Morse are guilty of a 'psychologism' which leaves no room for the possibility of the kind of relationships with others in which a person is truly himself and has no doubt about his own identity—about where he belongs and what he wants in life.

This criticism can be developed. But this said, what particularly strikes me about this study is the triteness and juvenile character of the experimenters' conception of the world we live in and of the kinds of thing they think would boost people's confidence in themselves or deflate it. Human beings can, of course, be trite and shallow, as this has been portrayed in good literature. But you need depth in order to portray triteness and to contrast it with its opposite. By contrast the triteness I find in the psychological study quoted by Gergen is part of the way the psychologists who have devised this study think about human beings. They themselves seem to lack awareness of it. This I submit is an inevitable outcome of the advocacy of the experimental method of investigation for psychology. For how can you expect more than this from a world

confined to scores, rewards, punishments, and 'self-administered' treats and telling-offs?

I complained about the dissociation of psychology from philosophy in universities where psychologists are educated. Let me now add that the simplistic view of the world, of which the triteness and shallowness I have mentioned are a part, is the result of the way psychology has severed itself from its literary heritage under the lure of the prestige it finds in science.

I want to finish with an example of the kind of language and concentration on trivia that you find in experimental psychology. Behaviourism is immeasurably crude, but has been superseded; so I take my example again from cognitive psychology. I take it from a survey on 'self-control and the self' by Walter and Harriet Mischel in the book from which I have been quoting. The section in question is called 'self-regulatory systems' which suggests the investigation of the mental equivalent of electronic systems. They are supposed to enable people to carry out chores, for instance, in the pursuit of certain interests and achievements. I have put this in my language. The writers in question speak in terms of 'delay of gratification', 'self-regulation', 'progress toward goal attainment', 'self-generated cognitive operations through which the person can transform the aversive "self-control" situation into one which he can master effectively', 'attentional mechanisms', and so forth. The examples in terms of which they think of what they seek to understand are those that can be adapted to experimental investigation—such as (I quote) 'how long preschool children will actually sit still alone in a chair, waiting for a preferred but delayed outcome, before they signal with a bell to terminate the waiting period and settle for a less preferred but immediately available gratification' (p. 44).

After mentioning several so-called hypotheses investigated, the writers tell us:

> Investigations of the role of attention during delay of gratification, however, revealed another relationship: not attending to the goal (potential reward) was what facilitated self-control most dramatically. More detailed analysis of attentional mechanisms during delay of gratification showed that the crucial variable is not whether or not the subject attends to the goal objects while delaying but, rather, how he focuses on them. (p. 45)

This is pseudo-scientific language: it gives an air of precision and concreteness—'a closer look under the bonnet while the

engine was idling and a detailed analysis of the mechanisms involved revealed the cause of the drain on the charge of the battery'. But in reality what is being talked about in this high-falutin language is something which should be plain to common sense— namely, that if you are not treating what you are doing as a means to some further end, enjoyment or the avoidance of something unpleasant, but find it interesting in itself (precisely what we found went wrong with Secord's discussion of commitment) then you will not need an external incentive to keep to it. Your interest will keep you to it and keep you from being distracted or diverted.

In any case someone who is interested in what he is doing is not interested in obtaining gratification, and the gratification he does find, when his work goes well, is simply a bonus. It does not exist apart from what he is doing—like the donkey's legendary carrot. My point is that an interest in obtaining gratification breaks up the unity of the task in hand. In contrast, if carrying it out involves doing certain things that are tedious in themselves, the interest in what one is doing and one's commitment to the task carries one on. Such interest, devotion and commitment take the task in its unity, and they are expressions of character.

Oblivious to this the writers then go on to talk of 'cognitive transformation' and come up with what is a most absurd form of experimental substantiation:

It was found that through instructions the child can cognitively transform the reward objects that face him during the delay period in ways that either permit or prevent effective delay of gratification. For example, if the child is left during the waiting period with the actual reward objects (e.g. pretzels or marshmallows) in front of him, it becomes difficult for him to wait for more than a few moments. But through instructions he can cognitively transform the reward object in ways that permit him to wait for long time periods. If he cognitively transforms the stimulus to focus on its non-arousing qualities, for example, by thinking about the pretzel sticks as little brown logs, or by thinking about the marshmallows as round white clouds or as cotton balls, he may be able to wait for long periods. . . . It is what is in the children's heads [which the writers describe as 'a colour picture in your head]—not what is physically in front of them—that determines their ability to delay. Regardless of the stimulus in their visual field, if they imagine the real objects as present they cannot wait long for them. (pp. 45–46)

It is presumably the children's patience and self-control that are being tested or tried, and the psychologists in question show

no recognition that these are qualities of character. Their idea seems to be: demean the object that tempts you and you will be able to wait, to resist the temptation. But patience is the ability to wait without doing so—just as courage is the ability to face danger without minimising it. The education that develops such moral qualities is something very different from the kind of manipulation in our fantasy or imagination of what faces us—what is described as 'cognitive transformation'—and this can easily degenerate into fooling oneself and so into dishonesty—the sour grapes syndrome.

The latter is an instance of what George Miller calls 'technical tricks' that belong to a bogus technology which encourages a manipulative and thoughtless approach to life. Such tricks are only a palliative substitute for what can come only from the person. Thus the example by Secord of 'the individual who leaves home without cigarettes or money in his pocket so that he won't smoke', or the one by Skinner of the mother who seals her lips with adhesive tape to keep herself from nagging her child, are not examples of *self-control*. Psychologists sometimes call them 'self-management'. People resort to such measures precisely because they lack self-control. It is because they have failed to come together that they use 'aids' to 'manage' their own behaviour as if it belonged to someone else—as in the case of the murderer in Secord's paper (significantly entitled 'Making Oneself Behave') 'who begs to be put into prison so that he won't commit any more murders'.

One further comment I have concerns the naivety of thought that makes what these psychologists are speaking about a discovery to them: what we respond to are not physical stimuli, as behaviourist psychologists had claimed, but the significance we attach to the things and situations that face us in our lives—and these are not 'stimuli', nor are their significances 'images in the head'. Gestalt psychologists had appreciated this nearly a century ago and had articulated it in a less naive, more sophisticated language, in their notion of our 'behavioural environment'.

What experimental psychologists are slow to appreciate is that we live in a human world, shot through with, and indeed shaped by, forms of significance which come from our culture and language. I am suggesting that the language which experimental psychologists are attempting to put in its place, in the name of science, is blind to the richness and variety of these forms. Insofar

as the culture in which experimental psychology is thriving accepts that language, experimental psychology will have played some part in distancing us from our cultural heritage and impoverishing the world in which we live.

Its situation, in this respect, I would argue, is very different from that of the physical sciences. Their language is a 'suburb of our language' and draws its life from that language. Physicists themselves speak our everyday language in their civil life, and, for the most part, even in their laboratory. Experimental psychology, on the other hand, is foisting its language on us and trying to make it the language in which we think about ourselves and live our lives. If it succeeds—and it cannot do so without help from other quarters—then our life will no longer be the same, and nor shall we. Experimental psychology will thus have succeeded in moulding man in its own image of man.

2 'The Psychology of Moral Behaviour'

2.1 INTRODUCTION

I want to ask whether there is such a thing as 'the psychology of moral behaviour'. This is something that is taken for granted in psychology. *The Psychology of Moral Behaviour* is indeed the title of a 1971 book by Derek Wright, an academic psychologist. It is a survey of work done by psychologists in their empirical study of moral behaviour and of the different approaches in the field. Wright discusses these approaches without having an axe to grind and himself puts forward his own positive views about moral behaviour in its different aspects.

I will use Wright's book as a source of the views and examples which I shall discuss. The criticisms I make will be directed not at Derek Wright himself who, on the whole, writes with moderation, but at academic psychology, the psychology which is responsible for the way Wright thinks about moral behaviour.

My contention in this chapter is that there is no such thing as 'the psychology of moral behaviour' and that we have nothing to learn about moral behaviour from the academic psychologist. We can learn from him about human frailties in the face of the demands of a particular morality, perhaps, but *only* if he has a proper understanding of those demands, and that I find doubtful. For everything about the approach and language of academic psychology—at any rate as illustrated in the book by Derek Wright—militates against the possibility of such an understanding.

I do not deny that there is a connection between an individual's psychology and his morality in the sense of what it takes for him to be loyal to his moral beliefs. However, to find enlighten-

ment on this question it is to the philosopher and the novelist that we need to turn. For to be clear about it we need to reflect both about life and the place of morality in human life. I do believe that a *thoughtful* psychology has a contribution to make; but such a psychology has to be very different from the kind of psychology that is taught and studied in universities nowadays.

2.2 Psychologism and Moral Behaviour: Some Examples

I now turn to Derek Wright's book. I want to draw attention to the 'psychologism' that infects the psychologist's conception of moral behaviour and examine its consequences. By this I mean the conception of moral behaviour as something that calls for psychological explanation. The result, we shall see, is that the moral character of moral behaviour is totally lost because moral actions are thought of as issuing from non-moral motives, and the distinction between what is genuine and what is false in moral behaviour ('false' as in 'false pearls') disappears.

Chapter 3 of Wright's book is called 'Resistance to Temptation' and it considers what we could call self-restraint or self-control in the face of a temptation. It asks, What makes for self-control in situations where people are tempted—something specific to the situation or some general tendency, for instance, towards honesty? Children are put into various situations in which they are tempted to cheat, to lie, to steal, and the results are compared. The little correlation found between the results leads the experimenters to conclude that there is no support for 'the view that there is a general trait of honesty' (p. 13). Kohlberg, another psychologist, asks the same question: Is there any psychological disposition which can be conceived of as 'conscience' or 'internalized standards'? He concludes, similarly, that 'if there is little consistency from situation to situation involving the same standard, we cannot assume that conforming behaviour is determined by the standard and not by situational forces' (*ibid*).

Clearly these psychologists pose the problem as one calling for a decision between two different psychological explanations of restraint in the face of temptation: what are the *psychological* determinants of moral behaviour—'conscience' conceived of as 'inter-

nalized standards' or 'situational forces'? Situational forces are such things as the fear of being found out and the fear of its consequences—punishment, disgrace, ostracism. As for 'conscience' conceived as 'internalized standards', much in the way that Freud conceived of what he called 'the super-ego', it is indeed another psychological determinant rooted in the individual's personality. 'Internalized' is the key word. The person takes on the role of early figures in his childhood whose word was his command. Their voice now speaks through him and he feels obliged to obey it for fear of what would happen to him if he failed to obey it. The original voice *may* have been a moral voice, that is the voice of someone who, morally speaking, knew what he was talking about. But the voice that speaks through him is a mere *copy* of it and as such cannot be a moral voice. Besides, even if what such a voice dictates happens to be a moral prescription, the motive of the person for obeying it can hardly be a moral one. So what determines the behaviour of the person obeying it is his psychology, *not* his morality. His relation to the morality to which he thus conforms is purely external. As Kierkegaard has pointed out, a person who does the decent thing out of the fear of punishment or in order to have the approbation of others is not really a decent person—not in himself. As Plato said, make him invisible so that he won't be found out, and he will not do the decent thing if it doesn't suit him. Let me add: give him a pill to make his super-ego go to sleep and, again, he will do what he is tempted to do without compunction. So what he does when he is visible to others or to their representative in himself, that is, when he runs the risk of being found out, is what, as far as he is concerned, *happens to be* the decent thing. He does not do it out of any decency in himself. He doesn't *know* what decency is, only what he is *told* it is.

By contrast, a person who is moved by moral considerations is someone who cares for honesty and decency as this finds expression in the way he treats people. These are not to him things that happen to have a certain label attached to them by the people among whom he lives, labels which attract certain responses from them. They have a significance for him personally. They give him a perspective from which he sees the situations that confront him in the life he lives. It is a significance which for him and for all those who share this perspective belong to the identity of these situations. They thus characterize the world in which he lives and

shares with those who share this moral perspective—and that means the various things with which he engages morally. It is in this world that he finds himself and acquires moral integrity, in this world that he finds a unity of self and consistency of action. This is not a matter of his psychology but of his commitment and his moral understanding. This is what constitutes 'the generalized trend of honesty' which proves so elusive to the psychologists whose experiments Wright describes.

When one appreciates this, what these experiments seek pales into total insignificance. They can only throw light on what I am tempted to call the 'external' features of behaviour and their 'associations'; and the moral character of the individual's behaviour does not and cannot appear in these externals. By the external features of behaviour I mean what comes to view without the need to have any knowledge or understanding of the individual person whose behaviour is in question. Indeed, as we shall see, in the way academic, experimental psychology investigates human behaviour, the person himself and his contribution to this behaviour is by-passed. In the very way, for instance, in which self-restraint and self-control are spoken of it is not the person himself who restrains himself or is in control of what he does.

> Probably because we only become vividly conscious of moral rules when they conflict with inclination, we tend to think that in conforming to them man demonstrates his superiority to other species.

> It is [however] now abundantly clear from the labours of ethologists that other species have developed very effective social controls for inhibiting intra-species strife, regulating sexual behaviour, looking after their young and defending their territory against enemies. The control of antisocial impulses, guilt and altruism all have their behavioural counterparts in other species. Heroic self-sacrifice in the service of his fellows is not the prerogative of man. The mechanisms underlying these behavioural analogies of morality have evolved biologically; they derive from the genetic constitution common to the species. The consequence of this genetic programming is that under normal conditions the presentation of a given stimulus produces the appropriate 'moral' response whether the animal 'likes it or not'. (pp. 16–17)

Wright goes on to say that 'of course environmental conditions and individual learning play their part in the development of these

controls'. But the learning itself is seen as something external: it is something to which the individual submits, not something in which he participates. As Wright puts it in describing the third type of approach in psychology which he considers in Chapter 2: 'Put more technically, parents are sources of negative and positive reinforcement and they serve as models' (p. 39). The consequence of such 'learning' is 'the development of these controls'. The individual, that is, does not learn self-control, but rather acquires 'controls': he comes to be controlled. External prohibitions become internal inhibitions—another instance of what psychologists call 'internalization'.

At the end of the passage I quoted, Wright says that 'the fact remains that the "morality" of other species is primarily instinctive' (p. 17). He puts inverted commas round 'morality' here and towards the end of the book he makes an attempt to characterize the kind of moral autonomy of which human beings are capable.

In the same chapter on 'Resistance to Temptations' Wright mentions a whole series of tests in which 'subjects' were given the opportunity to cheat, to steal small sums of money (p. 54). He comments on the next page that 'in these studies . . . resistance to temptation was found to be related to impulse control in situations that did not obviously raise moral issues'. These results, he writes, 'imply that self-control in morally tempting situations is a function of some more general control factor rather than of a specifically moral form of inhibition' (p. 55). The expression 'moral form of inhibition' is telling; an inhibition is something to which a person is subject, something which he suffers. It is not surprising that the distinction between restraining oneself and suffering an inhibition is lost to this way of thinking. But again the consequence is that no distinction is made between acting from moral considerations on the one hand and acting under social pressure, or in order 'to be a good boy or a good girl' on the other.

At every point of this study of moral behaviour we see psychologists failing to focus on distinctively moral behaviour, or genuine moral behaviour. Indeed they seem hardly to have a conception of it—the only conception they seem capable of is a corrupt one. Thus, for instance, in a later chapter on 'Altruism',

when discussing the connection between 'attachment and altru-
ism', Wright writes that 'altruism is an indirect form of self-seek-
ing' (p. 132). The thinking here where he writes about friendship
and attachment to another person is very muddled. He takes it
that when one is attached to another person by bonds of affection
this is a form of self-extension—that is, the other becomes a part
or extension of oneself. He shows no understanding of the way
that in love and affection one can forget oneself and come to put
the other person first. He writes: 'when we put our eggs in some-
one else's basket, the fate of that basket becomes very important to
us' (p. 130). This is an instance of what earlier I called a corrupt
conception, in this case, of what he calls 'attachment'.

> It is through our relationship to others, our social embeddedness, that we
> define ourselves. *My* wife, *my* children, *my* friends and *my* country all con-
> tribute in varying degrees to my sense of who I am. My self-esteem depends
> on how those I value value me. In serving the interests of those to whom I
> am attached, I am therefore strengthening my sense of identity, and, insofar
> as this increases their attachment to me, enhancing my self-esteem'. (p. 130)

It is true that a person's self-esteem develops in accordance
with the way he is treated by others in his formative years. If he is
loved and valued he will develop self-esteem and this will stand
him in good stead in later life. He will be able to weather criticism
and rejection without being too dejected, he will not have to
depend on the encouragement and reassurance of others, and he
will not need to prove himself by way of compensation. This will
make him relatively independent of the approval of others. Thus,
if I am secure in my self-esteem it will *not* be true that 'in serving
the interests of those to whom I am attached I am strengthening
my sense of identity and enhancing my self-esteem'. But in any
case the reasoning that because 'my self-esteem depends on how
those I value value me', in serving their interests I am 'enhancing
my self-esteem' and therefore serving myself, is totally faulty. It also
shows a crude appreciation of human life.

Here Wright mentions social psychologists 'who explain altru-
istic behaviour by assuming that we value people and do things for
them to the extent that they are in some way positively rewarding
to us' (p. 131). That this happens and that it may be more com-
mon than we care to admit may be true. 'I scratch your back, you
scratch mine' is a well known saying. But the idea that this is the

principle that governs all human relationships is crass, and the idea that it explains what we call 'altruistic' behaviour is totally muddled. Wright adds that 'this approach is well illustrated by the study of friendship'. He goes on: 'The experimental study of the conditions under which friendships are formed show that at least three factors are important.' He mentions two: (i) We like people who we sense will like us. It is this reciprocity which sustains our friendships. (ii) We make friends with people with whom we have something in common—people who share our attitudes, values, and interests, and who complement us in some way or other. So far so good. There is nothing morally sinister in any of this—except that there can be no experimental study of the conditions under which friendships are formed. For friendships are formed in real life situations and need time to develop.

In any case the conclusion which Wright draws from this is a complete *non-sequitur.* 'These conditions suggest the usefulness of conceiving friendship as a social-exchange in which altruistic action is one of the goods exchanged. A friendship is viable when each party derives profit from it, and when there is an equilibrium in the amount of profit that each receives; help given is matched by help received' (p. 131). But to like someone and find pleasure in his company does not have to be conceived as profit. If, there-fore, one seeks the company of someone one likes this does not mean that one is treating the other's company as a means to some profit or benefit one derives from it, that one is seeking it as a means to some benefit for oneself. The pleasure one finds is *in* the company of one's friend and one finds pleasure in it because one likes one's friend. Wright's reasoning is faulty. If one really did treat one's friend as a means to some benefit one derives from it then this would sully one's friendship.

Wright adds a second *non-sequitur* to his first: 'It may seem that altruistic behaviour is somehow debased, and not truly altruistic, when it is treated as part of the currency of a kind of social barter-ing. But when we remember that the goods in this case include such intangibles as enhanced self-esteem and a sense of well-being, it is surprising how far an analysis in these terms will take us' (pp. 131–32). The fact, however, that the goods for which the friend-ship is maintained are intangible makes absolutely no difference. The friendship in such a case—even if such 'friendships' are com-mon—is as much debased as in the case where it is based, let us say,

on the other's fame or social position. By way of justification Wright mentions the example of the mother whose 'selfless care of her baby is amply repaid by the increased status, importance and attention accorded her, especially when he [the baby] becomes intensely and exclusively attached to her'. The mistake in reasoning here is elementary. If she cares for her baby because of these rewards, that is if her baby is precious to her because of the rewards he brings her, then at best she loves him with a love that is impure. If, on the other hand, these rewards are an unsought bonus, they do not sully her love for him—always provided that she does not dwell on them with gratification and let them eclipse her love for her baby. Of course, if she finds looking after her baby rewarding because she loves him, then her love is not dependent on any reward, but rather the other way around. As for her baby becoming dependent on her, the moment she becomes aware of it she should be concerned about it if she loves him and puts him before herself.

Earlier there is a short paragraph in which Wright speaks about attachment: 'attachment implies preference' (p. 130). That is true; and it is equally true that friendship is a form of love which implies preference—as opposed to compassion or charity. 'Both Christianity and Buddhism . . . point out,' Wright writes, 'that attachment can interfere with . . . the development of disinterested concern for' others and 'they have consequently urged upon their most aspiring adherents a life of discipline in which natural affections are systematically mortified.' Yes, but the key word here is 'natural'. There is a sense of this word in which friendship, like many other forms of love, *naturally* tends to encourage need and dependency, and this can easily sully such love and friendship. This is a tendency in us which we bring to our loves. It takes self-knowledge, discipline, inner work, and an attitude of faith and trust, to free ourselves from it, to purge our love of it. I say 'faith and trust' because the inner work in question involves the jettisoning of natural tendencies which leave us exposed and vulnerable to exploitation.

Simone Weil, who has written on friendship with great insight, says:

> When a human being is in any degree necessary to us, we cannot desire his good unless we cease to desire our own. Where there is necessity there is constraint and domination.

... When a human being is attached to another by a bond of affection which contains any degree of necessity, it is impossible that he should wish autonomy to be preserved both in himself and in the other. It is however made possible by the miraculous intervention of the supernatural. This miracle is friendship. (Waiting on God, pp. 154–56)

She means a friendship that is pure. By the 'supernatural' here she refers to the attitude of faith and trust with which someone, out of love, engages in the inner work of what Plato called 'purification of the soul'. As she puts it: 'in all human things necessity is the principle of impurity' (ibid, p. 157). In the contrast she makes between 'gravity and grace', where gravity represents what is natural in us, necessity belongs to gravity. It pulls us downward morally towards what is low and impure. Faith and trust, on the other hand, belong to grace and lift us morally. This movement upwards is the unsought and unexpected bonus of the inner work of spiritual purification undertaken out of love. We can neither explain it nor take any credit for it.

None of this is or can be within the conceptual grasp of empirical psychology and it is clear that what Wright presents as friendship is a friendship that is not pure. What makes it impure are the motives behind it—in other words what makes it susceptible of psychological explanation. It is its psychological determination that sullies it. It is the search for the psychological determinants of friendship, which I called 'psychologism', which blinds the empirical psychologist to the character of friendship and its moral dimension.

Steeped in this blindness Wright continues:

We started this chapter with the assumption that altruistic action is sustained by its consequences for the actor. It might be argued that this cynically devalues altruism by treating it as disguised self-seeking. This would be unfair. It is no challenge to the worth of altruism to say that this assumption helps us to understand it better. It could still be the case that the altruistic action benefited the recipient much more than the actor. (p.140)

Wright's claim here is that the worth of an action resides in and is confined to its consequences. But if this were the case then an action aimed at harming someone would be a worthy action if, through some miscalculation on the part of the agent, it ended up by benefiting the person it was aimed to harm. Wright's 'altruist'

presumably *does* aim to do good to another, but only for his own benefit. This, he thinks, does not detract from the worth of his action, nor take away its altruism so long as such a person's gain is not greater than the benefit of the other: 'the tendency to be sceptical of the do-gooder (he writes) is partly based on the suspicion that his gain is greater than that of those he serves' (p.140). This is simply not true. We would have cause to be suspicious in such a case, and our suspicion would only be allayed if we could be convinced that he did not aim at the other's good as a means to his own. It is this that is crucial to the worth of the action and to the altruism of its agent.

Failing to appreciate this, Wright persists in arguing that there is no single explanation of altruism, but many different ones: 'altruistic action has many motivational roots' (p. 150). It may be a means to salving one's conscience. Or people may give to charities because they feel psychologically compelled. This is what Wright understands by 'a sense of duty' (p. 140). It may be 'sustained by the glow of self-approval it produces' (*ibid*). But in these different cases what is so explained is *not* altruism—not *genuine* altruism.

Wright complains that psychological studies of altruism often 'make no attempt to distinguish between the different kinds of altruism' he lists (p. 142). But what that amounts to is a failure to distinguish between different ways in which people deceive themselves about their actions. The important distinction for a study of moral behaviour is the distinction between what is genuine and what is false—between genuine altruism or concern for others and its false and corrupt varieties. And this is something which the psychologism of a psychological study of moral behaviour militates against. Such a study stands in the way of an understanding of human life and moral behaviour.

At the end of the chapter Wright points out that 'there is an altruism of a more disinterested . . . kind' (p. 150) and that 'this kind of altruism has been almost entirely neglected by psychologists—indeed certain of the theories they have adopted seem to imply that it could not exist' (p. 151). This is precisely my point, except that in what has thus been neglected altruism itself has been neglected, and such a neglect it not an accident. Here Derek Wright shows some common sense, but his psychological training conspires to suppress it.

2.3 PSYCHOLOGISM AND MORAL BEHAVIOUR: FURTHER EXAMPLES

Other examples where the false, the impure and the corrupt are made to parade as genuine instances of what is examined under the title of moral behaviour are to be found in what is said about guilt, confession, reparation, conscience, self-control, a sense of duty, moral education, and religion. Thus guilt, for instance, is characterised as an 'unpleasant emotion' (p. 102), 'a disagreeable emotional condition which directly follows transgression, which persists until some kind of equilibrium is restored by reparation or confession and forgiveness, and which is independent of whether others know of the transgression' (p. 103). This is at the outset of the section entitled 'The Nature of Guilt'. But there is no conception here of an emotion as a mode of apprehension, and thus of a moral emotion as a mode of moral apprehension from the moral perspective of the agent's moral beliefs and commitments. The person finds feeling guilty a disagreeable experience because it confronts him with something he wants to avoid and not have to think about. But much more important is the fact that what he apprehends affectively is painful. The feeling may be 'disagreeable', but its object is painful. Wright thinks of the feeling as just something that happens to one, as a mere accident so to speak. It is disagreeable in the way that the taste of codliver oil may be disagreeable to a child. He does not appreciate that what makes it disagreeable has to do with the person's unwelcoming attitude to what the feeling brings into focus for him.

It is part of this way of thinking that reparation or confession and forgiveness are thought of as antidotes which restore 'some kind of equilibrium' in which the disagreeable feeling of guilt disappears. In other words the relation between reparation or confession and the reduction in a person's feelings of guilt is thought of as being purely instrumental. As for the forgiveness which the confession 'brings about', it is thought of as simply letting one off the hook. As Wright puts it: 'although these responses—apology, confession, reparation—have been taken as expressions of guilt, it is plain that many of them . . . can be interpreted as techniques of forestalling or ameliorating the disapprobation of others' (p. 102).

Once more what Wright, the psychologist, fails to appreciate is that as such they cannot be genuine expressions of repentance.

And repentance is an inner change—just as forgiveness is. That is, the person who for instance has committed a crime sees his action differently now from the way he thought of it at the time. The feeling of guilt is the first step in this change of apprehension which involves an affective change or change of heart in the person, that is a change in his mode of being. Forgiveness on the part of the person who has been hurt or harmed is a response in which he, in return, gives up the resentment or feeling of offence which alienates him from the other. It too is an inner change which is reciprocal to the repentance of the other. It takes trust, courage, and self-confidence on the part of both parties for them thus to turn back towards one another. It is a humbling experience for both parties in which the person who forgives gives up the resentment in which his self or ego thrives, and the person who is forgiven eats humble pie in shouldering responsibility for the harm he has inflicted on the other. A purely empirical study, as illustrated in Derek Wright's book, cannot appreciate any part of this.

It is instructive to contrast such a study with Dostoyevsky's study of 'crime and punishment' in his novel by that title. How very differently he speaks of repentance:

> And if fate had only sent him repentance—burning repentance that would have rent his heart and deprived him of sleep, the sort of repentance that is accompanied by terrible agony which makes one long for the noose or the river! Oh, how happy he would have been if he could have felt such repentance! Agony and tears—why, that too, was life! But he did not repent his crime. (p. 552)

Repentance for Raskolnikov is no technique; he fights it tooth and nail and he pays for doing so with an arrest of life. When in the end he opens his heart to it Dostoyevsky speaks of 'the dawn of a new future' and of 'a full resurrection to a new life' for him together with Sonia. It is well known that people who cannot grieve the loss of someone near and dear to them suffer an arrest of life. It is the same with someone who cannot grieve his own wicked deed in remorse and repentance. Wickedness alienates people from goodness; repentance is a reintegration with it. Alienation from goodness makes for shallowness of life. Similarly a life in which a person's relation to the morality of those with whom he lives takes the form of using apology, confession, and reparation to manipulate them is a life of alienation from that

morality and from the people who are part of it. A psychology which cannot see anything more in life than this is itself doomed to be shallow. It cannot reflect anything more than what is shallow in human life.

As a further instance of this consider how Derek Wright, as a psychologist, understands what blaming and guilt are:

> By blaming I mean here a reflex response of aggressive condemnation of others when they infringe the moral code in some way. It is the same kind of intolerance which when directed towards ourselves we call guilt. (p. 105)

'The moral code' is an expression which represents morality as something external to people, governing their lives by an arbitrary decree. Moral behaviour can then be studied purely externally, in the name of objectivity, without any regard to the sense which its so-called environmental determinants have for the agent. For such a study human beings are little more than Martians.

Now blaming someone is holding him responsible for an action of his we consider to be a misdeed and of which we disapprove. Linking it with aggression is psychologizing it. It may indeed involve strong moral feelings such as indignation, but that is not the same thing as aggression. When blaming is an expression of aggression, the aggression exists independently of the blaming and the blaming is a pretext for attacking him. Something he has done attracts our anger or hatred and blaming him is a way of getting our own back on him. But in such a case what we are doing is not really blaming him, but simply hitting him back. Here the moral concern of which blaming is an expression is absent. There is no genuine concern in such behaviour; or at best what concern there is is corrupt for being in the service of the self.

Furthermore blaming is not a form of intolerance. Intolerance is the inability to tolerate what *ought* to be tolerated. To attribute intolerance to someone is thus making a moral judgement about him—just as calling him 'judgemental' is doing so. To tolerate anything whatever without limit is *not* tolerance; it is moral indifference or total passivity. When Wright says that guilt is 'the same kind of intolerance . . . directed towards oneself' he is labouring under the same confusion and running together different things that need to be distinguished. There is, to begin with, 'learning to accept oneself'. To do so one has to be honest with oneself. To be

honest one has to know how to be critical. To be critical one has to have standards. Those standards come from one's values. It is in the way one owns those values that one comes to oneself, that one finds oneself. If one has done something which looks bad to one from the perspective of those values one needs to be honest with oneself about that. Avoiding feeling guilty, that is biassing one's appreciation of the character of what one has done, is failing to be honest with oneself. It is a form of self-deception. Unless one can admit this to oneself and face what one has done in the guilt one feels one cannot come to terms with it. Indeed, avoiding feeling guilty will leave one divided in oneself or alienated from goodness. In either case it will leave one with a curtailed autonomy.

As I said before, facing one's guilt in one's feelings in the light of one's values is the first step towards coming to terms with what one has done. Coming to terms with it involves working through one's guilt, which is a form of mourning—mourning the loss of one's integrity, of the goodness for which one cares. It involves making good the harm one has done to someone else, the hurt one has caused him, the injustice with which one has treated him. That is what reparation, making amends is: it is compensating for this harm, as far as possible making it good, undoing it or taking it back by accepting to suffer for it. Only then can one become acceptable to oneself through forgiveness; only then can one accept oneself. If one is morally indifferent one will have no problem with what one has done; but then there will be nothing to accept either. This is neither tolerance nor acceptance.

To accept oneself one has to be acceptable to oneself: one must meet one's own standards. If one is indifferent, one has no values and no standards, one will not be acceptable to oneself in the sense that there will be nothing to be either acceptable or unacceptable to one. This has nothing to do with tolerance.

The same confusions prevail in what Wright presents in connection with confession, with duty, with moral education, and with religion. After referring to a great many studies with children as their subject Wright writes: 'The authors interpret this last finding that when children learn that reparation averts punishment it makes them more ready to risk yielding to temptation' (p. 116). But these psychologists show no appreciation of the fact that the reparation in question is not sincere and so not genuine. The same thing has been said about confession. But then what is being

referred to is not confession; it is a pretence or a piece of self-deception. As Verkovensky, a character in Dostoyevsky's *The Possessed*, puts it: all my life I have lied, even when I was telling the truth—that is, telling what as a matter of fact happened to be true. I wonder whether academic psychology has the conceptual resources to understand this!

Wright also says that 'confession can be motivated by the desire to punish the self through shame and retribution' (p. 117). Once more this is not genuine confession. For confession is something that is wrung from one. Even when it is voluntary and one is fully behind it, it is not easy, nor is it something one enjoys. Where there is no cost in telling the truth there is no confession; and where there is pleasure and gratification in it the confession is corrupt. This is not to say that when one pays the affective cost there is no relief and no long-term benefit. But the confession must not be for the sake of such relief; it must not be a means to such an end if it is to be genuine.

As for duty, it may of course conflict with desire and it may go against the grain of one's attachments. But that doesn't make it something externally imposed on one. Here we need to recognize that something imposed on one by one's own character and psychology can be *external* to who one is and so still externally imposed on one. We have a good example of this in Ibsen's character Mrs Solness in *The Master Builder*, as Peter Winch has pointed out in his Inaugural Lecture 'Moral Integrity':

> Mrs Solness . . . is someone who is obsessed with the Kantian idea of 'acting for the sake of duty'. She does not appear, though, as a paragon of moral purity but rather as a paradigm of a certain sort of moral corruption. No doubt her constant appeal to duty is a defence against the dangerous and evil resentments she harbours within her. For all that, it is possible to think that the situation would have been a good deal less evil if she had occasionally forgotten her 'duty' and let herself go. (*Ethics and Action*, p. 180)

The 'duty' which Winch puts in scare quotes in that last sentence is motivated by the desire to keep evil resentments at bay. That is its psychological explanation. So regardless of its content Mrs Solness doesn't really perform it as a duty; it does not have its source in any moral concern on her part. The psychology behind it is real enough; but it is not 'the psychology of *moral* behaviour'.

Moral education is a topic which hardly fares better in the hands of academic psychologists. The different psychologists presented by Derek Wright think of moral education as the *shaping* of behaviour by means of the deliberate employment of techniques (p. 39). Thus punishment is seen as one such technique: 'activity that culminates in punishment tends to be inhibited' (*ibid*). But if this is all that happens to the child, it means that he has not learned anything. The experiment with puppies confirms what I have in mind. Conditioning by 'rewarding the behaviour' desired by the person doing the conditioning is 'shaping behaviour', and it can in certain circumstances be called 'teaching and learning new forms of behaviour'—that is, learning to avoid certain kinds of dangerous situations. But it by-passes the person, the child. The person does not acquire any new form of understanding and so it does not develop or change him in himself; he simply acquires a new form of behaviour.

It is the same with training, for which there is certainly a place in education and learning. Thus in learning to play a new musical instrument training, exercise, and repetition have an important role to play. But the person has to learn to understand music and at the higher stages he has to so develop musically as to be able to have a feeling for what he plays and to be able to put himself into it. He has to be able to develop musical themes, to be able to find and use enriched chords. Something similar is equally true in moral learning and even more so. The person has to be able to think for himself and develop a moral imagination. If all that moral education achieves is conformity to certain patterns of behaviour then the person has learned almost nothing morally.

As for the role of examples in moral learning, if all that a child learns is to copy such examples, conform to such 'models', as psychologists call them, then again he has learned nothing from them morally. When one learns morally from someone's example one learns from personal contact with him, and it changes one. As Simone Weil puts it: 'goodness cannot be copied' (1948, p. 82). That is, what one comes to by mere copying is not and cannot be goodness. Goodness has to come from one; and for it to do so one must come to goodness in oneself. One must journey to it through a development in which one changes in one's very being. This takes time and personal participation in such a development. In the course of it one comes to own what one may have been

exhorted to do when young, one comes to see sense in it—but not an instrumental sense. One's actions then come from one; one is behind them with the understanding and sentiment-formation one has acquired.

Yes, this is what constitutes moral autonomy. Derek Wright makes a jab at giving an account of it in the penultimate chapter of his book under the section called 'The Altruistic-Autonomous Character'. I applaud him for recognizing that there is more to moral action than mere conformity of behaviour to certain rules. However he is unable to find the conceptual resources in his professional formation to give a satisfactory account of what more there is than that. This is what he writes:

> The conscientious character is autonomous in the sense of being relatively independent of current social pressures. But like the other characters described so far, the content of his moral code is decided by others . . . The values he actually lives by have been so thoroughly built in through years of intensive conditioning that they are very resistant to change. The autonomous character has an additional freedom: he chooses the rules he lives by, and feels free to modify them with increased experience. The modifications he makes . . . are followed by changes in his behaviour. This means, of course, that the abandonment of all moral controls is for him a live option in a way in which it is not for the conscientious character. The reason why he does not do this is that his experience of personal relationships has convinced him of the validity of basic moral principles. Although committed to these principles he is flexible, even original and creative, in applying them to particular situations. Of all characters he is least bound by the letter of a moral rule and therefore likely to devote energy to sorting moral problems. (pp. 222–23)

What Wright calls the 'conscientious character' is the person who is not a conformist and doesn't always do the done thing or what others expect of him. There are situations in which his conscience rebels, cannot approve of what others approve. When Wright says that 'the content of his moral code is decided by others' he means that his values come to him from outside—from his parents, from his school education, from the people he comes to admire. But this does not mean that they are decided by others. They are no more decided by anyone than is the language we speak a human invention. Yet though we learn to speak it, in doing so we come to have something to say; it makes it possible for us to think for ourselves and to express our own thoughts.

It is the same with morality. We learn it and it makes it possible for us to reason and judge, deliberate and decide what to do for ourselves. We wouldn't have any moral problems were it not for the morality we make our own; and if moralities had not developed among people living together people's lives would be totally flat. It is in the morality we learn and come to own that we find our individuality, that life presents us with situations that are inherently significant for us. It is in our engagements with them that our life as individuals acquires a sense so that we have things to care for, things to fight for, things to stand up to, things to come to terms with, and on the down side failures, things to be dismayed about, a new dimension of pains and things to grieve about.

'Either they are decided by others or they are chosen by oneself' (or as Sartre puts it, 'invented' by oneself) is a false dichotomy. The real contrast is to be found in the way people stand related to the values they find in the life they share with the people they live with. This relation can remain external in all sorts of ways or the person can come to own certain moral values: make them his own. In the first kind of case he sees nothing in them, except the reflection of other people's demands, threats and expectations, or their submissiveness. He sees nothing there that makes him care for them, nothing that calls for his loyalty. Where, on the other hand, he comes to see something in the values which belong to the life he shares with others, he may come to care for them, believe in them, commit himself to them. This changes the character of his engagements with what he meets in that life and in these changed engagements he comes to himself. He no longer acts out of conformism, from the desire to have the approbation of his fellow men, or out of the fear of punishment. His actions now come from conviction—the form of conviction in which he is himself.

Such a person is normally decent, honest, helpful *as a matter of course*. Where he is tempted to act contrary to his values normally his commitments and loyalties give him the strength to resist the temptation. Where he witnesses an injustice he finds the courage to oppose it; and where he comes in contact with another's distress he finds the compassion to want to try to help and relieve it. If in a moment of weakness he gives in to a temptation he feels guilty, remorseful, penitent. And where life presents him with moral

problems, he weighs the alternatives in the life of his values, reflects, deliberates, and decides in the light of these moral considerations. *This* is where he decides for himself. Why does he do all these things, behave in these ways? *Not for any reason*, but simply because he holds certain moral beliefs, cares for and is committed to certain values.

Because Wright conceives of moral autonomy in terms of the freedom to 'choose' one's values he says that 'the abandonment of all moral controls is for him [the autonomous character] a live option'. Clearly he thinks of morality as something that controls the person and of the autonomous person as having the freedom to cast it off—like a tight-fitting garment. The reason why he does not do this is, according to Wright, that 'his experience of personal relationships has convinced him of the validity of basic moral principles'. But what could such 'experience' be? And what could 'validity' mean in connection with moral principles? Wright does not say. But the tenor of his thinking inclines me to the view that what he means is this. His experience, as an open-minded and unbiased person, leads him to conclude that moral principles are needed for regulating relationships and that one is better off with some such principles than without any. By all means discard a tight-fitting garment, but replace it with loose-fitting clothes. Don't go about naked, with no clothes on, if you don't want to catch a cold and offend people into the bargain. This is uncannily similar to Freud's rationalistic conclusion for the person who has come free of repression and adopts moral principles voluntarily.

As for the 'flexibility, originality, and creativeness' which Wright claims for the morality of the autonomous character, this is of a piece with his idea of autonomous morality as freely chosen on 'rational', that is on pragmatic, grounds, and of morality as a set of rules for regulating behaviour and reducing human conflict. The individual is flexible, that is, he is ready to compromise for the sake of harmony and mutual advantage. This sounds to me more like 'politics without morality' than *morality*. By 'originality' he means freedom to improvise—again to the same end—and by 'creativeness' he means something like what these days is referred to as 'creative accounting'. I am afraid that given the conceptual framework available to him in empirical psychology this is the best that Derek Wright can make of a bad job.

2.4 PSYCHOLOGY AND REFLECTION

This brings me finally to the question, 'What makes a person moral—that is, behave morally? For instance, what makes a person honest?'. I have argued that any psychological answer to this question degrades and falsifies the morality in question—the morality of the person, the morality of his behaviour.

The question, 'What makes a person moral?', calls for reflection and clarity on what is meant or understood by morality—or a morality. When such clarity is achieved it will become plain that this is not a psychological question like 'What makes a person delinquent?'—although here too there is room for critical reflection. On such reflection, one will come to see that what makes a person moral or honest are the opportunities he has had for moral learning and his participation in that learning—or, more briefly, what he has learned. The *psychological* question here is not 'What makes him moral?' but 'Why has he failed? Why does he tend to lie and cheat when he is in a corner? Or why has he turned out to be dishonest? Why has he developed into a con-man?' These are very much more like the question 'What makes a person delinquent?'

To answer these properly psychological questions, however, calls for a great deal of prior reflection and clarity for which the training of empirical psychologists in universities ill prepares them. I mean both conceptual reflection and reflection on life. An academic empirical psychology, keen to devise experiments and questionnaires, is singularly ill equipped for this. A decent psychologist needs to learn to think about human life and morality, about the place of morality in human life, to appreciate all that is radically distinctive in human life. Unless that is appreciated his contribution will remain confined to muddled thinking and trivia.

In physics we have both theoretical and conceptual thinking. In psychology what is offered by way of theories and their justification is bad—very bad—philosophical thinking. There is bad and very bad philosophical thinking in philosophy too and also fashions in styles of thinking standing in the way of its correction. But in philosophy at least thinking, however bad and however fashionable, is offered to criticism—the stock-in-trade of philosophy. The psychologist, on the other hand, misconceives the nature or character of his thinking; he thinks of it as offering conclusions that are

subject to empirical confirmation—as in physics. Consequently, as Wittgenstein put it so eloquently:

> The existence of the experimental method makes us think we have the means of solving the problems which trouble us; though problem and method pass one another by. (*PI*, Pt II, §xiv, p. 232)

3 Psychology and Morality

3.1 TOWARDS A THOUGHTFUL PSYCHOLOGY

I have argued that there is no such thing as 'the psychology of moral behaviour': psychology cannot tell us what the psychological determinants of moral behaviour are. For the determinants of moral behaviour are not psychological but moral. A person's moral behaviour issues from his moral beliefs and the significance he finds, from their perspective, in the situations in which he acts. A genuinely moral action is autonomous; it comes from the person, not form his psychology. Consequently psychology, the discipline, in its concern to explain moral behaviour can only shed light on the psychology of false or corrupt moral behaviour.

Does this mean that psychology, as a study, can have nothing to say about the genuinely moral person—about his behaviour and psychology? I believe it can; but not as an experimental discipline. To be able to do this is needs to be a *thoughtful* psychology. It has to give time to reflecting on both life, as it is actually lived by human beings, and on the distinctive character of human life. For it is as such that morality belongs to it.

The distinction I made in the last chapter between a person and his psychology is one about which we need to be clear. When, for example, a person lacks a sense of inner worth, because he has not been loved and valued by his parents during his formative years, so that now he is constantly driven to compensate for this and can think of nothing else in his feelings, we can attribute this behaviour to his psychology. We can say that he is ruled by his psychology and lacks autonomy. Freud said: 'the ego is not master in its own house'. His psychology stands in the way of his giving him-

self to things and thus finding a direction to his life in his engage-
ments with them. Such a person cannot have found himself in the
sense that he has not reconciled the conflicting aspects of himself
and so does not know where he stands in these conflicts. He has
not found a place on which to stand from which he can face these
conflicts to be able to work through them.

Working through them involves different things for different
people depending on what their inner conflicts are. It may involve
giving up certain pretensions about themselves of a defensive or
compensatory nature. It may involve reconciling themselves to
their limitations and taking a more realistic view of their capacities
and virtues. It may involve coming to value qualities they ignored
and made little of in themselves and consequently being able to
use and develop them, thus finding new confidence in themselves.
This is an instance of what is called 'coming to accept oneself'.
Forgiving oneself is another instance of it. It is clear that, whatever
form it takes, to accept oneself one needs to change in oneself, in
one's mode of being, in certain respects. This in turn involves giv-
ing up certain forms of defensive behaviour to which one clings in
fear. One has to face those fears to be able to give up those forms
of behaviour. As one is able to do so one will move towards being
oneself and as one's fears diminish one will acquire greater confi-
dence in oneself. What one does will now come more from oneself
and will be less dictated by one's psychology.

In what sense does what one does come from one here and not
from one's psychology? It does so in the sense of coming from
one's convictions, judgements, and assessments, and these in turn
not being subject to one's psychological needs. They are thus
properly one's own; the judgements and assessments have been
freely arrived at by oneself. They are free, that is, from both exter-
nal interference and psychological pressures. This is what, I take it,
Freud was moving towards when he described his aim in psycho-
analytic therapy as the enlargement of the ego. It is not of course
the enlargement of the self-seeking ego; it is the very opposite of
that. For that is one of the things one has to give up in coming to
oneself: it stands in the way of one's taking an interest in and giv-
ing oneself to things outside one. It is in such giving of oneself and
the engagements it makes possible that one finds oneself.

I am not, of course, denying that every person has a psychol-
ogy—his psychology—including the autonomous person, the per-

son who is himself. But the autonomous person's psychology is not a 'determining' psychology but an 'enabling' one. If we are asked to say something about his psychology we shall say such things as that 'he feels secure in himself so that he *does not have to* deny or compensate for his insecurities', that 'he has on the whole accepted himself and has managed to work through his inner conflicts so that he is not pulled this way and that *without being able to help it*', that 'his approach to people is not defensive so that he *can* be open with them', that 'he is in control of his tongue, but *not afraid* to speak his mind when he deems it appropriate', that 'he has the *courage* of his convictions', that 'he does not *run away* from what is painful and is *open* to the pains of living', that 'he does *not* constantly *have to* think of himself, so that he *can* take an interest in things and other people, and in caring for them he *can* be generous', and so on. Here we should notice the 'can' and 'does not have to' which I have emphasized: 'he can', 'he does not have to', 'he is not afraid', 'he is open', and so forth. In other words his psychology does not force him to do certain things, to compromise with himself, to avoid doing or facing certain things and so to live in a restricted space. This is what I mean by an 'enabling' psychology: it gives or provides him space, a space in which he can be himself. It is in his inner unity that he is himself, has a mind and a direction of his own. This is what I mean by autonomy.

It is striking and interesting here that in characterizing his psychology and the capacities he exercises in moving to it what we give is a *moral* characterization of him. This is no accident. But what has psychology, the discipline, got to contribute to our understanding of it? Its contribution, as I see it, would take the form of shedding light on the *transition* from the different aspects of a psychology which make for a curtailed autonomy to a greater autonomy, on the kind of *inner work* it takes to make such a transition, and on the *capacities* that belong to the psychology towards which such a transition is directed. An understanding of this is an understanding of individual affective development, its arrests and remobilizations—that is a person's release from such arrests—and its achievements. Here there is no sharp line between moral education, learning in the school of life, and psychotherapy. In all three a person has to be active, engage with what he meets, take and make something of it himself, that is learn from it.

Thus, to give a few examples, psychology as a discipline, provided it is thoughtful, can throw light on the problems of loving and caring and of accepting love. It can throw light on the way losing someone one loves can leave one in total limbo and on the way in mourning this loss one can recover oneself. It can throw light on the way an alienation from goodness brings about an alienation from oneself in dissipation and on the way grieving its consequences in remorse can bring one together through a reintegration with goodness. Surely an understanding of such changes in a person is something to which a thoughtful psychology has a contribution to make: what sort of changes these are, how the person participates in them, why they cannot be imposed on him or take place without his participation, and the character of what he comes to in so changing. I am of course referring to the changes on the way to a recovery of the self. Such a psychology can also help us understand how changes in the opposite direction come about, the kind of things that tempt or overwhelm him for him to give in and give up on himself.

I emphasize again that such a psychology has to be *thoughtful* and it has to be *in touch with life*. It cannot be thoughtful if it is not in touch with life. I do not see how a psychology which believes it can come to understand such matters by investigating human reactions in the artificial set up of a laboratory can be either of these things. For a laboratory caters for a very different kind of interest: an interest in finding out how things work, how organisms react to various stimuli or causal conditions. What is thus investigated are objects, organisms, animal reactions, and it is directed to them as kinds, instances. The aim of the investigation is to find out how objects of this kind, that is having such-and-such a structure or properties, react to such-and-such conditions. Ultimately the aim is to find this out with a view to being able to control the reactions investigated—either to bring them about or to prevent them from coming about. The investigation thus is broadly causal and directed to kinds or types, not to individuals; it is instrumental or pragmatic in character.

Certainly it calls for integrity, intelligence, and the appropriate skills on the part of the researcher; but a thoughtful attitude to life is completely irrelevant to this kind of research. It is irrelevant because such research is not concerned with human life, the kind of life lived by human beings, the kind of life in which human

beings have their distinctive mode of being. Yet one can understand human beings and their behaviour only from within such a life, not in detachment from it—from the outside, as if they were Martians. That is why, so far at any rate, those who have best shed light on it and have helped us to understand human beings confronted with moral problems, have been novelists, dramatists, artists. As Dr Drury puts it in his lecture 'Science and Psychology':

> The great novelists, dramatists, biographers, historians,—are the real psychologists . . . It is hidden inwardness that is the rock over which scientific and objective psychology will always come to grief . . . I wish to state emphatically that [such a] psychology, whatever progress it makes . . . will never replace psychology A [the kind of psychology we find in a great novelist], as a more accurate, a more scientific, a more efficient discipline. (*The Danger of Words*, pp. 37, 43)

That is not to say that a psychotherapist who works with human beings on a one-to-one basis, over a considerable stretch of time, trying to help them with their problems of life, cannot contribute to our understanding of human behaviour, *if* he takes a thoughtful attitude to life and avoids theorizing about human beings, seeing them as types. For lack of a better name I characterize his discipline as 'clinical psychology' while dissociating it from the implication carried by the word 'clinic' as a place where such people are treated. I use the word 'clinic' to highlight the contrast between a clinic and a laboratory. What I wish to highlight is the idea of a clinic as a place where individuals bring problems they have outside it, in their lives, and where they are attended to as individuals. Thus the understanding of the clinical psychologist grows through his engagements with the individuals he attends to in their distinct individuality and in the light which what they tell him about their lives throws on what they bring of themselves to the clinic. I take psycho-analysis to be a clinical psychology in this sense despite its scientific pretensions.

3.2 Determining and Enabling Psychology

I now return from psychology as a discipline to the psychology of an individual person and to what I called an 'enabling psychology'—a psychology which permits and enables a person to be

autonomous. I am thinking of a person who can think for himself, acts on his own behalf, has deeply held moral convictions and integrity. He is attached to life by interests that are directed outwards and concern for other people. His inner security and lack of narcissism *permit* him to have such interests and concerns in which he forgets himself and finds meaning in life and affective richness in living his engagements to the full. It is clear that such a person is genuine in his affective responses and is capable of generosity, courage, and kindness.

The question is not what is it that *makes* him so, but what it is that *permits* and *enables* him to be this way? What permits him are his lack of narcissism, his having grown out of his early ego-centricity, his having resolved his inner conflicts. What enables him to do so are the positive capacities he has acquired in working through the earlier affective positions which restricted his autonomy or stood in the way of his development towards it. These capacities are at one and the same time moral and psychological capacities. The psychologist's contribution to answering the above question would thus take the form of filling in the details of the form of answer I have sketched. That would be at least part of his contribution to an understanding of moral behaviour. But the individual psychology which is thus depicted, in its different aspects, is not 'the psychology of moral behaviour' in the sense of the kind of psychology from which our moral behaviour issues. For our moral behaviour issues from the morality which we have made our own or, to put it another way, from ourselves when we have come to own our morality and in doing so found ourselves.

What is it that enables a person to have a mind of his own and the courage of his convictions? Obviously he has to have come some way in learning to think, with everything that this entails. We can take this for granted in the present discussion. But what are the inner qualities in question? Well, certainly he must have a secure sense of inner worth. I am not referring to something which is incompatible with humility. The antithesis of humility is conceit, thinking of oneself as 'God's gift' and indispensable, as above or better than others. Having a secure sense of inner worth, on the other hand, is something unobtrusive. A sense of inner worth is not something of which one is aware; one is only aware of its absence. Its presence does not make one do anything; only its absence does. One lacks it, one fails to come to it, if in one's early

childhood one is ignored, unloved, rejected, made use of, made a scapegoat for other people's failures and mistakes, treated without respect. One then comes to feel that there is nothing in one worthy of respect, that one does not exist in one's own right. Such a person becomes servile or obsequious, or indulges in behaviour designated to buy the respect, approval, and acceptance which others find as a matter of course. Or, at the other end of the scale, he reacts by making himself objectionable to rouse people to take notice of him as a substitute for the respect he feels they are unwilling to give him and at the same time to get his own back on them for this unwillingness.

I mentioned servility. This is the very opposite of serving others. Servility is a grovelling for other people's regard, whereas in serving others one doesn't think of oneself. To be able not to think of oneself, however, one has to have accepted oneself, to be comfortable with oneself, to have self-respect. If one lacks this one cannot stop thinking of oneself. We can compare this with pain. Normally when one walks one is not aware of one's feet, one doesn't think of one's feet. But if one's feet are not comfortable in one's shoes walking becomes painful and one's feet are thrust into one's consciousness in the pain one feels. In each step one takes one is aware of one's feet. Likewise if one is not comfortable in oneself, if one has a low esteem of oneself, one will be uncomfortable in one's relationships with others. The response to each move one makes in a relationship will make one aware of oneself in the doubts, poor opinion of oneself, and insecurities it touches in one.

Let us be clear, to have self-respect is not to think highly of oneself; it is not to think of oneself as lower than others. Indeed, it is not to think of oneself at all. One who has self-respect will respect others and will not be a parasite to them. He will not stoop to anything to get what he wants. Here we have the makings of dignity and moral integrity. The dignity on which one stands with ostentation and pomposity, however, is a corrupt version of the dignity to which I am referring, used defensively to preserve a sense of one's own importance to make up for the insignificance one feels underneath.

We see how the foundations of a person's morality are laid in his early relationships. The character of what he later picks up or learns by way of morality will bear the imprint of what goes into these foundations. For it is with what we bring to the values we

encounter later in our life that we make what we make and take what we take of them and so to the kind of relationship in which we come to stand in them. But what we thus come or fail to come to in what we thus acquire morally is never irrevocably fixed; what we have come to can be lost and what we have failed to come to or lost can be acquired or regained if we are willing to pay the cost for it.

Thus, for instance, a person who has been unloved, used, or abused in his early relationships and has, in consequence, courted contempt and rejection in later life may, nevertheless come to pull himself out of this situation and break out of the vicious circle it feeds. In the process he can find self-respect and the respect of others. This will change his whole relation to the morality to which that far he has remained externally related. As part of this same change his relations to other people will change. In coming to respect them they will acquire a reality in his feelings they have never had before and he will no longer feel alienated from them. In the fellowship he feels for them now he will be more likely to meet kindness and generosity and more likely to appreciate it. This will open his heart and enable him to reciprocate. Where his heart had been a desert he will find love and kindness beginning to grow. What he does for others will now come from him and not from a sense of duty externally imposed. His deepest moral convictions will now find expression in his behaviour and will be visible to others there. They will not be something adopted and conformed to in his behaviour, but something embedded in his very mode of being, in his whole affective orientation. The moral character of his behaviour will come from this mode of being thus arrived at.

That is, it is in his mode of being that such a person is moral and it is *that* which gives his behaviour its moral character. I had said earlier that the morality which anyone thus comes to exists outside him, in the culture of the society in which he grows up. He finds it there in the relationships into which he enters and he comes to it in his engagements in those relationships. That is where he comes to himself as well, coming to both together, hand in glove. Here, as I said, psychology, the study or discipline, can throw light on the kind of development in which a person finds himself or moves towards autonomy, on what constitutes obstacles to it, on what it takes to overcome these, resolve inner conflicts

which threaten to arrest such development. The psychological story is at the same time the story of a person's moral development.

3.3 THE TERMS OF FREUD'S STORY OF THIS DEVELOPMENT

Freud told this story in terms of the notions of identification and introjection or internalization. Thus, the story goes, we take sides with the figures which represent the morality which governs the lives of those with whom our lives are intertwined in our childhood. We do so in order to placate them and win their support and acceptance. But although they become part of us in the process they remain implacable. We thus become divided in ourselves between their continuing demands and our natural desires. The self, conscious of both, is thus represented as embattled, divided between these two sets of irreconcilable demands from within—between duty and inclination as it was put by Kant—and also the requirements of 'reality considerations'. It tries to deal with this situation by means of compromise and appeasement or by taking sides with one or other of the parties to the conflict.[1] But, as Freud sees clearly, autonomy is not to be found in any of these directions. However, his theoretical solution to this problem is unsatisfactory: it consists of a voluntary acceptance of the discipline of morality seen to be necessary for the regulation of the behaviour of essentially selfish human beings. That is as human beings become less repressed—perhaps as a result of psycho-analytic therapy—they are able to voluntarily accept what was originally imposed on them, doing so in the name of enlightened self-interest. What they did blindly and under compulsion, that is unwillingly, they now do voluntarily and rationally. In thus finding rationality they become autonomous.

This is unsatisfactory and rests on a number of assumptions which need criticism—for instance the assumption that human beings are essentially selfish and unco-operative and that, therefore, they need a motive to consider others and co-operate with

[1] I have compared Freud and Kant in a paper 'Reason, Passion, and the Will' in *Philosophy*, vol. 59, no. 228 (April 1984).

them. The motive which Freud finds is rational self-interest. But it is doubtful whether rational self-interest can either unify a divided self or provide the path along which such a self can find autonomy. One may voluntarily accept some particular discipline for a specific purpose; but to live one's whole life in this way would be stifling unless there was something more positive in that life which gave one a purpose other than self-interest. It may be in our interest to get on with our fellow beings, say, in the workplace, but only because we are interested in the work and enjoy what we are doing or, if that is not the case, then because we need the work to support our family. In any case if we were really interested in the work this interest which we share with our fellow workers would make for co-operation. I mean we would co-operate in the interest we share; we would not co-operate because it is in our interest to do so. Rational self-interest comes in only in particular cases to counteract specific reasons for discord. And then some things are in a person's rational self-interest—for instance, to get on with someone who gets on his nerves or a group of people who are quarrelsome—only because he has independent purposes, interests, affections, concerns.

Surely what underlies the possibility of our having a morality at all, whatever its content, is our ability to care for things independently of the way they may serve us. Rational self-interest, therefore, could not be a basis for any morality. A morality with which we come in contact can enter our soul only through our ability to care for things, to see something in them for which we value them—that is independently of any way in which they may serve us. Indeed, we only come to have a self we own, so that we have purposes and concerns of our own as individuals, through our engagements with things for which we care.

In his references to identification and introjection Freud could have moved towards something important, but he missed it. The trouble with identification is that it is often a defensive measure: 'If you cannot beat them, join them'. It bolsters up that part in us in which a person is all for himself. Yet, paradoxically, it is a sell-out of one's autonomy, as can be seen clearly in a mentality of clannishness and jingoism. It, therefore, gives the wrong emphasis to what Freud wants to say. What he is trying to move towards but misses here is the role which having someone one looks up to plays

in coming to have a morality: one wants not merely to imitate him but to become like him because he represents an ideal. Freud himself appreciates this in his notion of an 'ego-ideal'. An ideal is a measure in terms of which one makes sense of things.

As for 'introjection' or 'internalization', the trouble here is that what is introjected or internalized, as Freud describes it, remains a thorn in one's flesh. That is it remains unowned: an external conflict is merely internalized, duplicated within one. The person ends up divided in himself—between duties imposed and enforced by a super-ego, modelled on an external authoritarian figure, whose voice comes through as an arbitrary dictum, and, on the other hand, inclinations equally unowned. But, as Melanie Klein pointed out, a genuine conscience is not the same thing as the Freudian super-ego. Nor is wanting or desiring something being subject to impulses, itching to do or craving to have something.

The reason why Freud can make nothing better of a genuine moral conscience than what he gives us in his notion of the super-ego is that he thinks that a child learns morality through the introjection of a feared and hated father as represented in his Oedipus complex. He thinks of love, modelled in its directedness to the mother, as sexual in character and, therefore, belonging to the id, on the other side of the camp. Consequently the idea of the introjection of a loved figure does not occur to him. That one can learn morality and discipline from a loved figure is thus ruled out; all that can come from such a figure is indulgence which is the opposite of moral discipline. So Freud thinks.

I have suggested that what Freud and other psycho-analysts after him call 'introjection' does not have to be a defensive measure. It is that only when the figure introjected is a feared and hated figure. It is not so however when the figure introjected is a loving and loved one. Introjection then is the child's way of keeping this love alive in his feelings. In his feelings he thus maintains the conviction that he is loved. This conviction sustains him and gives birth to a whole series of affective abilities and responses: friendliness, gratitude, loyalty to loved ones, allegiance to what he admires in them, trust and the ability to tolerate criticism. This is what I call a *genuine* moral attitude towards others. Furthermore, it enables a person to learn from those he trusts and

admires and to put what he learns into practice in his life and engagements. What he learns thus comes together in its exercise. Indeed, in this coming together of what he learns he too comes together in himself.

It is an appreciation of this which Freud opened the way to without himself coming to it. What Freud called 'introjection' is a way of continuing a formative or otherwise emotionally significant relationship by living and reliving it in one's feelings apart from one's actual engagements with the person who is or was a party to this relationship. It is closely related to what Freud called 'transference' in that in transference that relationship is lived and relived with other people. In the case of introjection it is lived in the convictions it reinforces. The responses which have their source in these convictions then become part of one's mode of being.

What Freud did not appreciate is the difference between introjecting a feared and hated figure and introjecting a loving and loved one. In a way this is surprising since he appreciated well enough the difference between what he called a 'positive' and a 'negative' transference. The introjection of a feared and hated figure is defensive. As such it ties a person down and closes him in. That is, emotionally it commits him to the repetition of the same pattern of responses irrespective of the real character of what he is responding to. Where, on the other hand, the figure introjected is a loving and loved one what he lives in his feelings is not frozen into a cycle of repetitions. It leaves the person with the openness and confidence to learn and hence to grow, to respond not with a repertoire of pre-set responses which do not vary with circumstances but with responses that arise in his engagement with what he meets in particular circumstances and in contact with them.

The difference in question is in the end the difference between love and hate, the kind of relations each makes possible, and the moral dimension inherent in love which characterizes relationships of love and absent in relationships devoid of love and regard. What I called an 'enabling psychology' is thus the kind of psychology to which a person comes in coming to a mode of being sustained by love and the loving, caring responses reinforced through the introjection of loving and loved figures. I believe this to be central to Melanie Klein's contribution to psychology and psycho-analysis.

3.4 PSYCHOLOGY AND MORAL EDUCATION

What I want to develop briefly now is encapsulated in Melanie Klein's dictum that 'love mitigates hatred' (see Klein 1957, pp.25, 31, 67, 76, 77, 91). What I articulate now is the kind of positive contribution which I believe psychology as a study or discipline can make to our understanding of the relation between an individual's morality and his psychology. I have in mind 'moralities of love' such as are to be found in Plato, in Christianity, and in other great spiritual religions.

Intellectual learning requires interest and discipline and it may meet and so have to overcome obstacles in the learner's character such as laziness, lack of concentration, an inability to sustain interest. But none of these is endemic to intellectual learning. People are not inherently lazy, for instance, and a person can develop an interest in things quite naturally and in that interest find an incentive to work and accept discipline. Moral learning involves the education of the emotions; indeed the education of the emotions is at the centre of moral learning. Moral education, therefore, is an education of the self and changes a person not merely in his understanding of things but in his very mode of being. Moral learning, where a morality of love is concerned, is making one's own its values—such values as kindness, honesty, trust, trustworthiness, loyalty, forgivingness. Making these values one's own is coming to possess these virtues in oneself, that is *being* kind, honest, trustworthy, forgiving—*genuinely* so, not merely outwardly, and not as means to something else one wants.

As both Plato and Christianity have shown us, there are obstacles to coming to own these values, to coming to possess these virtues in their purity, *inherent* in our nature as human beings. Moral learning thus involves learning to give up, and thus growing out of, something in us, something that is part of us, something in which we find gratification, and so a certain kind of thriving, and also protection from what we fear. Plato spoke of it as 'the purification of the soul', as 'making dying one's profession', that is dying to the self, and as 'an initiation to love'. Christian writers have spoken of 'the mortification of the self' and of learning humility. Plato said that 'knowledge is virtue' and clearly learning here or coming to moral knowledge or wisdom *is* changing in oneself, in one's whole affective orientation in the direction in which moral virtue comes to characterize one's mode of being.

I spoke of moral education as the education of the emotions. Our emotions are our responses to things and as such they involve a perspective on things in their significance for us. Thus in coming to a new affective orientation we come to a new mode of being and a new vision on things at one and the same time. The mode of being and the vision are the two sides of the same coin. Hence the Socratic paradox that knowledge and virtue are one in matters of living and morality is no paradox.

Obviously the education to such knowledge and virtue, early in one's childhood, begins by learning to recognize others, to respond to them, learning to appreciate what they give one, to say thank you, to be grateful for their kindness and help, to respect them: that is learning to recognize that they have a life of their own, that they are capable of goodness, and that they are not there just to cater to one's needs. To do so means growing out of one's early narcissism, out of one's early ego-centricity, learning to trust others, to co-operate with them, to consider them, to forgive them when they hurt one. This in turn involves learning to come to terms with feelings of envy and rivalry with others, of anger when they stand in one's way or simply ignore one. What is in question is a whole web of responses bound together within a self-centred affective perspective, sustained positively by greed and an arrogant pride, or fuelled negatively by a lack of belief in one's own reality for which one seeks compensation, a feeling of insignificance before others which one holds against them and resents. More briefly what one needs is to grow out of one's greed and conceit, and to come to terms with one's vulnerabilities before others. In the case of each the ego expands, or seeks to do so, offensively or defensively, and it resents any action on the part of others which frustrates such expansion.

A person in such condition is mistrustful of others, ready to take advantage of them if he can get away with it, in constant competition and struggle with them, envious of their successes, vulnerable to humiliations which he resents. Obviously he cannot have much consideration for them. Now each person in his early childhood has within him, to some degree, the makings of these psychological conditions in which he feels pushed in the direction I have indicated if only because of his relative weakness before others and his proneness to 'phantasy thinking' in his judgements. Thus a moral education, an education of the child to consider

others, will have to start by appreciating these conditions. Only then can it try to reduce them by producing a psychological environment helpful to his growth. Growth here means growing *out* of what *in him* are *obstacles* to a genuine consideration of others. Thus to come to consider others the child has to change *in himself.* As he so changes those obstacles that stood in the way of his doing so are reduced and start disappearing. The child's ʹmoral growth then becomes part of a benign cycle.

To help the child to such a cycle, first of all, his parents have to be *loving* parents, themselves capable of considering others and relatively free of vulnerabilities in their ego and whole in themselves. They have to be capable of giving their child love, support, and an intelligent understanding of his problems in growing up. They have to make him feel secure in their love for him and give him protection without cosetting him. They have to cater to his needs, but with discrimination and without indulgence—without spoiling him. Otherwise they will only help his ego to expand and to make him ego-centric and greedy. On the other hand if he is not to grow up feeling unloved and neglected and with a chip on his shoulder, his parents have to discern his genuine physical and psychological needs and attend to them. Again, they have to be tolerant of his weakness, patient with him and forgiving, but still they must help him to learn discipline. They have to give him their trust so that he can become trustworthy and learn to trust others. They have to trust him with freedom so that he can make contact with the outside world, the world outside his immediate family, and learn to find his feet in it, learn from his mistakes, and gain confidence in dealing with the outside world.

The moral qualities I have in mind all have their source in love, in the capacity to love, to care for and consider others. The education of the child to morality in this sense, therefore, is an education or initiation to love; and the most important part of such an education is the giving of love to the child, a love that is genuine and as far as possible pure—a love devoid of possessiveness and any other trace of selfishness. Such a love is a form of endorsement of the child in his separate existence. In it, therefore, he finds confidence, inner security, a sense of inner worth, and conviction in his own independent existence. It helps him to develop into an individual who has a mind of his own and who is not afraid to be himself. Without that he could not come to have moral convictions

of his own, he could not come to own his morality, and he could
not in turn come to himself in that morality.

The growth towards coming to own that morality will require
in him personal qualities which he normally acquires in his child-
hood. Coming to own it will require from him the exercise of these
qualities and the working through of difficulties he comes to
encounter on the way to it. This can take many different forms.
For instance someone who gets involved in charity work, in part at
least for the wrong reasons, may eventually come through it as a
better and deeper person, with less baggage, such as vanities and
pretensions, and altogether more genuine. Something of a similar
nature may happen to a prisoner of war. He may come through
this experience humbled, more focused and more open to others.
A person who falls in love may be brought sharply face to face with
his inadequacies—spiritual and emotional. His struggle with the
difficulties he experiences in these inadequacies may purify his
soul and deepen his love. As Kahlil Gibran puts it so well in *The
Prophet*:

> Like sheaves of corn he [love] gathers you unto himself.
> He threshes you to make you naked.
> He sifts you to free you from your husks.
> He grinds you to whiteness.
> He kneads you until you are pliant;
> And then he assigns you to his sacred fire, that
> you may become sacred bread for God's sacred feast.

But one has to open oneself to it, yield and respond to its
demands, give oneself to it.

This is equally true of accepting responsibility and punishment
for one's misdeeds. That, of course, involves coming to recognize
them as such which may, in turn, involve making one's own a
moral perspective. Accepting punishment is a form of paying for
one's misdeeds, a form of restitution. One pays for the pain one
has caused others by accepting the pain of punishment; and
accepting it is coming to recognize that one deserves the punish-
ment one gets. Previously one had been ready to do what one did;
even if one did not think one was justified, one at least thought,
'Why not!' Now that one comes to see what it meant to others and
care for it in one's sorrow one finds the answer to one's earlier
'Why not?' In repenting for it, in the remorse one feels, one

grieves for what one has done, one mourns the goodness on which one has turned one's back. Such mourning is a turning to it, an asking to be forgiven, and it reintegrates one with goodness. In the forgiveness one finds one comes to a new wholeness.[2]

It is the same with any form of genuine psychotherapy which is a healing of inner divisions or conflicts, so that with the wholeness of self it brings one finds a new direction in life—a direction in which one gives oneself to something constructive, something outside oneself. It is in such giving that one grows. This is the opposite of being stuck emotionally in one's childhood battles, for instance, fighting them over and over again in one's present life, or in maintaining one's defences and approaching every new situation with the same set of responses. It is the opposite of being stuck in the same place by continually taking umbrage for behaviour not directed at one, or seeking reparations and compensations from others for past insults and injuries, real or imagined, thus clinging to them, or continually sponging on others emotionally, taking, complaining, keeping up vendettas. In these various ways one goes round and round within the closed-in space of one's ego.

Any genuine psychotherapy seeks to make contact with and mobilize what is constructive in a person so that he can himself work through his inner divisions and with the greater autonomy he thus achieves emerge from this closed-in space. What it mobilizes in him are derivatives of what capacity of love he has developed in response to the love and care he has received in his early life. If he has not received this, then it tries to help him develop it through the care and attention it gives him—the care and attention implicit in the psycho-therapy. By 'derivatives' of love I mean the capacity to appreciate, to be grateful, to forgive, to be willing to stand on one's own feet so as not to be a burden on others, to give, to help, to contribute to the life of others, to support them, to trust them, to show confidence in them. It is the exercise of these capacities, first directed to what in one's soul mirrors the bad things one has experienced in one's early years, that constitutes the working through of what one has retained in one's feelings in response to these experiences.

[2] For a further discussion see Chapter 10 below.

These are, at one and the same time, the mobilization and exercise of one's *moral* capacities—for instance: forgiving, giving up grudges, turning away from a parasitic life, shouldering responsibility. Thus the learning in question is *moral* learning, the only kind of moral learning that really is *learning*, as opposed to copying, submitting, conforming. I mean that it is the only kind of *genuine* learning—whether it takes place within psychotherapy or outside it, in one's everyday relationships in the family, at home, in school, in one's friendships, work, love relationships, or elsewhere in the school of life.

3.5 MORAL INTEGRITY AND WHOLENESS OF SELF

I argued in Chapter 2 that there is no such thing as 'the psychology of moral behaviour' in the sense in which academic, scientific psychology speaks of it. For moral behaviour issues from a person's morality when it is genuine and not from his psychology—a psychology independent of his morality. Such a psychology can explain only a person's moral weaknesses and failures. But this does not mean that there is no connection between a person's psychology and his morality. This chapter has been concerned to elucidate what kind of relation there is between them.

I argued that it is an 'enabling' relation, not a 'determining' one. What I called an enabling psychology is one which permits one to own one's morality, that is to find oneness with its values, to integrate them into one's mode of being, and in doing so to find a wholeness of self in which one has autonomy. The two sets of predicates in terms of which such a person's psychology and his moral mode of being are described characterize the two sides of the same coin. What I called an enabling psychology constitutes one side of the coin. It permits genuine moral commitment and autonomy in that it offers no barrier to these things. A person comes to it, I argued, in the way the moral capacities he acquires in his early relationships work through his psychology to transform it and the way, so transformed, his psychology makes it possible for him to own the morality that comes to him in his later relationships within the context of the culture in which he grows up.

Thus an enabling psychology is one towards which a person moves in shedding his defences, resolving his inner conflicts, so

that he can face his anxieties and feelings of guilt accrued in his earlier relationships. In the light of day in which he faces them his anxieties are cut down to size and diminish. As he works through his feelings of guilt through forgiveness and restitution he is able to be more genuinely giving in his relationships. As he gives up his grudges his anger diminishes and he is able to develop greater friendliness towards others. As the past anger and anxieties which he relives in his present relationships diminish he is able to respond to situations that confront him in his present life without burdening them with significances which he projects on them from the past.

In the benign circle thus set up he is able to develop. The more he is, in consequence, able to engage with others in this way the more he is able to stop thinking about himself or be driven to push himself forward. His self-absorbtion diminishes, and at the same time he becomes more open to the joys and pains of others, more in contact with the ups and downs of the life he shares with others, and more ready to deal with them on a realistic basis. In a nutshell, my argument has been that moral learning takes place *in* a person's coming to undergo such changes and that he undergoes them in working through his conflicts, anxieties, feelings of guilt, anger, and depression. It continues in the contact with life which such a release makes possible. Moral learning is thus an intrinsic part of a person's growth to autonomy.

Freud's determinism very largely has its source in his perception of the extent to which our psychology is a determining psychology. His tri-partite division of the self draws a picture of the divided personality with the 'ego' occupying its centre. Psycho-analytic therapy, on the other hand, aims to resolve the inner conflicts which thus divide a person. As the divisions in his personality are healed the parts thus divided are transformed. The super-ego loses its compulsiveness and is transformed into a genuine conscience. The id loses its impulsive character and is integrated with the ego. The ego itself is transformed into a self which owns its morality and is able to engage with others on an equal footing. It is no longer embattled and consequently no longer self-absorbed. Here—and this is the topic of the following chapter—the whole is not the sum of its parts, for the wholeness which the self reaches is reached through a transformation of its parts.

Since the self so transformed owns its morality and hence has a moral mode of being the psychological terms we have to use in characterizing its mode of being are at the same time moral terms. This has been my main contention. I now turn to Freud's conception of the way a change to such a mode of being comes through self-knowledge in psycho-analytic therapy.

4 Self-Knowledge and Change in Psycho-analytic Therapy

4.1 INSIGHT AND THE HEALING OF DIVISIONS WITHIN THE SELF

Psycho-analytic therapy is a method for helping individuals who seek it to change in themselves, individuals whose problems stem from having been stuck in the way they are. It does so primarily by helping them to come to know themselves. It is a method which engages the patient as agent. It can work only through his participation. It leaves any change in the patient to come from him; it leaves the patient to heal himself. What it does is to put him in touch with 'healing processes' within himself. It is the patient who is responsible ultimately for the outcome of his analysis, the receiving of which is a form of learning—learning to be oneself. I shall try to make all this clear.

My main interest is in two questions. Why should self-knowledge make change possible in the person who has got stuck in the course of his development so that it begins to move again? And why should such movement be in the direction of greater wholeness and autonomy? But first, what is the self which the patient comes to know in the course of his analysis?

It is not, as Hume put it, a bundle of impressions and ideas. Indeed, it is not a bundle of anything. It is not a thing, not even, as Descartes will have us believe, a thinking thing. So what is it? It is what a person is searching for when he asks 'Who am I?'; it is what the person is who is himself. This is not, of course, an answer; it is the prelude to an answer. Peer Gynt, in Ibsen's play by that name, is looking for himself. If he cannot find himself, he is going to be melted down in the button-moulder's casting-ladle: a fate

worse than death. If he is melted down, the way he has been in his life will be immortalized and his life will have come to nothing. For in that life he has made nothing of himself. Ibsen thus represents him as peeling all he is, layer by layer, like an onion, and finding no core to it. In other words he comes to no centre of commitments and attachments from which he can own the different things he has been and is.

Peer Gynt is someone who has wasted his life and squandered himself. To find himself he would have to find something to which he can give himself, grow roots in, something in relation to which he can make something of himself. When he asks Solveig:

Where was I? Myself—complete and whole?

She replies:

In my faith, in my hope, and in my love.

Ibsen's suggestion is that in all his wanderings Gynt has failed to look for himself in the one place where he could have found it: in his response to and engagement with Solveig's love. This means that he can only find himself by stopping running and giving himself to something—something that makes sense to him. Of course, he has to look *within* to get clear about why he has been running so: running away from what? He has to be clear about this. This is where analysis helps. It remains true, however, that he will find himself in his engagements with what lies *outside* him. It is only there that he can acquire a self to which he comes.

This is true of a person's development from childhood to adulthood: it is in what he learns in his engagements with others, in the first place with his parents, that in time he comes to himself. There are, of course, hazards, pitfalls. He may hide from what he finds overwhelming, develop defensive postures in which he becomes false. He may evade, shelve difficulties which need to be dealt with. Consequently he will be unable to be fully himself in his engagements and his contact with the world around him will be curtailed. He will start running in the same spot and little that is new will enter into his life: he will stop growing affectively.

Freud spoke of what such a person thus fails to come to as his *true self*. He used a metaphor of Michelangelo to explain what he

meant. He said that the psycho-analyst, like the sculptor, helps the patient to find himself, his true self, *per via di levare*, that is by chipping away at his, the patient's, defences and resistances. The sculptor comes to the sculpture he creates by chipping away at the block of marble. But clearly the sculpture is not in the block of marble in the way that later it is in the crate on its way to an exhibition. Nevertheless there is a perfectly good sense in which the sculptor *finds* it in the block of marble. This is the sense in which we speak of the artist finding the right blue for the sky he is painting, or the poet finding the right word or line for the poem he is writing. What they find does not exist in the way that the continent of America existed before Columbus discovered it. It exists, nevertheless, in the sense that it is what the individual person or artist comes to when he moves in the right direction—the right direction for him, personally, given his experiences, his past, the artistic tradition within which he works. It lies at the end of a path he has to forge for himself on a terrain that is shaped by the tradition to which he belongs, in the case of the artist, and by his past, in the case of the analytic patient.

In his *Introductory Lectures on Psycho-Analysis* Freud speaks of this as the patient's 'best self'. He describes it as 'what he would have been under the most favourable conditions' (1949, p. 364). Compare with: what the artist or sculptor comes to when he moves in the right direction. The artist too has to be himself if he is to move in the right direction, if what he comes to is not to be a mere imitation or copy. He has to be creative. He must not even merely repeat himself. The sculpture which the sculptor 'finds' in the block of marble is his creation. There is a sense in which this applies to the patient in analysis: he too has to be creative in dealing with the old conflicts that come up for revision in the course of analysis. For he has to find his own solutions to them. These must come from him; they must not be imposed on him, they must not be copied from others. Otherwise the patient will be constrained within an alien pattern of conduct and he will not be himself in it. As Freud puts it: 'we want nothing better than that the patient should find his own solutions for himself' (p. 362). Thus in a paper, 'Turnings in the Ways of Psycho-Analytic Therapy' (1919), he distinguishes between 'psycho-analysis' or 'interpretation work' and what he calls 'psycho-synthesis'. What he has in mind is the coming together of the patient, as inner conflicts he had shelved

are resolved and he becomes progressively himself. He says, 'psycho-synthesis [should be] achieved without intervention' (1950, vol ii, p. 395).

Freud talked of the aim of analysis as 'making conscious the unconscious', 'removing the repressions', 'filling in the gaps in memory'. 'They all amount to the same thing', he said (1949, p. 363). He also later talked of the achievement which psycho-analysis aims at as: 'where id is there ego shall be' (1993, p. 112). We can add: 'where super-ego is there ego shall be'. Here we should remember that the divisions Freud marked within the personality—ego, id, and super-ego—are dissociations. As these are healed through 'psycho-synthesis' or 'integration' in the resolution of the long-standing conflicts, what comes together is at the same time transformed. Thus, as Melanie Klein points out, the super-ego is transformed into genuine conscience (1948, p. 68), and dissociated sexual impulses are transformed in being assimilated into relationships of love. Sexuality becomes part of ('fused with' as Freud puts it, 1949b) love and, as such, something that the person stands behind. Aggressiveness, too, is turned away from hatred, revenge, or the staving off of attacks anticipated by a person in his insecurities; for these are reduced as their bases disappear. It is put in the service of the pursuit of constructive interests. It becomes the liveliness with which these are pursued, the vigour with which the person puts himself into them. It is thus transformed from a destructive force which rules the person to an expression of the conviction with which he puts himself into what he pursues in the face of obstacles.

The ego too is transformed into the self which the person finds. Freud had thought of the ego as the seat of reason dissociated from the centre of energy and emotion in the id. It guides the person, but cannot move him. To do so it has to divert the id's energy by inhibiting its aim by means of repression which it carries out 'at the behest of the super-ego'. That is, the person, as ego, is torn between what is imposed on him from outside and desires he has not made his own. He feels helpless before each of them. From a position of weakness he deals with this situation by identifying himself, in part, with the outside demands and by denying the forbidden desires which nevertheless continue to exercise him however much he shuts his eyes to them. He thus fails to come together and the conflict is simply preserved by being put in cold

storage or, to change the metaphor, covered up—like Pompeii, as Freud puts is, whose burial has been its preservation (1979, p. 57). What is thus preserved becomes a fixed structure of the personality—ego, id, and super-ego—which shapes the person's day-to-day responses and conduct.

In the course of the transformations I indicated the person becomes more genuine in his morality and, at the same time, his sexuality is channelled into personal relationships and loses its impulsive character. He comes out of his retreat in the beleaguered ego, where he was doing his best 'to serve its three harsh masters' (1933, p. 108) and establishes new relations with his former masters. As he loses his servility to them they, in turn, lose their uncompromising harshness. He now can be at one with them in their newly acquired character and the divisions within him disappear.

In thus making his own the values he had used as reaction-formations to his sexuality, in accepting the latter and growing with it, in putting his aggression into his convictions where it is transformed, the person acquires self-mastery and autonomy. He can now dispense with repression and, in the new orientation he develops towards others, he loses his ego-centricity. In the considerations that enlighten his life he is no longer split from his feelings; he is affectively related to the norms of reason which provide the framework for these considerations. Consequently he is affectively behind his judgements, deliberations, and decisions. In this way, alongside the super-ego and the id, the ego too is transformed: it is transformed into a locus of convictions, commitments, affections, loyalties, concerns, and interests directed outwards to people, values, activities, and matters of significance. It is in the way that he engages with these, takes them into his life, that the person is *himself*. This is the *self* I spoke of earlier and into which the ego is transformed.

4.2 ILLUSTRATION THROUGH AN IMAGINARY EXAMPLE

In my book *Freud, Insight, and Change* I called these transformations 'enlargement of the self' and I distinguished them from what constitutes an 'enlargement of consciousness'—the unconscious

becoming conscious as Freud described it. Here let me make up a simple example. Suppose that an employee in a firm resents his employer's or boss's treatment of him. Having, let us imagine, always been 'a good boy' in his childhood and youth, however, and his whole adjustment to life having revolved around doing the right thing, pleasing people, and relying on the support of their approval, he cannot face acknowledging and owning the resentment he feels. Consequently, all he feels is a vague discontent which he cannot pin on anything. He has to push himself to do his job well, suffers a number of mishaps for which he is apologetic, and is more than usually eager to please his boss, by way of compensation, who in turn takes advantage of him.

Let us now imagine that he goes for analysis and gradually becomes aware of his resentment. This is what I called 'enlargement of consciousness'. The resentment was there; now he becomes aware of it. So his feelings do not change; what changes is the scope of what he is aware of. But though his feelings do not change, their expression becomes more direct. So far he has not changed, except insofar as he now allows his feelings of resentment a more direct expression. With further work in analysis, however, he may come to recognize how much at odds are his newly recognized feelings with his normal pattern of behaviour. His newly acquired directness can now be seen to pose a threat to his adjustment to life and his way of dealing with people.

So far this constitutes what I would call 'gaining insight into oneself', that is into one's mode of being. It is a step in the direction of self-knowledge. But the person may recognize all this about himself, become uncomfortable about the way his defensive adjustment to life is being threatened, and still he may cling to it. That is, he continues to remain the same. Obviously until he can *own* the feelings he now finds he has harboured he will not know what to do with them.

Let us suppose that with further progress in his analysis and with the increase in self-confidence that comes with the acceptance he finds there, he is able to come forward and firmly but politely not allow himself to be taken advantage of. Obviously how his boss and others he has to deal with will respond to this change in him depends on what *they* are like. The way they react may shake his confidence, daunt him and set him back. But even then he may persevere and learn not to be daunted. To learn this is for him to

come to believe in himself. But he must want to persevere for himself. It must be because he feels he is as much entitled to the respect of others as anyone else on a basis of equality. This already is itself a change in the way he feels in himself. In coming to feel this way he loses the need to please and placate others in the way he has done so far. He can now dispense with that part of his adjustment to life in which he has so far compromised on being himself in the life he has lived.

We have already come a considerable way since this person's discovery of the resentment he has been harbouring. Already more than a change of consciousness has come about in what I have described. The person has now greater confidence in himself and he has been able to dispense with some of his habitual defences. This is a further step towards his becoming himself. The conceptual point I want to make is that the self towards which he thus grows, unlike the feelings of resentment he becomes aware of, does not pre-exist his coming to it. It is something in the emergence of which he participates, to the formation and consolidation of which he contributes—just as, in the past, he has participated in and contributed to his own development until he got stuck. He got stuck in the measures he adopted in the face of the conviction he came to, let us imagine, of his own unacceptability—measures to secure a place for himself in other people's good books. He got stuck because the measures deflected him from doing things out of the interest he finds in them and because the price he had to pay for people's favours and approval further served to convince him that he had to win acceptance and could not have it for what he *is*.

The courage that reverses this vicious circle and breaks the stalemate in his development has to come from him. It belongs to and so comes with the *conviction* that the acceptance and approval he seeks is not worth the price he pays by selling himself short in the way he has to please others. It is in this conviction that he does not have to earn the acceptance of others that he begins to find himself, and in remaining true to it he sheds what is false in his relations with others. Thus he no longer pleases them because he needs something from them, but because he wants to, because he likes them.

This is an example I have made up, deliberately simple and one-dimensional, so that the points I am concerned to make are

not lost in the detail. My main point is that the psycho-analyst
helps the patient to see things about himself which he avoids rec-
ognizing and to put him in touch with feelings he dare not live
openly—good feelings as well as bad ones, love and affection as
well as anger and hatred. This is what Freud calls 'making con-
scious what is unconscious'. Feelings that are unconscious are
inaccessible to him: he can neither own them, live them, take
responsibility for them, nor can he repudiate them, turn away
from them, give them up. The analysis thus, through the work of
interpretation, brings into the open conflicting feelings and
desires, conflicting aspects of the patient's personality, of his
unowned aims and adjustments. These are what the patient has
reached an accommodation with and put into deep freeze. As one
analyst, Charles Berg, once put it, he has not lived them, he has
been lived by them. Now that they have become accessible, the
patient has the opportunity of finding a solution to his longstand-
ing conflicts—one he finds *personally* acceptable, given his convic-
tions, his past, his attachments. He has thus the opportunity to
come together and shed what has so far been false in his life and
excess luggage.

I said 'given his convictions', but he may have to *come* to con-
victions he can give his heart to and make his own. This he may do
as feelings that have been kept in cold storage become accessible
and bring him in contact with aspects of life from which he had
kept at a distance. Out of these convictions may arise solutions to
the old conflicts behind his current problems and difficulties. He
may, for instance, be able to give up old resentments poisoning his
present relationships.

To give them up means *forgiving* what he feels to be an injus-
tice, an offence, affront, or humiliation. Until he does so the past
injustice or affront, real or imaginary, will continue to taunt him.
It will not let go of him until he thus lets go of it. To do so he has
to remember the past offence so as to be able to forgive it.
Obviously he hasn't forgotten it: he dwells on it unconsciously, he
cannot turn his mind away from it. Yet he cannot place his resent-
ment where it belongs: he cannot remember that. If and when he
remembers it, it will become accessible to him in consciousness.
This is what I called an enlargement of consciousness. So far this
is not a change in him. If he can find it in his heart to forgive the
offence or injustice *that* will be a change in him. He will then be

free of the resentment and of the suspicion with which he approaches others in certain relationships. I repeat, it is not the remembering that is a change in him, but the forgiving. It is a change in which a split within the self is healed: the ability to give himself to something in which the person can find enrichment and growth is restored to the person.

'Growth' here means growth in generosity, in the contribution the person can make to the life of those around him. It means growth in appreciation and in interest in things outside him. The words 'growth' and 'development', as used here, are obviously not morally neutral terms. But my principal point now is that the growth I speak of goes on from the kind of coming together in oneself which comes about with the resolution of inner conflicts and the authenticity which that makes possible.

4.3 Coming to Self-Knowledge as Learning to Be Oneself

I now turn to the kind of connection there is between self-knowledge and the kind of change we have been considering. Coming to see something new *about* oneself, coming to see *what one is like*, as we have seen, is a step in the direction of self-knowledge; but it is not the same thing as coming to self-knowledge. Whether or not it adds up to self-knowledge depends on what one does with it, how one takes it into one's life. One may know what one is like, but unless one is oneself *in* or *behind* what one is like one will not have come to self-knowledge—and there are certain ways of being in which one cannot be oneself. In coming to oneself, in accepting oneself in one's limitations, one gives up being in any one of these ways. Anyway, my point now is that self-knowledge is not knowledge *about* oneself. Yet it is very easy to come to think it is. It is because one thinks that in psycho-analysis the patient simply learns *about* himself that one wonders why that should make a difference to the way he is, why that should change him.

I should like to make it clear that there is a big difference between 'learning *about* oneself' and 'learning to *be* oneself'. It is in the latter case that one comes to self-knowledge. Thus a person who *knows* himself is one who is in touch with himself. That is he *lives* what he feels about things; he has made his feelings his own.

That means that the direction of his life, within the limits of contingencies that he can do nothing about, is his: he is *in* the life he lives, *behind* his responses to things. We say that he *knows* what he feels about things in just this sense, namely that his feelings inform his convictions and his responses. He *knows* what he wants in the sense that he is himself in the things he seeks. What he wants are things he can make sense of in terms of values, concerns, and interests that are *his* in the sense that he has made them his own. He *knows* his own mind in the sense that the mind he makes up is his. That is, he decides things for himself. He *knows* what he thinks about things in the sense that he thinks for himself: his thoughts are his, they are not second-hand.

Coming to know oneself is indeed a coming to *know*: coming to know one's own mind, to know what one thinks, feels, wants. I have pointed out what these expressions mean colloquially. This is something we need to take seriously. Yet philosophers and psychologists tend to forget it and turn the knowing in question into a knowledge of what is already there—a knowledge of what one is like: of one's character, one's inclinations and inhibitions, of the way one habitually reacts to things. As a result self-knowledge comes to be confined to the kind of thing Freud had in mind when he talked of 'the unconscious becoming conscious': coming to know one's unconscious wishes, intentions, phantasies, and feelings. But this short-cuts the transition from insight to the kind of change in which a person comes to himself and leaves the connection shrouded in mystery: why should knowing what one is like make one different? Why should such knowledge be enough to cure the patient? Surely knowing something, whatever it may be, is one thing, changing it is another. Surely changing it is something over and above knowing it even when one doesn't like what one finds out. One is misled by the grammar of 'know' and 'find' here, as well as that of their intentional object, namely what I called 'the self' as this expression occurs in 'oneself'.

If I am right, then, it is clear that coming to *know* oneself is coming to *be* oneself—just as Plato pointed out, coming to know goodness is coming to *be* good, that is coming to goodness in *oneself*. It is equally clear that coming to *be* oneself involves coming together in oneself, so that one can put more of oneself into what one does and how one lives. Hence in coming to self-knowledge, in the sense of learning to be oneself, one moves towards greater

autonomy. Equally since such a person's feelings and responses to things are more and more *his* in coming to be himself he becomes authentic. We see that coming to self-knowledge *is* changing in oneself; and the self to which one comes in so changing is one in which one's inner divisions are healed. In coming to such wholeness one inevitably finds greater autonomy and authenticity.

We can further see why such a person is said to have self-knowledge. He is not deceived in himself, he is authentic or true, and he is at one with himself—all marks of knowledge, except that here the lack of deception, the authenticity or truth, the oneness, characterize the self. Thus the knowledge the person has characterizes the person *in himself* and *not* his beliefs about himself. In *this* self-knowledge is like wisdom, innocence, and certain forms of self-deception. The wise person, the person who has what Plato called 'moral knowledge', is wise in himself and virtuous. The innocent person is child-like: he is someone who has not learned to lie, he is trusting like a child. A person who, in Tolstoy's words, 'lives a lie', is someone deceived not *about* himself but *in* himself. He will come to self-knowledge in realizing that his life is a lie, in taking this to heart, and in turning away from it. As his life changes so inevitably does *he* change— in himself, in his mode of being.

To return to psycho-analytic therapy. Psycho-analytic interpretations are communications of the analyst's insight to the patient. The patient can respond to it in various ways; but he will benefit from the analyst's insight only when he can make it his own, come to see what is conveyed to him for himself. The transition from such insight to self-knowledge involves the patient in giving up his defences, which the analyst would have pointed out, taking this insight into his life and coming to terms with it there. This means working on it affectively within the context of his life—dealing with his anger, depression, feelings of having been neglected, rejected, betrayed, or of having failed in one way or another. This will involve, for instance, revising his view of what he is angry about in the light of the perspective of newly discovered feelings in himself which he has come to own—a perspective which had not been available to him before. It will involve him in going to the root of his anger, of his feelings of failure, appraising what truth they contain, what they say about the way he has lived, accepting that truth, reconciling himself to it, and seeing how and where he can go on

from there, what he can still make of what he has—for he may have overlooked, denied or underestimated that.

It is *here* that the prospect of change in analysis lies, change in the direction of self-knowledge. But this is something that has to come from him—otherwise whatever he comes to will not be *his* and so will not be self-knowledge. He comes to it in the way the insight he comes to engages him affectively. It is in this engagement that the divisions within him are healed.

What a person is like, I argued, is a mixture of what he has made of himself in relation to what has been his lot and of the lot which has been his and was not his doing. He has, I argued elsewhere, participated in and contributed to his own development. What he has made of himself can, in principle, be undone, the vicious circle that keeps him in the same spot can be reversed, and he can continue to go on from there. Obviously there is a time and a place for things in a man's life and what he has missed may not be restorable, and much of what has been his lot may not be alterable. Even then he can change his attitude to it, come to see it from a new perspective. In doing so he will change in himself. This may reduce what he has found painful in it or it may increase the pain. But in either case it will bring him relief and a change towards making something of his life despite what is unalterable there. It will bring him greater freedom within its limits. Indeed, insofar as his lot cannot be altogether divorced from the significance it has for him personally, with his change of attitude towards it his lot will change with him in certain respects. This is the sense in which coming to know oneself alters the self one comes to know, alters it in the direction of greater wholeness, authenticity, and autonomy. These comprise the values or ideals of psycho-analytic therapy. The analyst helps the patient to achieve these in helping him to come to greater self-knowledge and, as a corollary, he respects the patient's independence and autonomy.

As for the pain and distress the patient suffers, this too is bound to have a mixed source. Certainly insofar as some of it comes from the perspective of feelings that will change in the course of analysis it will be reduced. Equally too insofar as some of it comes from the conflicts and difficulties that beset him in his current life and which are the product of what he has been clinging to, as he lets go of it so will the distress bound up with it diminish. On the other hand, there is much in life to hurt a person and

cause him pain, particularly a person who is open to life. One who is open to what life has to offer will inevitably be also open to its many pains. Thus in the last paragraph of *Studies in Hysteria* Freud considers the following objection:

> You say yourself, that my suffering has probably much to do with my own relation and destinies. You cannot change any of that. In what manner, then, can you help me?

Freud replies:

> I do not doubt at all that it would be easier for fate than for me to remove your suffering, but you will be convinced that much will be gained if we succeed in transforming your hysterical (neurotic) misery into everyday unhappiness, against which you will be better able to defend yourself with a restored nervous system. (1950b, p. 232)

For 'a restored nervous system' here we can read 'a person who is more himself than he was, has come to a greater unity in himself and has thus gained in toleration of pain and in self-mastery'. By 'against which you will be better able to defend yourself' Freud means, 'you will be able to face it and bear it without going to pieces', 'take it on the chin instead of tying yourself up in knots trying to soften its blow or avoid its full impact'.

5 Happiness: Can It Be Pursued as an End?

5.1 A PHILOSOPHICAL QUESTION

'What is happiness?' In these words one sometimes seeks a resolution of certain philosophical difficulties: Is happiness the satisfaction one obtains when one's desires are satisfied? Or is it the capacity to be pleased with what one has and enjoy what one does? Is the happy person one who enjoys life or one who has attained inner peace? How far does a person's happiness depend on his state of soul, his values and attitudes to things, and how far on his external circumstances? What can one do to be happy? Can the desire for happiness be anything other than a form of self-seeking?

These and other questions come crowding in. Yet they do not come from ignorance. One who asks them knows well enough what the word means and what he or she is talking about. They are an expression of perplexity and seek for an order in one's apprehension of what is familiar territory, for a clearer view of the application of the concept of happiness and its relation to a host of other concepts: enjoyment, pleasure, satisfaction, gladness, joy, doing what one wants, contentment, serenity, virtue, and many others.

It is worth noting that the words 'What is happiness?' may also express a request for something different: for one's conception of happiness to be made explicit—what *personally* would constitute happiness for one. This involves articulating what one considers to be of supreme importance in life. Here too one is called on to reflect on what one already knows, on 'what lies open to view'. But what is in question here is not the application of and the connections between concepts with which speakers of one's language are

familiar. What is in question are one's own thoughts, attitude to life, desires and ambitions, beliefs and values. The question this time calls for self-reflection, and this bears a certain resemblance to philosophical reflection. It may even lead one to certain philosophical questions and so come to be intertwined with philosophical reflection.

Two people can thus attach the same meaning to the word 'happiness' and yet have very different conceptions of happiness. Consequently they may differ over whether or not someone is happy, as Socrates and Polus differed over whether Archelaus, the Macedonian tyrant, was a happy man or not (*Gorgias*, pp. 56–63). But there are other ways in which people can differ in their answers to such a question. There is room for disagreement here even when the man whose happiness is in question is well known to the disagreeing parties. For whether or not a man is happy can be gathered only from his life, his words and actions, and it is not always easy to know what to make of them. Even the person in question may not always find this an easy matter. In the novel *H.M. Pulham, Esq.*, by J.P. Marquand, the hero likens such reflection to 'having a lot of numbers that don't look alike and don't mean anything until you add them all together' (quoted by Wisdom in 'Gods', in Wisdom 1953, p. 153). But it is easy to make mistakes, and these are not like mistakes in arithmetic.

5.2 Happiness and our Outer Circumstances

'Does happiness depend on our own powers or on our circumstances, and even on what are matters of accident?' People say: 'I am happy that you could come', 'I am happy to make your acquaintance'. They thus express their pleasure at various things. They are glad to have the company of someone they like, pleased to meet someone of whom they have heard much before. These are moments that brighten their day, moments that come and go, although their content is determined by what precedes and what follows them. Much has to come together for me to be glad now, at this moment; much that cannot be identified without reference to what takes place at other moments of my life.

Certainly those things that make a man glad, the things that he appreciates, enjoys, feels grateful for, are the things that make him

happy. As the hero of Marquand's novel puts it: 'All the things that two people do together, two people like Kay and me, add up to something. There are the kids and the house and the dog and all the people we have known and all the times we've been out to dinner. Of course, Kay and I do quarrel sometimes, but when you add it all together, all of it isn't as bad as the parts of it seem.' But for a man to be happy there must not only be things for him to be glad about and enjoy, he must also have the capacity to be glad and to enjoy things. He must be able to take an interest in people, to find pleasure in things, to be able to forgive those who hurt him, to feel grateful for what he has. This is something that comes from *him*.

So the sources of whatever happiness one finds in life also lie within one. If a person didn't care for people, was not interested in anything, did not appreciate the good things in life, if he did not find some things good, nothing could make him happy. If he was full of resentment, or he turned up his nose at everything, or if he had no interests and were indifferent to what goes on around him, he could find no happiness in life.

Someone who, at an extreme, takes an interest in nothing but himself, who doesn't care for others, who feels no affection for anyone and forms no attachments, cannot find happiness. Such a person, it is true, would be incapable of deep pain either. But it would be the emptiness of his life that is the source of his unhappiness. He might run after one momentary pleasure or another and describe himself as 'looking for happiness'. But he would be looking for it in the wrong place. For as he is unable to stop anywhere and grow roots the only thing he can find are 'sensations'. He may seek to obtain power, if he is that way inclined, in the hope that it will compensate for his inner poverty. Often that will lead him to evil, to harm others and bring pain into their lives.

Thus if a man is unable to find beauty in things, if he values nothing, if he lacks the capacity for gratitude, nothing will make him happy. For instance, if he believes that everything can be bought, if he measures the worth of things in terms of money, if he sees no intrinsic worth or beauty in them, something that inheres in them quite apart from their utility or what they would bring him as possessions, nothing can make such a person happy. His life would exclude those forms of significance in relation to which he could find most of the things that bring happiness—fullness of life, gratitude, appreciation, spiritual nourishment. Such a person

would say he was happy while he was able to satisfy his desires and lusts. But what inner life we can attribute to him would be like quicksand: nothing would take there. He is like a man who stuffs himself with food which gives him neither nourishment nor satiety. Socrates describes him in the *Gorgias* as a man who tries to fill a leaky vessel using a sieve.

It is true, of course, that happiness cannot be made secure. While those who form attachments to people and places, believe in certain values, and take an interest in others, can find happiness in life, the very things which bring him happiness at the same time leave him vulnerable to pain, hurt, disappointment, grief, and even guilt and remorse. But although genuine happiness is thus inevitably vulnerable, this does not make it unstable. Its vulnerability comes from the person's accessibility to the pains that form part of life, while its stability comes from its 'inner dimension—from a person's ability to bear pain without giving up or going to pieces for instance. Indeed, those whose happiness lacks stability are those who take too much from those situations that make them happy without putting anything into them. Their happiness is thus like a bubble which is easily pierced by a change in their circumstances. Their soul is a mirror which reflects the passage of outer events without being able to stand up to their impact. They depend on circumstances to sustain their happiness. The things that make them happy skate on the surface of their soul and fail to give them any permanent sustenance.

Thus one can be related differently to those events which make one glad or joyful, and this relation is an expression of the kind of person one is. Where it is a form of passivity, where the soul basks in the warmth of a moment of gladness, the happiness it finds will be evanescent. When the warmth is removed the chill will sent in. Where, on the other hand, a person cares deeply he will radiate the pleasure he finds in a happy moment, give pleasure to those who are part of it, and he will be transformed in the process. In his response to the happy moment he will give something of himself, put something into it, sustain it. The gladness will then permeate his soul and what he will thus be able to keep from it will enable him to weather sadness and disappointment in the future without letting these things colour the whole aspect under which he sees life. It takes a sense of proportion, humour, patience, trust, and courage to withstand what life may throw at one at a later time.

Certainly a person can remain cheerful in adversity, when his circumstances change, without denying the adversity and insulating himself from its impact. I mean he will not let gloom envelop his life, will not indulge in self-pity, and he will not forget or lose touch with the good he has had. Nor will he become the centre of the universe for himself in his suffering. Pain has a tendency to narrow one's consciousness onto one's suffering and it takes courage to resist this: to keep one's breast open to the pain, to take it on the chin, and yet not get sunk by it.

Some religious writers have even spoken of a happiness which no adversity can destroy. This has been meant and understood in different ways in different religions and even within the same religion. Spinoza was articulating one such conception when he advocated detachment from a perspective on things 'from their midst'. I can understand this insofar as it means something like giving up the interests of profit and advancement and worldly concerns which take a short-sighted partisan view of things. In what he calls a view of things as from their midst, what we are interested in is seen in isolation from other things that do not interest us, and the world is thus fragmented—not seen as a whole. In a view of things *sub specie aeternitatis*, by contrast, we become immune to the pain of particular failures, hurts, and personal adversities which seem trivial in the context of 'the order of the universe', the beauty of which fills us with wonder and takes us out of ourselves. In such a view each particular thing in or part of the universe can assume a significance which inspires love and the desire to care for and protect it. Presumably when it is harmed one will be saddened but without being dejected. Thus a child whose toy is broken may shed tears of real unhappiness. Until it is mended nothing will make him happy. A few years later looking back on it the incident will bring him a smile. Likewise, Spinoza thinks, the significance of much that upsets us and makes us unhappy may so change in our new perspective that it no longer upsets us *in the way* it did before, no longer generates the heat it generated when we clung to it as if it was the one and only thing that mattered. The partial view is the view of the moment to which we cling because we cling to the ego.

I am not saying that there can be a happiness that is thus *absolutely* secure from all pain and adversity. But some people have found a way of putting their trust in something outside themselves which has taken them a long way in bearing pain and adversity.

This has so sustained them that their view of things as a whole has remained uncoloured by their suffering. That is they have kept their trust and faith in the teeth of their suffering. But I don't see how there can be any trust or faith that is fool-proof in the face of affliction.

5.3 HAPPINESS AND CONTENTMENT

I spoke earlier of gladness and joy and the way these are generally directed outwards, even though they can take root in the soul of the person who feels them. They are primarily a person's response to what exists independently of him, and only secondarily are they states of soul, what the person becomes in relation to what makes him glad or joyful. Though we do speak of being contented with this thing or that, contentment is primarily a state of soul. A contented person is pleased with what he has, satisfied with his lot. That is, he doesn't want more, or something different, he doesn't think that what he has is not good enough. He accepts himself without thereby feeling pleased with himself. He is at peace with himself.

Contentment is an expression of self-acceptance, of having found what one wants. But it is not a form of acquiescence. The contented person may have to fight for what he believes in and what he wants. He is as upset as anyone else when things go wrong, though not in the same way. His disappointment or pain, however, remains confined to its object. It does not alter his view of the world; he does not lose sight of the things he has trusted, found support in, and thought worthwhile. The contented man, one could say, is 'in harmony with the universe'. He is happy to let things be as they are in the sense that he does not have to have them a certain way that will suit his purposes—for instance so that he can believe in himself. Consequently when they change his confidence in himself is not threatened.

At least one antithesis of contentment is greed and envy. Another one is a bad conscience.

Contentment is unobtrusive; when it purrs it has already changed into smugness. Such smugness is to contentment what manic exuberance is to joyfulness.

5.4 HAPPINESS AND AUTHENTICITY

We sometimes confuse contentment with satiety and happiness with having what one wants. We think that if a man does all he wants to do he must be happy and that, therefore, it is in seeking pleasure and satisfaction that happiness is to be found. It seems then that restraint and discipline are necessarily obstacles to happiness.

We find such a view in Freud's *Civilization and its Discontents,* though I do not myself believe that it represents what Freud really wanted to say. In this monograph the view that some inner conflict is inevitable in the course of any individual's development towards greater autonomy and that dealing with it by repression preserves the conflict, blocks its resolution, and perpetuates self-division, is distorted by various philosophical confusions. While Freud here identifies civilization with repression, he has himself clearly distinguished, in some of his other writings, between repression and self-restraint, and he appreciates the importance of standards and discipline for the learning of self-restraint.

I have already pointed out that contentment is not satiety but freedom from greed. The inner peace of which it is an expression does not come from the satisfaction of one's desires, but from having found what one wants in life. This involves the reorganization of one's desires around certain beliefs, concerns and interests; and that means the subordination of some desires to others and the giving up of certain desires or their transformation in the context of new activities. These are what one learns to take part in, within the new spaces of one's broadening horizons. This is part of intellectual and emotional development, and it takes place against the grain of inclinations to which one clings, and amidst fears, resentments and anxieties which prevent one from making what is new one's own and thus changing in the process.

In my reading of it this is absolutely central to Freud's conception of individual development or 'the development of the ego' as he called it—more properly 'the self'. Finding out what one wants also involves the taking on of new responsibilities and the making of certain crucial choices: making certain beliefs one's own, endorsing certain desires and inclinations, rejecting or repudiating others—this latter to be distinguished from what Freud called 'repression'.

Giving way to greed is the opposite of what is in question. The greedy man does not know what he wants. Greed is an expression of perpetual dissatisfaction, of an inner emptiness. In contrast, the convictions, interests and concerns which the man who knows what he wants has made his own give him a fullness of being which is the antithesis of the inner emptiness of the greedy man who finds no sustenance in what he seeks and so craves for more.

A person who does what he wants is not necessarily a selfish person, nor is he necessarily someone who seeks pleasure and satisfaction. Whether he is selfish or not depends on what he wants. Certainly a man who pursues his interests is not seeking satisfaction. In any case, satisfaction is not what one seeks when one pursues the object of one's desires, even though when one obtains that object one necessarily obtains satisfaction—not self-satisfaction, necessarily, but the satisfaction of one's desires.

Similarly for pleasure and enjoyment. A man who enjoys nothing, who finds no pleasure in anything, cannot find any happiness in life. This is what I claimed earlier when I said that a man cannot find happiness in what leaves him cold or indifferent. However to say this is not to advocate a life of pleasure. The antithesis of what I am trying to bring into focus is alienation and inauthenticity, of which these are different forms. It is these that I claim exclude the possibility of a happy life. One may, for instance, think of a person in whose life everything is a burden, a chore, where everything is done as a duty—for example Mrs Solness in Ibsen's play *The Master Builder*. Or one may think of a person whose actions are subordinated to the desire of keeping up appearances—such as Ivan Ilytch in Tolstoy's story *The Death of Ivan Ilytch*.

To say 'Do what you want' need not be to give a person licence. It need not mean: 'If you *want* to do something, then that is all right. Go ahead and do it.' Or: 'Ignore what other people want'. In one common usage it means: 'Whatever you do, be sure that it is what *you* want.' In other words: 'Do what you, yourself, believe in and endorse. Be sure that you are behind what you do, that what you do comes from you.' As far as *what* one is to do is concerned the above injunction leaves the field wide open. It only asks that the agent should be the one who determines that. It speaks about his relation to what he does, whatever that may be, not its content.

It is *this* that is presented as a precondition of happiness in the words: 'Be sure that what you do is what you, yourself, want, if you want to be happy.' But it is distorted in the thought that happiness can only be found in a life of pleasure, or in self-seeking, and that accepting any limitation to such a pursuit must be detrimental to a person's chances of being happy. Hence Callicles in Plato's *Gorgias.*

5.5 THE PURSUIT OF HAPPINESS

'If you want to be happy . . .' If one assumes that people want to be happy, what is it that one assumes? That this is the driving force behind people's actions? That in what they do and in the way they arrange their lives people are engaged, however clumsily or misguidedly, in the pursuit of happiness? In his more speculative moments Freud fell into the error of thinking so. Thus in *Civilization and its Discontents* he asks 'what the behaviour of men reveals as to the purpose and object of their lives', and answers that men 'seek happiness, they want to become happy and remain so' (pp. 26–27). Further down he says that 'the force behind all human activities is a striving towards the two convergent aims of profit and pleasure' (pp. 57–58).

The first thing to say is that it is a mistake to think that behind the various things that men do there lies one or one of a few fundamental aims or motives. It is true that sometimes what aims a man pursues in reality are very different from what they appear to be—even to himself. Sometimes behind all the different things he does there is mostly one and the same aim that he seeks—success, or power, or profit, or self-aggrandizement. But this is not true of everyone, and where it is true usually the person is not in the driving seat.

Freud was a psychotherapist and people came to see him because, in one way or another, they were unhappy. They sought relief from their sufferings. But it does not follow from the fact that people who are suffering and unhappy would like to see an improvement in their condition that they engage in the pursuits that fill their lives in order to find happiness. Even if we were to say people want to be happy, what could this really amount to? No

more than that other things being equal everyone would like to be happy, that no one would choose to be unhappy. To say this, however, is not to deny that men are often willing to put up with suffering and unhappiness for what they believe and for the people they love. Generally, engrossed in the activities to which they give themselves they think little about their happiness and care little about the dangers and discomfort to which these activities may expose them. The fact that they are behind their actions, that they put up with pain and discomfort willingly, does not mean that they do so for the sake of the reward in which they will find happiness.

To say that 'men want to be happy' in this qualified sense is one thing, to say that they want the different things they seek as a means to happiness is quite another thing. In fact, happiness is something that always eludes those who seek it directly: understandably, since it has no substance of its own. It is not something over and above the different things in which men find happiness. The moment any one of them is made into a *means* to happiness it can no longer bring happiness.

One may, of course, be unhappy and reflect on where one has gone wrong in one's life. One may feel one has lost one's way in life and give expression to one's consternation in the words 'I wish I knew what I wanted'. This search is sometimes described as a search for happiness. But what is being sought is not the means to happiness; what is sought is something that the person can make sense of, see some point in, perhaps an occupation in which he can find an interest and grow. In it he would find happiness. He must be careful, however, not to let it become an evasion from what troubles him, a way of filling in the void within him. There will be this danger if he thinks too much in terms of finding happiness.

A person will find happiness, I am inclined to say, if he can do whatever he does creatively, or in other words, by giving himself to it. But, of course, one has to add: if he is lucky, or other things permitting. To be able to be creative in this way one has to have some talent, however modest, and the opportunity to develop it. In this too chance or luck has a role to play. A truly happy person, I think, is someone who is grateful for what he has. He sees the good in what he has; what he does not have does not engage his thought or exercise him.

5.6 SOURCES OF UNHAPPINESS ENDEMIC TO LIFE

In his paper 'Ten Questions for Psycho-Analysis' (*Philosophy,* 1993), Professor Phillips asks whether there are not forms of unhappiness which are endemic to human life and about which we can do nothing except learn to accept them. He thinks that at least in its popular conception psycho-analysis denies this, fools people about life, and encourages what he calls a 'success ethics', namely the view that each person must do all he can, use all available help, to be happy in life. In sharp contrast, he reminds us of Freud's words that all that can be hoped for in psycho-analysis is the alleviation of neurotic misery, leaving people more lucid about their share of the ordinary unhappiness of human life and hopefully better equipped to cope with it. At the source of such unhappiness, Phillips points out, are problems and difficulties that are bigger than each person, and it is a delusion to think that they have a solution: loss of loved ones or their suffering, unrequited love, problem children, various other forms of evil and pain.

It is perfectly true that where there is human life there always will be such problems, pains, and difficulties. Their 'causes' in human life cannot be removed without altering human life beyond recognition. Some psychologists, like Skinner in his utopia *Walden Two* have imagined that the causes of human unhappiness can be removed by controlling the environment and manipulating human emotions: 'the emotions which breed unhappiness are almost unknown here, like unhappiness itself' (1976, pp. 92–93). But, as I argued in my book on Skinner, there are serious considerations which should make one doubtful whether such surgery, if it were possible at all, would leave the character of human life, and so what is possible within it, unaltered (see Dilman 1988b, Chapter 8). In *Brave New World* Aldous Huxley gives us some idea of what human beings would be changed into if the dreams of such psychologists as Skinner were realized. Indeed Huxley's suggestion is that culturally we are already on the way to it; he uses his portrayal of such an hypothetical extreme to criticize where we are now—or where we were when he wrote his novel.

I believe that this is equally what Phillips has in mind when he speaks of a popular conception of psycho-analysis which encourages the idea that the causes of unhappiness can be removed at an individual level. Consequently many people who go for a personal

analysis seek a pie in the sky they call happiness and while they cling to this thought make themselves the centre of their concern. But how far are Freud's ideas to blame for this? How far has psycho-analysis contributed to the cultural changes of which this is a consequence, and how far is this popular conception of psycho-analysis itself the result of changes in the culture within which it has developed? The latter question is complex. No doubt the popular conception is the result of a two-way, indeed three-way interaction between (i) misunderstandings and distortions of Freud's ideas of shared powerful individual phantasies shaping public perception of psycho-analysis, (ii) changes in a materialistic culture in which certain values and an appreciation of certain virtues are being lost, and (iii) the impact of certain developments of psycho-analysis, within a changing culture, on these changes.

As for Freud's ideas themselves, as I have already pointed out, Freud's view was that life is inherently problematic and that growth towards individual autonomy comes with the learning that is part of a person's struggle with his share of life's problems in contrast with the evasion of personal responsibility for them. Psycho-analytic treatment is indeed the opposite of what it is so often taken to be, namely getting the patient to take responsibility for such problems.

Indeed, those who seek psycho-analytic help about their problems do so for many different and mixed reasons which vary from person to person. But these reasons themselves are always subject to analysis in a serious psycho-analysis. Thus a patient in analysis may learn that he is seeking a pie in the sky, that he is hoping to take the easy way out, to turn over his problems to someone else whom he endows with magical powers. It is important for him to come to see this in his analysis and to understand why he does so. To do so is to come to accept responsibility for his problems and to take a more active role in trying to come to terms with them. That is, psycho-analysis changes the very attitude which from a distance it may encourage in some people in what they project onto it. This attitude dates back to their childhood and psycho-analysis can help people to grow out of it and in the process to grow up.

This is a very different picture of psycho-analysis, of course, from the one we find in the popular conception Phillips criticizes. He quotes from Beckett: 'You can't go on like this'; 'That's what you think!' In certain cases Vladimir's reply is apt and apposite;

but in others its antithesis would be the insightful thing to say: 'But you can do something about it; you have within you the resources to enable you to do so, if only you could be put in touch with them and so find a way to tap them.' Psycho-analysis, as I understand it, does no more than help one to do so.

Where a person contributes to the problems and difficulties he experiences in the activities and relationships in which he engages, psycho-analysis aims at getting him to be *lucid* about this contribution and to do something about it—something with which he can be at one as far as possible. This involves coming to himself. Insofar as what he suffers comes to him from outside and is irremediable he has to learn to accept it and live with it. This too calls for certain resources which psycho-analysis may help him find in himself or acquire while he, the patient, moves towards coming to himself. This is what I take Freud to have meant by replacing neurotic misery with ordinary unhappiness.

6 Psycho-Analysis and Ethics: The Self in Its Relationship to Good and Evil

6.1 MORALITY AND HUMAN NATURE: FREUD'S VIEW AND ITS REVISIONS

Freud's view of morality is well known. He sees morality as opposed to our nature as human beings. To be oneself or authentic one has to give due recognition to what belongs to one's nature. One who sides with morality, therefore, takes sides against one's own nature which is instinctive in character. Morality is thus a force of repression and prevents men from becoming themselves.

Freud makes it clear that he does not advocate licence in holding this view. He regards morality as beneficial insofar as it regulates human conduct in community life. He distinguishes between 'voluntary self-control' and 'repression' and advocates accepting the discipline of morality. One can do so without being taken in by its pretentions and without submitting to its repression. To do so is to learn to accept discipline without giving up on who one is. Freud thinks of this as learning to renounce the prospect of immediate pleasure for the sake of long-term and abiding objectives.

He sees the opposition between instinctive human nature and the morality which comes to us from our culture as a conflict within us. For that morality too becomes part of us, in the form of the super-ego, as we side with its demands, imposed on us in our childhood. But although those demands are thus 'internalized' they still remain 'external' to the ego. The super-ego thus brings pressure on the ego to ignore the demands made on it by the id which represents the inclinations of our instinctive nature. It is thus the agent of repression within us.

If the super-ego and the id can be 'assimilated' by the ego—the aim of psycho-analytic therapy—the conflict will be resolved: the person in question will willingly consider and, when his judgement is satisfied, abide by the claims of the morality he has made his own on grounds of rational self-interest. Willingly means not out of fear, and that is what Freud means by 'voluntary self-control'. On those occasions the person voluntarily renounces his instinctual inclinations without sweeping them under the carpet and denying his own nature.

Freud thus sees morality as a negative force in the individual's life. The only positive role it plays is that of an external regulator of human behaviour in society. This kind of view is familiar in philosophy and raises many difficulties. But this much in Freud is true, namely that a person's morality, more often than we recognize, is not his own. When that is the case it *does* prevent him from being himself. It is *also* true that in such cases the change it takes for such a person to move towards being himself involves coming to self-knowledge. On the other hand, Freud's view lacks a recognition of the integral way in which morality (of one kind or another) belongs to human life and the *positive* role it plays in the life of the individual when he makes it his own: the way he comes to himself in making it his own.

This is something Jung had complained about in the early stages of the development of psycho-analysis. He objected to Freud's views for divorcing sexuality from love, reducing the self to the ego, and thus making morality into something bound to remain external to the individual's life. He pointed out that there is a radical difference between a genuine moral conscience and Freud's archaic super-ego and described Freud's psychology as a 'psychology without a soul'. Morality, he said, is not something 'imposed on us from outside, we have it in ourselves from the start'. It is 'a function of the human soul as old as humanity itself' (Jung 1953, p. 26)—in other words it belongs to the human soul and emanates from it.

Similar ideas are echoed in Melanie Klein's work, however different it may be from Jung's. She brings a recognition to psycho-analysis of what is missing in Freud, namely a vision of the positive role which the child's moral relations play in the formation and development of his personality. For Freud it is *reason* which plays a positive role in bringing coherence to the individual's life and

securing co-operation between individuals. In Melanie Klein it is *love*, seen as having a moral character, that has such a positive role. It has the power to heal inner conflicts and interpersonal rifts. It is the good feelings in the individual that make self-mastery possible and not the exercise of the will in the light of 'rational self-interest'. It is concern and regard for others and good will towards them that is the source of co-operation, trust, and loyalty, and the courage it may take to sustain these.

All this constitutes an advance on Freud. However in the way that his critics 'correct' what they find objectionable in Freud's view of morality they themselves err in the opposite direction. I have in mind Roger Money-Kyrle and Erich Fromm. Freud had claimed that morality, whatever form it may take, is something *alien* to human nature and as such *bound to be* something artificial, arbitrary, and deceptive. His critics claim that this *need not* be the case and that there is a morality that is *part* of human nature. They thus share with Freud a dichotomy between nature and convention which needs criticism. Where Freud had put morality on one side of the dichotomy, the side of convention, his critics claim that there is a morality which belongs to the other side, that of human nature: 'humanistic morality'.

What neither party recognises is that the line between human nature and human culture, which Freud identified with convention, between what is inherent and what is learned, cannot be drawn in such an exclusive way. Freud's critics *further* seem to share with Freud the idea that for a morality to be something genuine, non-arbitrary, and true, that is something that does not deceive the individual in his allegiance to it, it must be grounded in something *objective*—something independent of the morality in question and the life it characterizes. But does it take that for a morality to be *genuine*, or 'authentic' as Fromm puts it? And is there a sense in which human beings are moral *by nature?* I begin with the second question.

6.2 IDEA OF A MORALITY THAT IS INHERENT IN US

Jung held that we have morality in ourselves from the start. Winnicott spoke of an innate morality (1957, Chapter 11) and Marion Milner of one that is inherent in us (1977, p. 67). It forms

part of our nature as human beings and so we all have it in us, even though it is often stifled by the morality that is 'imposed' on us.

At least part of what is thus being claimed is that human beings have the *capacity* for love, concern for others, trust and good will, that they are not, as Freud supposed, fundamentally and ineradicably selfish and self-centred. But it is, of course, a capacity which they come to have in their individual development, and they may fail to come to have it. In other words, where attitudes of love are concerned there is much room for learning. Thus Fromm talks of 'mature love', that is one that has been purged of ego-centricity and dependence and all attitudes that stem from these, such as possessiveness and domineeringness. He argues that only the mature person, one who has learned to accept the separateness of others and to respect them as individuals in their own right, is capable of mature love. Here some difference of opinion is to be found in psycho-analysis about what such learning involves. Some hold that, given 'favourable conditions', a 'facilitating environment', the child will *naturally* develop in this direction. Others hold that such development engages the individual more actively: a child has to come to terms with, work through, and outgrow ego-centric and destructive feelings that are equally 'inherent' in him. And here those that are close to him can help him positively.

However, the line between what is 'inherent' and what comes from outside is not easy to draw in this context. A person's moral interactions begin early in life and through them morality enters into his life so that later moral considerations make sense to him. What is 'inherent' in us are certain capacities which develop in certain ways given certain experiences. What we have at the beginning are certain reactions to others, those with whom we are in daily contact. But at that stage the world in which we live is a very limited one in terms of the range of significance that is available to our apprehension. Nevertheless, within its limits, there is still room for responses which could be said to be expressions of recognition, love, and co-operation, as well as others which point in the opposite direction, such as responses that are the expression of greed, envy, and hatred. These are part of our human inheritance, probably largely irrespective of the particular cultures in which we develop. Together they set the stage for later developments. In different cultures, no doubt, they are extended in different directions and become the source of different moral attitudes and values.

This is the kind of thing Marion Milner must have in mind when she speaks of an 'inherent morality' and Winnicott when he speaks of 'the innate morality of the baby'. Milner is thinking of the infant's capacity to feel guilty when he has been naughty even when he has not been punished. This capacity has its source in love, in the sense that it is part of love that one does not want to hurt or displease someone one loves, since one wishes for his good and welfare, and one finds hurting or injuring him painful, blaming oneself and grieving over one's action. Winnicott is thinking primarily of the baby's natural tendency to co-operate with his mother while being fed and cleaned and during play. Winnicott is here speaking from experience and what he says is diametrically opposed to Freud's 'theoretical' views. Freud had claimed that we are by nature pleasure-seeking and selfish creatures, not naturally capable of co-operating with each other. In a paper entitled 'Freudianism and Society' John Anderson criticizes Freud's 'individualism' and argues that men find common interests in common work and it is these interests that make it natural for them to co-operate with each other. Winnicott, on the other hand, is speaking of an early period of life where common work is not part of the baby's world. The co-operation he speaks of finds expression in the very special one-to-one relation the baby has with his mother prior to his initiation into social life. So he speaks of the way 'civilization starts inside a new human being' (Winnicott, p. 63).

It's true that much of our nature is the result of nurture; but it is equally true that it is part of our nature that makes nurture possible. It is the latter that both Marion Milner and Winnicott emphasize. The truth in what they say is that while our 'moral education', in the broad sense of initiation, can take different forms, it can take the form of simply providing a secure and responsive environment (responsive to the young child's needs) in which the child develops his own responses to things. Winnicott thus contrasts two methods. In the one the mother aims 'to impart goodness and a sense of right and wrong' in her baby, which drives a wedge between the baby's spontaneity and the world's demands, leaving the behaviour demanded 'without firm roots'. In the other, the baby's 'innate tendencies towards morality' are allowed and 'the roots of the infant's personal moral sense are preserved' (p. 62). Thus even when the mother does not impose her standards on the child, he learns

something positive from her: a love that is patient, tolerant and respectful of others.

Winnicott admits that 'standards vary' even within the same block of flats (p. 59). Nevertheless 'moral education' builds selectively on the child's natural or primitive propensities. It encourages the child in some of these and supports him in his opposition to some of the others. The direction and form varies with the culture and, indeed, with the family or household.

It is in this sense that we have the *seeds* of our morality in us from the start. But that is not to say that we are born with a morality already in us. What kind of morality these seeds will grow into depends on the soil in which they grow and on the kind of watering they receive. That is, it depends on the culture and moral environment in which they grow and on the care and attention we receive during our formative years.

However, what is 'inherent' in us in this sense does not constitute a 'morality' in the absence of the kind of framework of values which gives us a perspective on life. It is from such a perspective that we see things as having different forms of significance which attract our admiration and our abhorrence, and that our desires and feelings are shaped. These significances place limits on our conduct and constitute the soil in which we develop an elaborate vocabulary in terms of which we describe, assess, criticize, and reflect on human conduct and the situations in which we act. All this is something we *learn*, are initiated into; there is nothing 'inherent' about it. This learning shapes not only our understanding but our very *being* as a person. In this sense the moral values which each individual makes his own come to him from *outside*, from the life into which he is initiated.

This, however, does not make our morality into something that is 'implanted' in or 'grafted' onto us. When I say that the morality we acquire shapes us I mean that in what we learn we acquire our being. That being which becomes ours was not there before. On the other hand, this learning is not absorbing something which goes to constitute us either. No, moral learning is a kind of participation through which each person contributes to his own development. We are not simply a product of the culture and morality in which we grow: through what we learn we 'find' our being in it, in some ways like the way a writer 'finds' what he has to say.

There are two points I should like to select for re-emphasis and they both come from the work of Melanie Klein. The first one is that the reactions of the child from which his morality develops in the course of his interactions within the cultural environment in which he grows are not the only ones 'inherent' in him. There are also those which impressed Freud and made him characterize human beings as selfish, pleasure-seeking, and self-centred. Thus we can speak of the *duality* of human nature, the human soul. There are two currents in human life which pull the individual in opposite directions and both stem from what lies in the individual: one of these is giving, creative, and healing; the other is ego-centric, taking, exploitative, and destructive. With these in mind, great literary writers have spoken of the good and evil that is in human beings. From the perspective in which they spoke what Melanie Klein brings to our attention in the child constitutes the roots of this good and evil. They pull the child in opposite directions. A person can thus grow to become good or evil, or more good than evil or more evil than good. But there is an important sense in which in the one direction what he comes to is the result of his working through of the bad feelings in him—his hate, resentments, envy, and greed. Melanie Klein speaks of the mitigation of hate by love in forgiveness, grieving, making restitutions (1957, p. 76). In contrast, advance in the opposite direction is a form of yielding to or indulgence of one's ego-centricity. Thus while the two directions are each other's opposites, movements along them are not symmetrically related. More will be said about all this in 6.5 below.

Secondly, the 'integration' of the early instinctive reactions of love and friendliness into a personality that becomes stable, responsible, and mature, is made possible by the range of *significances* that become available to a child's apprehension as he learns to speak, think and participate in the activities that go on around him. The source of these significances evidently lies *outside* him, in the framework of concepts which belong to the language and morality in which he is brought up. What can thus be said to belong to our *nature* and be inherent in us as human beings and what comes from *the form of life* into which we are initiated as we learn to participate in its various activities and form relationships with those who belong to it are *complementary* and *inseparable*.

6.3 MORALITY, THE HUMAN WORLD, AND THE REALITY OF THE SELF

Jung spoke of morality as 'a function of the human soul'. I rephrased this as: Morality belongs to the human soul and emanates from it. That is, morality, of one kind or another, belongs to human life; it is integral to it: it is an important part of what makes human life the kind of life it is, the kind of life in which we are the kind of beings we are, so that it makes sense to speak of a person's soul. One could say that if a creature can be said to have a soul, it lives the kind of life in which there is logical room for moral concern—which is not to deny that a person may lack all moral concern or that what moral concern he is capable of may not go deep with him.

Still, however impervious a person may be to moral concern, his life will retain some relation to the life of those around him. He can still enter into and understand many of the occupations with which they engage. If he is someone who has given himself to evil he has something in common with many of those around him: he can understand many of their vices, weaknesses and preoccupations, share many of their jokes, pleasures, and disappointments— share in the sense that these are not alien to his own experiences. Indeed, otherwise his evil would hardly come to itself and have scope to take effect. For it is in the life he shares with others that his evil intentions are formed and translated into action. However, though he understands the moral language of those around him, it means little to him. It does not speak to him personally, engage him affectively. And though, for instance, in many of their disappointments others are not strangers to him, he does not *share* these in the sense of being able to feel sympathy and commiserate with them—that is, if evil has taken hold of his soul. His relationships with others are, therefore, shallow and his contact with them limited. There is much in what concerns, pleases and distresses them to which he has no response.

Thus one who is alienated from morality is not cut off from human life altogether, as one who is alienated from logic or reason in certain forms of madness is cut off from all human thinking and reason. There is, nevertheless, this parallel between morality and logic: morality is internal to human life, as logic is to human thinking. Indeed, just as the principles of logic are an articulation

of what already belongs to our thinking and makes it what it is, so equally our moral values are an articulation of what belongs to our relationships and makes them what they are.

I would argue that the significance which our values enable us to attribute to the various things to which we respond in living our lives characterise those things for us in themselves. The words in terms of which we identify them belong to our moral vocabulary. Indeed, their moral significance for us is part of their identity; it is as such that they enter our affective life and become the object of our responses. Thus, through the significance which our values enable us to attribute to things, our morality enters into the very constitution of the world in which we live. It is in this world that we find ourselves: the very self which we succeed in coming to or fail to come to has a reality in our interactions in this world.

I spoke of the significance which things have for a person in the life and culture to which he belongs. For instance, he may think of the money he has been offered as a *bribe*, he takes the words directed to him as an *insult*. Again, he may think of the help offered to him as '*charity*' and find it *wounding* or *demeaning*. In what he accepts he may consider himself to have become *indebted* to another. In what he does a person engages with such matters that have significance for him. What he engages with, where he stands with regard to the significance things have in the culture to which he belongs, makes him the individual he is. His 'substance' as a person is to be found there. Otherwise, though he exists in the sense that his name is to be found in registers, has a passport, can be taken to court, and is liable to pay tax, he is nothing on a personal plane: in him others find nothing to engage with, nothing to come to know. A person is who he is in his engagements and he has something to engage with only if things matter to him in the significance he attributes to them.

We have seen that, by contrast, the scope of an ego-centric person's engagements is limited. But it is not only limited; there is something self-stultifying about making oneself the centre of one's concern. The more a person 'feeds his ego' the more does his life become impoverished and so the greater his craving to be somebody—somebody others take notice of and like or fear. For the ego and matters of significance and interest to one lie in opposite directions and it is only in one's engagements with the latter that one acquires 'substance' as a person. Otherwise in his attempts to

compensate for its lack he will become false. Socrates points out in the *Gorgias* that ego-hunger is insatiable; one who is trying to feed it is like someone who tries to fill a leaky vessel with a sieve.

A person who has made himself the centre of his concern may have many different objectives. He may seek prestige, engage in business, making becoming rich his objective, seek prominence in politics. But, in an extreme case, he lacks convictions—convictions that set limits for a person in how he seeks to attain his objectives. It is those convictions which give a person's life the kind of unity in which he appears as a person who is himself. I have in mind the kind of unity one takes for granted in a person when one trusts him. We speak of it as 'integrity'. If he departs from it in that he gives in to a temptation to cheat someone, for instance, this may be a lapse for which he may feel guilty and later try to make amends. But in such a lapse he departs from himself. If such 'lapses' become frequent he will lose his integrity, indeed they will no longer be lapses, and if he stops caring altogether he will have lost himself. There will no longer be anything from which he could lapse in what he does.

A person with a definite objective will no doubt behave predictably. He will subordinate his desires of the moment to what he desires in the long term—in Freud's terminology, he will be subject to 'the reality principle'. Both Plato (1955, 68B–69D) and Simone Weil (1948, p. 61; 1950, p. 331) have pointed out that this is not a form of self-mastery, but rather its opposite, namely a form of self-indulgence. The man who pursues ever greater power, for instance, the vindictive man who bides his time in the revenge he seeks, the robber who is working to realize a great bank robbery, all exhibit singleness of purpose. They do not, however, subordinate themselves to anything outside themselves. They come in contact with a reality they have to negotiate, as opposed to merely indulging in phantasy—Freud's 'pleasure principle'. But what they come in contact with has reality for them only relative to their purposes, as something which facilitates or obstructs their schemes. It is there to be manipulated, to be used. It is not seen as having any value in itself, for instance as something for which they may feel affection or as something that can inspire awe. Consequently what constitutes reality for such people has only an ephemeral existence—'out of sight, out of mind' as they say. The moment it stops serving their purpose or bothering them, it is forgotten. So they

can find no spiritual sustenance in the reality with which they come in contact; in their self-seeking activities they cannot come to themselves.

For such a person, given his purpose or objective, expediency is all that counts. He adjusts his actions to fit his circumstances, the contingencies of the situation which he cannot manipulate and alter. But there is nothing he *must* or *cannot* do irrespective of circumstances. It is in that sense that while his actions are not random, or subject to the moment, they lack consistency—the consistency we find in the person who believes in something. That is why others can find nothing in him to enable them to trust him: he is not dependable. His word cannot count for anything when what he will do in the future, given his objectives, depends on the circumstances of *that* time. My point is that he has *nothing* with which to be in or behind his word.

One may even say that he does not have anything to call 'his' in a strong sense of that term. For he sees no meaning in anything except one which has his own desires as its source. It is what he wants that determines what he is, rather than the other way around. He may, for instance, rise up to an insult directed at his parents; not however because the people insulted are his *parents* but because they are *his* parents. It is not the significance of parenthood that enters into the offence he takes at the insult, but the relation to *him* of those insulted. For that reason, paradoxically, they are 'his' parents only in a weak sense. Indeed, this applies to his past, to his country, to those he calls his friends, to his belongings, and to what he regards as his achievements. He sees them as extensions of himself. The same achievements in others are a source of envy. He seeks them for the boost they give his ego. That is why he can find no growth and no fulfilment in them. Similarly, his belongings, which may include rare works of art if he is rich, have value for him only because they are a source of prestige and the envy of others. Consequently what he finds in them, namely their market value, is illusory. In themselves they have no value or significance for him.

His relation to them is self-centred, solipsistic. Nothing new or independent comes into his life from any of them. They are all the same thing to him: so many possessions, accoutrements, sources of power or prestige. He is thus caught up in a vicious circle and can find nothing in life in relation to which he can be real in himself—

interests to which he can give himself, affections and loyalties
which engage his responsibility. It is a person's moral convictions,
concerns, and interests in which he gives himself to something
outside of himself that accord his life the kind of unity we find in
someone we can trust and depend on, one capable of responsible
action. This is absent in an ego-centric person.

In short, then, we see that our morality enters into the consti-
tution of the world in which we live. The significance we find in
every part of that world, the human world, has its source in our
culture and morality. We find ourselves in such a world and,
indeed, the kind of self human beings have has reality in such a
world: it is in the kind of life to which our morality belongs that we
find ourselves. Let me hasten to add that so far, when I have spo-
ken of morality, I have meant 'morality of one kind or another'
and I have contrasted it with the kind of ego-centricity in which a
person is impervious to or estranged from any moral concern.

I now turn to the attempt, to be found in Money-Kyrle and
especially in Fromm, to find an objective basis for one kind of
morality, 'humanistic ethics', in human nature or in our humanity.

6.4 IDEA OF AN AUTHENTIC MORALITY WITH AN OBJECTIVE BASIS IN OUR HUMANITY

Early in his book Erich Fromm writes: 'Our knowledge of human
nature does not lead to ethical relativism, but on the contrary to
the conviction that the sources of norms for ethical conduct are to
be found in man's nature itself'. He means in 'our common
humanity'. Again he writes: 'I shall attempt to show that the char-
acter structure of the mature and integrated personality . . . con-
stitutes the source and the basis of "virtue", and that "vice", in the
last analysis, is indifference to one's own self and self-mutilation'
(*Man for Himself*, p. 7).

Reading 'soul' for 'self' in this last statement people may hear
echoes of Socrates's claim that the soul finds unity and flourishes
in goodness, disintegrates and perishes in evil. But in reality
Socrates differs from Fromm both philosophically and ethically.
Unlike Fromm, Socrates is not in search of an objective basis for
his morality in human nature. That is rather Callicles's concern.

Secondly, what Socrates regards as benefitting the soul has little to do with self-realization. Indeed, he contrasts the self with the soul. The soul is a moral concept: it is what is seen to have reality in the individual's relation to values implicit in Socrates's talk of good and evil. As Socrates puts it in the *Crito*, it is that part of us which is hurt and harmed by wrong actions and benefited by right ones (47c). What benefits and harms the soul cannot, therefore, be determined independently of the values in question. Thus when in the *Gorgias* Socrates and Callicles discuss whether an enhancement of life is to be found in self-assertion (a particular conception of self-realization) or in self-renunciation, Callicles compares those who have renounced the self to 'stones and corpses'. In response Socrates quotes Euripides to him: 'Who knows if life be death or death be life?' (Plato 1973, 493). In other words, what one man calls 'life'—for example the life of the self—may be no better than death to another man: it is what it is only from the perspective of the values of the speaker.

This is equally true of the notion of 'our common humanity'. It is sometimes said that people who are impervious to any moral concern are alienated from their humanity. What is meant, I think, is that whether such a person is evil or not, he will be necessarily alienated from something characteristically *human* in human beings. What is in question is the capacity for compassion, forgiveness, and remorse. This capacity is characteristically human in the double sense I indicated earlier: it belongs to us as human beings—it is not something we find in animals—and secondly it places a special significance and value on human beings regardless of who they are and what they are like. Our humanity in this sense, therefore, has a moral character: it has reality only from a particular moral perspective, and it comes to itself in our moral engagements and is lost with a person's alienation from moral concern. At an extreme a person whose life is steeped in evil, especially one who has become blind to it in his soul, is colloquially described as a 'monster'; his acts are often characterized as 'brutal'.

These terms are, of course, value terms, as is the term 'inhuman'. It is used of a person who lacks mercy and remorse. Such a person is said not to recognise the humanity of others in his treatment of them: he finds nothing in them to stay his hand. What he does not recognise is the special significance most people see in others as human beings, which places a limit to their actions and

reactions towards others. This significance is internal to the object
of compassion and mercy; its recognition is inseparable from these
affective reactions. It has reality for the person who has made such
reactions his own, that is, made them part of who he is. It belongs
to his notion of a human being.

This capacity to recognise the humanity of others, which is said
to belong to our humanity, it rooted in love in the broad sense in
which compassion is a form of love. Simone Weil describes it as
'impersonal love'. It is not directed to the other person by virtue
of what distinguishes him from others or of any special relation in
which one stands to him as opposed to others (1959, p. 158). It
makes no distinction between one human being and another. It is
the capacity for such love that is said to be part of our humanity.
Most people have it in them, though often buried in a mixture of
rubble.

But we have equally in us as human beings what makes us
ignore others in certain circumstances—for example, to hate
them when they stand in our way, to hurt and harm them and push
them out of our way. These responses do not recognise the
humanity of others in the sense that the former ones do. A person
who is taken over by them becomes the centre of his universe and
comes to see others as only there to promote or obstruct the satis-
faction of what he wants for himself. He will have no scruples
about using them and then discarding them when they are of no
further use to him. We speak of such a person as evil; we say that
his soul is at one with evil.

These then are two poles of the human soul. But we describe
what emanates from only one of these as belonging to our
'humanity'. When we do so we are speaking from the perspective
of the very morality we claim belongs to our humanity. There is
nothing wrong in speaking like this so long as we are clear that the
humanity we speak of here is a moral notion. It cannot, therefore,
give the morality in favour of which one is speaking an objective
basis or special status.

I doubt that authenticity and maturity can do this for it either.
For now I will only point out that the sense of these terms is bound
up with what is meant by 'individual development' in connection
with human beings, and here there is no neutral measure of what
counts as development, arrest of development, or decline. Thus
judgements regarding the maturity that a person shows in his

judgements and emotions are to be contrasted with assessments of the maturity of a tree, for instance, or a horse. When in the latter case we count the rings in the cross section of the tree's trunk or look at the horse's teeth we have an objective measure . As for the authenticity of a person, his being himself in what he does and what he feels, this cannot be understood as coinciding with something preformed or objectively given, as in the case of the authenticity of a document or painting. I will say more about this in the following section.

I don't think that the attempt to base a morality which places regard for human beings at the centre of its concern on human needs can assure a special status for it either. That is not what Simone Weil does in the first part of her book *L'Enracinement*. For the needs she speaks of there are 'needs of the soul', as she states explicitly, and I have already pointed out that there is no morally neutral measure of what the soul needs in order to have life. This is equally true of 'human needs'. Suppose someone argues as follows:

> Human beings do generally form personal relationships and they develop into persons in the context of such relationships—relationships which demand trust and honesty and make claims on their loyalty. Without such relationships a person is nothing, or at best a cog in a wheel, a member of an ant heap. Those who lose such relationships feel lost and alone. Such relationships are, therefore, hardly something to which they can be indifferent. It is not surprising therefore if human beings attach a special significance to them and attach importance to the fellow feelings they develop for others. The values of fellowship and community are thus rooted in our needs; they are based on what is necessary to us as human beings.

The trouble with this kind of reasoning is that while it may be true that we find notions of fellowship and community wherever human beings live together, what these mean to them depends on how they live together. They may, for instance, draw the line of fellowship in different places. This will inevitably make a difference to what fellowship amounts to and so to how 'the other' is conceived as an object of moral attitudes: is he, for instance, considered as 'my neighbour or brother' (without any suggestion of nepotism) or as a member of 'my tribe'? What the moral attitude is cannot be separated from how its object is conceived. Consequently, even though we shall find conceptions of honesty,

loyalty and trust everywhere human beings live together, there is no guarantee that they will always amount to the same thing. Clannish loyalty, for instance, is not the same thing as the loyalty of friends or comrades. The same applies to loyalty within the institution of marriage, for marriage itself may not be the same thing in different cultures.

The same goes for loneliness and isolation which human relationships exclude. Someone who belongs to a clan or gang will not be alone or feel isolated as many people who live in big cities on their own do. He will no doubt find some sustenance in the opportunity for identification with which clan-membership provides him. But it will not be the same as the sustenance to be found in a friendship or marriage. We cannot assume that the isolation eschewed in the two cases is the same.

Someone may say, 'No man is an island, he needs others', to explain the special significance he claims that personal relationships have for everyone. But that would be saying very little. What is it that he claims human beings need in others and what are others to them in what they need? There is no ground for assuming that this is always one and the same thing.

Freud had rejected morality because he could find no basis for it in human nature. Fromm and Money-Kyrle share Freud's presupposition that unless such a basis can be found morality would be something external and artificial, arbitrary, and deceptive. Not sharing Freud's negative conclusions, they argue that such a basis can be found for the values of psycho-analysis: 'humanistic ethics'. I have argued that this is a mistake: neither our humanity, nor the needs of human beings, nor the interests or potentialities of the self can constitute such a basis since they are themselves defined in terms of the morality for which they are supposed to provide such a basis.

Our humanity is not the source of the values of humanistic ethics, purged from the importance it attaches to self-realization. On the contrary, it is such an ethics or morality that is the source of our humanity. However, this does not mean that such a morality is, therefore, a 'mere product' of our culture and as such something artificial. It is no more artificial than our language. Besides, as I have pointed out, such a morality, as indeed any other, does grow out of something untaught in human beings. In any case it makes no sense to speak of the authenticity of a morality *as such*,

in abstraction from the individual who adheres to it. The authenticity of a morality is a matter of each individual's relation to it, not a matter of its relation to something independent. It is the individual's morality that is authentic or genuine, or not, as the case may be; it is only in their relation to one another that each is authentic or false. And it is only in the latter case that a morality can be said to deceive the individual in himself. When a person's morality is authentic, however, when his moral convictions are genuine, there is nothing arbitrary about his allegiance to it. For then his allegiance is neither a form of conformity nor a reaction-formation against tendencies in himself arbitrarily prohibited—as Freud thought it must always be. Rather it comes from what he sees *in* the values of the morality in question and what they mean to him.

6.5 MORALITY OF LOVE AND THE AUTHENTICITY AND MATURITY OF THE SELF

Melanie Klein, as we have seen, draws attention to two conflicting currents in human life which originally spring from the two poles of the human soul, one centring on love and the other on ego-centric emotions such as hate, greed, and envy. It is from her account of the resolution of their conflict that some of her followers have arrived at the notion of an 'inherent' or 'innate' morality, one that is smothered by an 'implanted' morality. When a child's natural moral reactions are thus smothered the opportunity for the polar conflict within him being resolved is missed. But it remains active and the 'implanted morality' assumes a defensive role in the person's life and personality. The morality itself takes on the character of a reaction-formation and becomes infected with the ego-centricity against which it reacts—as can be seen in the example of Mrs Soleness's 'sense of duty' in Ibsen's play, *The Master Builder*. As a result development towards authenticity and autonomy is arrested.

The idea is that, in such a case, for the development to be resumed the implanted morality needs to be jettisoned and the original conflict to be reopened, faced, and resolved. It will be resolved, however, only when what belongs to the non-ego-centric pole of the soul can be allowed expression and growth. In the

ensuing change the individual will return to the morality inherent in him from his early days and this morality itself will develop into the morality of a mature person. Thus the mature individual is at the same time someone whose morality is 'humanistic': maturity, autonomy, being oneself, and moral goodness in the humanistic sense coincide. We find this idea in both Money-Kyrle (1955) and Erich Fromm (1950). I now want to ask what truth it contains.

There are questions as to whether authenticity, in itself, can be a virtue, and some people have said that authenticity is compatible with evil. It certainly seems to me that unless a person is authentic he cannot be good. Thus it has been pointed out by Plato and by Simone Weil that goodness cannot be copied. In other words, unless a person's moral beliefs are his own and he is behind his moral actions he cannot be good. The goodness must come from him and be his, it must not be something to which he conforms or which he adopts for some reason or other, not even in order to be good. In contrast, evil can be copied: when a person falls into bad ways by imitation his soul participates in the evil involved.

But if it is true that a person cannot be good unless he is himself, it is not true that being himself or authentic is enough to make him good. For he may be a morally mediocre person, his goodness may be shallow: that may be as much as he is capable of. Can he be evil? Why should not an evil person be himself? In my book on the *Gorgias* I examined this question in terms of the example of Archelaus, the Macedonian tyrant, referred to by Polus in the dialogue. I argued that Archelaus was evil but that he was behind his evil deeds, and that Socrates was not denying this when he claimed that no one ever wills evil. Archelaus had no reservation whatsoever about his evil deeds; it was that which made him a thoroughly evil person. I do not wish to go back on this, but I wonder whether there may not be something in Fromm's and Money-Kyrle's claim that authenticity and evil are incompatible.

By 'goodness', I said, I mean respect and concern for others, irrespective of who they are, and by 'evil' putting oneself first and indifference to others as human beings. To be accessible to such goodness is to have a certain orientation towards other people— one of concern and respect. Such an orientation may be seen to give coherence to a person and bring unity to his life. It also makes for a greater recognition of the existence of other people in their

own right. I want to develop this by way of answering the question regarding the compatibility of evil and authenticity.

Someone may challenge what I have just said: why should our accessibility to others in our responses to them depend on our accessibility to goodness? Surely, an evil person makes contact with others in the fear and horror he inspires in them. His actions surely touch something real in them and, in that sense, 'find' them—that is, reach them as their target and touch them affectively. Furthermore, is it not also true that an evil person may have allies, and does he not make contact with them in the conspiratorial relationships into which he enters with them?

To begin with his relation to his victim. A hostile interest is not an interest in the other person in his own right. It is an interest in him as someone who is an obstacle or a threat, or as someone who possesses something the evil person wants for himself—something, perhaps, in the absence of which he feels demeaned. He may for instance work to ruin the other's reputation. In that case he is interested in redressing what he takes as an unfavourable balance; he is not interested in the other person. He meets the other person, therefore, at best in his (the other person's) defence of himself and rejection of him. Enemies who are divided by conflicting loyalties will make contact with each other in their combat *if* each can recognise this fact and respect the other for it (see Dilman 1984). But only someone capable of such loyalty can recognise it in the other. This rules the evil person out. As for the fear, horror, or repugnance he inspires in the other, the evil person is incapable of recognising what these responses have as their object: he does not know how the other person thinks of him and of his power and cunning in the feelings these inspire in him. If he did, that would stop him in his tracks; if he could understand why he inspires such feelings he could not go on in the way he does. At the very least it would make him more merciful, or rather less merciless. As Simone Weil puts it: 'evil necessarily flees the light' (1948, p. 77).

Turning now to his conspiratorial relationships with his allies, in them he no more meets the other than he meets those in whom he inspires fear, horror and repugnance. He manipulates them, and those who 'admire' him for his power, prowess, cleverness, and audacity, and join hands with him in their support, do not know him. If they did, they would fall away from him. They do not see that he is only interested in them insofar as they can serve

his interests and that he shares nothing with them. He does not really give them anything since what they think they receive from him has always some strings attached to it. He is never himself in what he 'gives' them, as one is when one says 'thank you' or 'sorry' and one means it. Indeed he does not know what friendship or loyalty is.

He may 'respect' someone more powerful or cunning than himself, as those who support him or do his dirty work 'respect' him. To 'respect' power is to fear it in others and want it for oneself: power makes for a cringing attitude towards those who possess it and inspires envy. This is to be contrasted with admiration. We want the good of those we admire, we want to see them prosper. We would be sorry to see them lose what we admire in them. In the envy we feel, however, we are indifferent to this: we want to take it from them and come to hate them if we fail. This is hardly what one would call 'respect'.

The evil man can take things from others, but he can receive nothing from them. Not even when some compassionate soul gives him attention. For unless such attention touches something in him and awakens a reciprocal response, he simply consumes it: it gives him a feeling of power or he resents it. Goodness makes demands on one who comes in contact with it. The evil person who is inaccessible to those demands, is incapable of putting himself out for others. He cannot, therefore, receive the other's attention with gratitude, he cannot come in contact with the goodness of which it is an expression. Gratitude is an acknowledgement of the good one is given and that acknowledgement involves a readiness to do the same for the other. Indeed, it is itself a form of giving. Resentment, on the other hand, does not recognise the good one has been given or done; it sees the giving of it as an interference. It rejects it and is an attitude of hate.

Insofar as the evil person knows no loyalty or trust, whatever he may feel, he has a lonely existence. For the world of evil, notwithstanding the dazzle and flamboyance it may have in the eyes of those whose relation to goodness is tenuous, is a solipsistic world: it revolves around the self. His relationships are characterized by collusiveness, suspicion, cunning, and pragmatism, and in these he is divided from others. In the gratification his actions bring him he breathes the air of his 'inner world'—I mean the world of his self-centred phantasies.

I now turn to my other claim, namely that gaining greater accessibility to goodness involves achieving greater coherence of self. I have spoken of the man who thrives in what he takes from others, though he is capable of neither giving nor receiving anything from others. I would suggest that a person comes to himself in giving. It is in giving that he finds growth and sustenance; though this is not something that he aims at or thinks about. If it were, he would not really be giving anything. To accede to the demands goodness makes on one is to want to give; but this is not a desire that one simply happens to have. One has to reach out for it, renounce a self-centred orientation, and this is not something automatic, just as personal growth is not something automatic. The inner, emotional work that makes it possible is what opens one up to the 'outer world', that is, a world that exists in its own right. Even when a person is *naturally* outgoing, is friendly, and shows an interest in others from his early days, this orientation will come to be tested by situations which try his patience, toleration, consideration, and judgement. What he learns through such experiences of challenge, provocation, temptation and confusion will constitute a consolidation and development of his natural dispositions in which, thus, he will find himself. However good a person may be in his natural dispositions he could not have come into the world already mature. For maturity takes experience and time to work through that experience and to digest it.

Evil, by contrast, is something one gives in or yields to, even where one learns it by imitation. Indeed, 'learning' means something quite different in the case of evil from what it means in the case of goodness. In the case of goodness one turns outwards, towards others; evil, on the other hand, obliterates all affective awareness of an independent world—a world that is not there to be plundered, one which is valued for what it is without reference to oneself, one which contains what one may feel affection, sympathy, and even awe for. In learning or acquiring goodness something new comes into one's life, whereas in learning or becoming evil what one learns is always within one and evil grows out of it. It has its source in one's bad feelings for others, in the pride and vanity that gives one an inflated opinion of oneself which veils others from one. Or, again, it has its source in one's low opinion of oneself which makes one seek compensation for it. It may make one project that opinion on others to get rid of it, tread on them, and

in the sense of power one finds in doing so counteract the low opinion one has of oneself.

But why do I want to say that the vain man is not himself in his vanity? If I say that he is full of self-importance and as such self-deceived this, of course, involves a moral judgement: the person who is full of his own importance does not consider others to be important in themselves. He may have a condescending attitude towards them, belittle their qualities and achievements. This question of the importance of others is a moral question. Still, whatever he may think of it himself, one with such a condescending attitude cuts himself off from others. To some extent at any rate, he lives in a phantasy-world, thinking that what makes him important in his own eyes matters to others.

Why, one should next like to ask, should what thus cuts him off from others separate him from himself? Certainly, he need not be false in the way that a poseur, someone who makes himself out to be something he is not, and who believes it, is false. All the same he is stuck in his vanity, he keeps turning in the same place, one in which he keeps breathing the same stale air. In that sense his vanity keeps him from growing, from reaching his height. But is not his height that of his vanity? If his vanity is a type of orientation that keeps him from growing, the height it gives him cannot be his height. My point is that the vanity in which he is stuck is an obstacle to further personal growth. It thus prevents him from reaching the height which otherwise is within his reach.

Let me now turn from the vain person to the man who loves power and exercises it ruthlessly, that is without any concern for what he does to others, without any concern for justice. This ruthlessness has its source in his love of power, for the more a person loves power the less he comes to care for what comes under its sovereignty. This brings us once more to the example of Archelaus. Our question is: If such a person lives the life he wants to live, is behind the deeds through which he lives it, if he is indifferent to its consequences for others and so has no inner reservations about the way he exercises his power, must we not admit, not only with Polus that he is happy, but also with Callicles that he is *himself*— even if *we* see the self he has as evil? I had said in my book on the *Gorgias* that when Socrates speaks of him as unhappy this is an expression of the pity he feels for Archelaus on account of the evil in his soul. I will not go into this again; it does not concern us here.

I want to consider the question whether Archelaus, in the evil in which his soul is steeped, is alienated from himself.

The answer to this question is not a simple one. If all we are asking is whether or not Archelaus is *behind* his actions, then, in that sense, Archelaus is at one with himself, with the evil person he is. But to say of someone that 'he is himself' means that 'he has found himself' and that implies that he has achieved a certain *unity* in his life, one in which he is himself. The kind of self that a person has, therefore, is relevant to whether he is himself in it. When I speak of 'the kind of self he has' I have in mind the affective orientation of his character, the poles towards which he gravitates in the relationships he forms with others, his capacity to give, to make commitments, to take on responsibilities.

I would suggest that the self-centred character of someone like Archelaus is something which he has come to be stuck on and failed to outgrow. This may sound paradoxical in view of the fact that he may never have wanted to so do. But the self that a person finds in finding himself is a self to which he grows, himself participating in that growth—not one in which he is stuck, one in which to stay is a form of self-indulgence and, in that sense, of passivity. Archelaus may be active in his aggressive pursuit of power; but in that pursuit he indulges in his love of power. It is in that indulgence that he is the person he is. Whereas, by contrast, it is in acquiring mastery over oneself that a person comes to himself—for instance in the exercise of his generosity. And generosity is not something one indulges in, for generosity is the thoughtful and responsible exercise of ministering to the needs of others. It is in the convictions which find expression in that exercise that a person acquires a self that is *his* in the strong sense—or, to put it differently, that he comes to a self that he *is*, a self that he *owns*. The contrast here is between 'being or finding oneself' and 'merely becoming the person others find one to be'.

In short, then, in giving in to the temptation of evil a man loses himself: the unity of a life of conviction and commitment, the give and take of human relationships and the contact with a dimension of reality or 'the human world' which that makes possible. He loses contact with the reality of others in their own right and of what belongs to their lives: their cares and joys, their struggles, successes and failures. The ego-centricity of evil, of meanness, envy, and cruelty, for instance, thus affectively alienates a person from all this.

I have argued that there is a radical difference between the psychology or the kind of self of the good person and that of the evil person and I have tried to relate this difference to the asymmetry between good and evil. I differ from Fromm and Money-Kyrle in that they think of a person's psychology and his morality as distinct from each other though, as psychologists, they observe them to overlap. I have argued that they are the two sides of the same coin: while the psychology in question cannot be articulated in morally neutral terms, the goodness or evil of the person cannot be separated from his psychology. Goodness and evil transform the soul, but in opposite directions. It is in the light of the good that one of these directions is seen as 'upwards' and the other as 'downwards' or 'downhill'. To move in the one direction takes work and discipline, the other is a form of indulgence. I do not mean 'upwards', however, in Kant's sense that one can only be good by acting out of a sense of duty and without wanting to do what one does. Simone Weil points out, quite rightly, that the truth lies in the opposite direction: one must want to do it, but out of love, for example compassion, and not because what one does is good or because it is one's duty to do it (1948, p. 52). Indeed, I suspect that Ernest Jones was thinking in terms of something like Kant's conception of morality when he contrasted 'a moral attitude' with 'an attitude of love' (1937). Still, to be fair to Kant, when he spoke of 'inclination' he had in mind something like Plato's notion of 'self-indulgence'.

So much for goodness and authenticity. I now turn to maturity. It is clear that the notion of maturity is bound up with the notions of growth and development as these apply to human beings: a person becomes more mature, or gains in maturity, as he grows and develops. I don't, of course, mean simply in years, although certainly time is an important factor: what the person reaches through time in his development is not something with which he can be born or something he can be granted by the wave of a magic wand, in one instant, as he could be granted greater physical height, for instance, all of a sudden. I think Rai Gaita makes this point in his book concerning wisdom (1991, pp. 270–71); and wisdom certainly is part of maturity.

If we speak of growth and development we have, of course, to ask: growth in what? Development towards what or in what direction? Where we speak of the growth or development of individual

human beings we have in mind, I think, their development towards individuality—and that means away from emotional dependence, away from being merely part of a group or organization, allowing oneself to be taken care of in return for doing and thinking as one is directed. An individual, of course, is not an island, nor does he have to be an individualist, and there isn't one set of values which an individual must have. He is an individual in his relation to the values in which he believes. These are values he finds in his culture, in the relationships he makes in the course of his life. Part of what we mean by an individual is that he is himself, not false, not stuck or glued to what he is, and therefore open to the 'outside world', able both to learn and in what he learns to change, and equally able to criticise, oppose and reject. He is, therefore, able to think for himself and accept responsibility for his actions, to undertake commitments and sustain what he undertakes to do, to stand by what he believes and to have the courage of his convictions—whatever they may be. If he is 'open', that is not on the defensive and not in need to put on appearances, and is therefore in touch with people, movements and events around him, that means that he is not ego-centric in his affective orientation, in his feelings, that he has lively interests. If, in addition, he has sufficient intelligence, he will be capable of discrimination and judgement, since he will have learned from his experience of life. It also means that he is sufficiently free from 'inner pressures' not to have to rush into action, to be able to pause and reflect when necessary, to be able to withstand outside pressure, to be able to be patient, and to tolerate uncertainty. It means equally that when he judges something must be done he has the courage to roll up his sleeves and to carry through what he thinks he has to do.

Not surprisingly this is a *moral* characterization of what it means 'to be an individual'. When we speak of a person having to become an individual we are inevitably referring to his *moral* development. This is his growth to *maturity*, and here too the moral and the psychological are at one, they are the two sides of the same coin. For instance, how can a person who is subject to impulsive behaviour be called mature? Such a person is not in touch with himself in the different things he wants or feels like doing on the spur of the moment and rushes into. We could say that it is the moment, not himself, which determines what he will do and how he will act. He has not 'integrated' his desires into who he is, they

do not belong to a 'coherent self': they are not *his* (as I would put it) in the strong sense. Nor is he in touch with the situations to which he responds; they simply ring bells in him which trigger his responses. But just for that reason he is not a person one can trust, rely on, or expect any loyalty from. His lack of a coherent self and his lack of serious conviction are once more the two sides of the same coin.

The same, I argued, is true of a very different person, the man who loves and has power and pursues its objectives to aggrandise himself. He, in contrast with the impulsive person I have just mentioned, is capable of pragmatic reflection and the sustained pursuit of objectives—to act in accordance with Freud's 'reality principle'. But part of his attraction to power comes from the ease that belongs to it: if you have it you do not need to plough and wait for its harvest, you can just blast. This very ease which removes the need for work, consideration of needs that are not one's own, patience and self-control, is precisely what characterizes an immature mentality—what some psycho-analytic writers have called 'phantasy thinking'. Such a person has not come to know what he wants in the course of coming to himself. Indeed he has not come to himself. It is not who he is in his convictions, loyalties, affections and attachments that gives him what he wants, shapes his desires, but rather his desires that constitute what he is. His power enables him to short-cut 'reality', it is a kind of magic that enables him to make his phantasies come true. Instead of modifying them in the light of reality, he imposes them on reality. That is why he never grows up; he has no need to grow up.

In my book *Freud and Human Nature* I said: 'From the claim that without maturity there cannot be goodness, it certainly does not follow that immaturity is a form of evil' (p. 197). On the other hand, I also said that evil, whether by imitation or inclination, comes from an immature part of a person. I took the example of what a person may do out of resentment: 'if a person resents something that has been done to him [or which he imagines has been done to him] and retaliates in kind, then he does descend to an immature level of action. For resentment is our response to an action which . . . makes us feel impotent' (p. 198). I added that 'there is no person, however mature, who is immune from the propensity to such regression'. Such vulnerability is part of our

humanity and in this vulnerability a person who has achieved a degree of self-mastery keeps in touch with his humanity. Professor John Wisdom once expressed this point in the form of a paradox: 'No man is good—not even St Francis.' He commented that 'a man who says this may be so using the words "good" and "human" that a creature with evil desires is not good even if he overcomes them, while one without such desires isn't human. Then this paradox couldn't be false' (1952, p. 257). He then explained that this does not mean that one who speaks these words in this way is not saying anything. He is.

Full maturity is a myth in which we purify the notion of maturity to a point where , again in Wisdom's words, 'sweet perfection wears a foolish smile' (op. cit. p. 258). For a person who is not vulnerable to temptation and to regression is a person petrified: he is no longer open to life and alive in spontaneity. His 'goodness' has turned into a 'plagiarism of his own past goodness'; it is a copy and therefore no longer goodness.

I had argued previously that evil, in its different forms, is ego-centric—though *not* that ego-centricity is the same thing as evil. I have now suggested that it comes from an immature part of the self and reflects an immature personality. This is as far as I can agree with Fromm's and Money-Kyrle's claim that as a person becomes more mature he moves nearer and nearer to goodness as conceived in 'humanistic ethics' because the psychology of the mature person allows him to become what he is in his nature as a human being. I have criticized and rejected the metaphysical presuppositions behind such a claim.

6.6 OUR HUMANITY WITHIN DIVERSE CULTURES

I have criticized the view put forward by Erich Fromm and independently by Money-Kyrle that what they call 'humanistic ethics' is the only authentic morality for human beings, the only kind of morality in which human beings can be authentic. I have rejected the anti-relativism which these two writers embrace explicitly in this view. Yet it seems to me that this 'humanistic ethics', provided we can purge it of its individualism, has something in it of the kind of spiritual morality of love which finds expression in the great reli-

gions of the world belonging to very different cultures and origi-
nating in different periods of history. The particular conception of
good and evil which I spoke about belongs to such a morality.

It is certainly not the only morality which has developed
among human beings and one cannot claim any special privileged
position for it except on *moral* grounds—and that means on
grounds that one adheres to from within one's own morality, pre-
sumably the same as the one for which one is claiming such a posi-
tion. But it is striking that one finds it in such diverse and even
surprising places, and that it is capable of finding an echo in the
hearts of individuals separated by a diversity of cultures, individu-
als even who have not been in contact with those cultures and reli-
gions in which it is found. It seems to me that this must have
something to do with the 'humanity' in us, human beings, in
which the psycho-analytic writers I have mentioned claim to have
discerned an 'innate' morality.

As I argued, what is innate are certain primitive propensities in
us with which many people retain contact in their diverse morali-
ties and sometimes despite these. This gives the morality in ques-
tion a certain *universality* which should not be confused with
'objectivity'—the kind which would free it from relativity. For
although it cuts across cultural boundaries it is not the only moral-
ity we find amongst men, and its only privileged position is the one
we can attribute to it from within the perspective of its values.

7 Good and Evil: Love and Ego-centricity[1]

7.1 HUMAN NATURE WITHIN A MULTIPLICITY OF MORALITIES

It's a truism, at least in anthropology, that within the different cultures and ways of living which men share they have developed moralities that differ from one another in many ways. Various conditions, physical and other, obviously shape men's lives. Lives so shaped are the soil in which different values are thrown up and grow, and these in turn contribute to the shaping of men's lives. The relationship in question is a two-way one. These conditions and the way men respond and adapt to them may be spoken of as the roots of the different moralities to be found among men.

Thus in the way men adapt to them these conditions shape people's lives, and it is in the course of this adaptation that men develop values which measure their lives and ideals which inspire them in the way they live these lives. These in turn further contribute to the shaping of the form of life in which they partake. The conditions and the values are thus related in a seamless way, the values and ideals themselves contributing to the conditions to which men adapt. While men appropriate these values and adapt to the conditions seen from the perspective of these values, the resources in them which they put into this work are themselves made possible by the values they develop in the course of their adaptation to these conditions. In the life of the individual it is

[1] The objections considered in the second half of this chapter come from a paper by Professor D.Z. Phillips, 'Ethics and Humanistic Ethics—a Reply to Dilman' (Alanen, Heinämaa, and Wallgren 1997, pp. 153–176).

difficult, if not impossible, to speak of the beginning of this two-way contribution. The individual is born into a life in which he is shaped by increasing degrees of active participation on his part. Through such participation, in turn, he contributes to the life he shares with others, shapes his own life, and himself changes in the process. What life he is born into and grows up in is of course, in a sense, an accident, though what he makes of himself in that life is not.

Now within this multiplicity of conditions in which the lot of an individual is an accident, there are certain constants or universals which constitute what has been called *human nature*. For instance, the individual, or at any rate most individuals, show a will to survive in the way they respond and adapt to the conditions which make up their lot—such as harsh physical conditions, for instance, scarcity of food, inhospitable surroundings, hostile neighbours. They have to take things for themselves, fight to keep them, confront hostility. Those who are squeamish or timorous go under: they either do not survive or fall under the dominance of others and survive in subjection to them. Others who would rather die than accept such a state fight to the bitter end.

Such aggressive energy used in surviving with at least a modicum of self-respect, with as much ingenuity, skill, and knowledge as the culture in which it is exercised permits, is part of the will to survive in inhospitable conditions. It is in most of us, to some degree, and is put into motion when the need arises to struggle for our very existence. Some will say it is part of 'the struggle for existence' which Darwin highlighted in the animal kingdom. Obviously, in hospitable environments and in what one may call 'civilized social orders' the need for such a struggle is reduced. Indeed, it may go to sleep, so to speak, and only wake up—if not atrophied—when circumstances call for it. There, in normal circumstances, active aggressiveness is reduced and its energy is diverted into other uses. It is enlisted in the development of ways of increasing the kind of prosperity which will benefit others than oneself and of enriching their lives—for instance, in artistic and scientific creativity.

It thus joins forces, as it were, is put in the service of a capacity which we equally have in us as human beings and which can develop in propitious circumstances. I have in mind our capacity

to love, feel, and care for, give ourselves to, and wish to serve our family, our neighbours, and even strangers whose industry or dedication to what they are engrossed in touches us, or whose misfortunes call on our compassion. The way men put themselves out for and go to the help of those to whom they are tied with 'bonds of identification', that is in whom they see themselves or consider as part of themselves, can change and grow into something quite different. It can grow into a love and care for those they regard as their 'fellows' and as such think of as both sharing a common fate and vulnerabilities and yet also as 'other than' or 'separate from' themselves.

The will to survive by sticking up for oneself and for one's allies which becomes active in certain circumstances, and the capacity for fellow feeling which involves the willingness to put oneself out for others, are *both* to be found in human beings in different cultures. They cut across differences of culture. It is for this reason that they are generally regarded as part of *human nature*; some would say part of our animal inheritance, transformed and *humanised*.

Obviously animals are not capable of the kind of concern and compassion that we find in human beings. Animal life cannot provide the kind and range of significances in which an individual feels threatened and has to stick up for himself. Indeed, 'sticking up for oneself' means something very different in the case of human beings, since the self for which the individual sticks up is something that develops in response to the wide range of significances that come from the language and culture which characterize human life. Thus in most cases a man has something to stick or stand up for when he stands up for himself, something that makes his life worth defending or preserving for. This is very different from the struggle for existence which Darwin found in the animal kingdom.

The will to survive when one's life is threatened, to stick up for oneself in circumstances which threaten or frustrate one in the pursuit of one's goals or interfere with one's commitments, and the willingness to put oneself out for others can thus co-exist and need not come into conflict. The energy which belongs to the one can serve the other. That is, the energy which the individual economizes when he doesn't have to fight for himself can be used in responding to and working for others. A person can fight with as

much aggressiveness in defending the rights of another human being or fellow creature as he may do when someone is trying to take his food from him. Yet in his aggressiveness he may be genuinely selfless. Certainly, sticking up for oneself in the face of what one considers an injustice does not have to be putting oneself before others.

Where, however, the one is dominant there is the risk of its changing character if the surroundings provided by the rest of the person's personality is such as to encourage or facilitate such a change. Thus the will to survive under adverse circumstances can turn into selfishness. When it is not balanced with what makes for concern and consideration for others it can act as a magnet for the person's ego-centric impulses and emotions. Given the right psychological conditions, it can turn the person into someone ego-centric.

There is bound to be a period in every person's early life in which he is ego-centric simply because he has not yet learned, in his affective life, the separateness from him of those people who come within the narrow ambit of his emotions. He thinks of them as satellites that circle around him. To grow out of this early ego-centricity, he has to learn that they have a life of their own. The love and affection which he is capable of developing in circumstances conducive to such development has an important role to play in the emotional learning which enables him to grow out of his ego-centricity.

Few people, if any, however, succeed in completely outgrowing their early primitive ego-centricity. What remains of it is then bound to contaminate what I called the will to survive, stand up for oneself, and be counted. In its ego-centric character the will to stand up for oneself is, of course, bound to conflict with a person's willingness to put himself out for others and to give of himself to them. In the way such a person resolves this conflict in particular cases he may either further outgrow the remnants of his early ego-centricity or allow his attachments and interests themselves to be contaminated by it.

It is thus not the will to stand up for oneself that belongs to a normal sense of self that is the problem for a person who has at heart the values of a morality of love. The problem comes from the ego-centricity which threatens to contaminate his best efforts.

7.2 Ego-centricity and Moral Alienation

By ego-centricity I mean an absorption in oneself which makes one, affectively, the centre of one's world, the world which acquires a living reality in the life one lives. Everything that exists independently of one, insofar as one has any apprehension of it, is then seen in relation to this centre. It is only within the ambit of such a relation that what exists outside one has reality. In other words, the reality of everything outside oneself takes on a subordinate status, like that of a shadow. It follows, at least in extreme cases, that nothing is left for such a person to give himself to. For giving oneself to what enhances the ego, to activities which aim at redeeming its standing, is not giving oneself at all. Such a person is thus impervious to any moral concern. He may obey the commands of an authoritarian morality, but he cannot care for what it enjoins him to do.

When I say that for an ego-centric person 'everything outside him', such as other people, their lives, pains, joys and interests, has a subordinate, shadowy existence, I mean *affectively*. This is how he takes these things in his feelings and emotions. Ego-centricity thus characterizes the perspective of his abiding emotions.

Most people have the capacity for a mixture of emotions. Different situations, given the significance which the person finds in them, call for different spontaneous affective responses from him. This significance has an objective and a subjective aspect to it. For instance, objectively, given someone's intentions, and the culture in which it takes place, his words may constitute an insult. If the recipient knows this but takes no offence, he is not touched by the insult. There is a sense in which he has been insulted and another sense in which he has not. For him to be touched by the insult and, in that sense, to be insulted, he has to be in contact, affectively, with what is going on so that he can take offence, or not do so, as the case may be.

If he is a stranger to the culture in question he will not be aware of the insult—or, at any rate, he may not be. If he is aware *and* is offended, provided he keeps a sense of proportion, the insult will have reality for him: he will see it for what it is without being overwhelmed, swamped by phantasy; he will live the insult as

its recipient. But there is no one way of living it; one way of living it is to accept it, rise above it, and so take no offence. Here mere 'intellectual knowledge' would be 'second-hand', 'indirect' knowledge. Its object would not make a direct impact on his affective apprehension. It is only when its recipient is affectively open to it so that it registers in his feelings that the insult acquires or has a living reality for him.

On the other hand his feelings can equally shield its recipient from that reality; they may amplify and exaggerate it, giving him an importance in the eyes of the person who insulted him, as he imagines it, which he does not have. The person who insulted him becomes a bearer of his phantasies and the insult, even when objectively real, becomes inflated with his phantasies and as such unreal. That which is alive for him in the insult is then a product of his imagination. Here the angry, offended sensibility through which in the earlier example the recipient of the insult was in touch with the person who insulted him has now degenerated into an *ego-centric* over-sensitiveness.

My point is that anger as such, or an offended sensibility, does not have to be ego-centric or its opposite, 'other directed'. It can take either form. This is equally true of love, except that to the extent that love becomes ego-centric it ceases to be genuine and, at an extreme, it ceases to be love altogether. Pure, genuine love is that through which we come to ourselves in what it enables us to give ourselves to. It is that which enables us to open ourselves so that we can at once receive what comes from outside and appreciate it. Only thus are we affected by what exists independently of us, by both what gives us pleasure and what gives us pain. Such love, in its ideal, purified form, has been central to the great spiritual religions of the world and to the moralities internal to them.

Certainly some of the feelings with which we respond to situations that face us in our lives are ego-centric. An ego-centric person is someone in whom ego-centric feelings preponderate; they shape his personality and through it his outlook. They, in turn, are encouraged and shaped by his personality. Such a person's contact with people in their independent existence, as having a life of their own, is precarious: they do not exist as such in his feelings. Thus their joys and sorrows do not touch or affect him. He cannot respond with compassion to their misfortunes; and if he shows any pity, it is himself that he pities in them. He cannot share their joys

either. His response to the values of the morality in which he was brought up is at best conformist—that is where he does not ignore them or use them for his own ends.

Ego-centricity, as such, is probably recognized in most moralities, but it has a *special* significance in moralities of love. For there, where the purity of love is of prime importance, such purity ('purification of the soul' in Plato's *Phaedo*) is achieved through self-renunciation—that is renunciation of the ego. The self renounced is the ego and not the self to which one comes through such renunciation. There is nothing paradoxical thus in the claim that 'to be genuinely selfless one has to be oneself'. What this means is that one can only be genuinely selfless if one is oneself in one's selflessness. That is what is involved in one's being selfless must come from one. One cannot, for instance, renounce oneself out of fear for oneself. For then the self one is supposed to renounce reappears in one's fear. Thus 'self' means one thing in 'self-renunciation', 'selfless', 'selfish' and 'self-absorbed', and something quite different in 'self-knowledge', 'self-deception', 'being oneself' and 'finding oneself'.

7.3 GOOD AND EVIL IN MORALITIES OF LOVE

I have said that ego-centricity is of special significance in moralities of love. Love is directed towards others as individuals; it is an affective form of consideration of the other. Ego-centricity, on the other hand, ignores others as individuals and sees them only in relation to the ego's needs—the need of an ego for attention, the need of one hurt or slighted for the restoration of pride, of one feeling handicapped for compensation, or one drunk with power or self-importance for constant reminders of it.

Love, when it is pure, is devoid of all ego-centricity. The two thus stand opposed to each other. A morality of love is one which articulates the perspective of a love thus purified and is the home of our notions of good and evil. But which ones?

There are, I think, two different ways in which we speak of *evil*. These need to be contrasted and only one is unique to moralities of love. In the one case which interests us here we speak of the evil that has entered a person's soul. In the second case we use this word to refer to a disgrace, to something we consider shameful,

something we think the person himself ought to find shameful. In this sense, a person who considers what someone did to be dishonourable, for instance, may call it an evil, but I doubt that he would describe the agent himself as evil. He would probably characterize the man himself in terms of a specific vice. The agent thus, if he thought of what he did as dishonourable, would feel *ashamed*. Such shame is connected primarily with one's conception of oneself and of one's worth in the light of that conception. (I put aside non-moral uses of the term 'evil' such as when certain calamities, such as earthquakes and pestilences, are described as 'natural evils'. They can, of course, be seen as punishments and so come to assume a moral significance.)

The same action, characterized in the same moral terms, for instance disloyalty towards or betrayal of a friend, may give rise to shame in one person and remorse in another. In the one case the person thinks of what he has done in terms of what that does to him. It is his own worth that he sees as damaged. There need be nothing ego-centric in this, for it may take the form of his feeling unworthy of others with whom his relation is free of ego-centricity. Here, although he is thinking of himself in relation to others, his own worth occupies a visible position in his thoughts. For that is what shame is; a damaged sense of worth, in this case by the agent's own actions, by his own mode of existence. He cares about that in the shame he feels.

In the other case the person is thinking of himself in relation to the other in a special way: as someone for whom he cares, someone whose welfare matters and is of concern to him. Concepts of welfare and harm to it vary, of course, from person to person and from culture to culture, although where a person's action springs from malice, envy, greed, or hatred of the other, it is directed against the other's welfare or well-being as the agent conceives of it. That is certainly the object of his intention: to hurt the other, to damage his well-being. If he then feels remorse, it means that he has had a change of heart and thinks of his action from the perspective of his regard, care, concern or fellow feeling for the other—from the perspective of his 'good feelings' or love for him. I use the term 'love' in a broad sense to cover all this. What he feels has reference to himself only as the agent of an action which harms or ignores the well being of the other, or at any rate as the owner of the intention to harm him. But, unlike the first case, here

his own worth is not of principal concern to him; at most the damage to it is of secondary importance to him relative to the harm intended or done to the other. He is the object of his own feelings *only* as owner of the intention to harm a fellow human being or as the agent of the harm he has done. His regard for the other which finds expression in the pain he feels for what he has intended or done leaves his self-regard totally in the shade.

In this sense the evil that characterizes a person in his actions, intentions, feelings and desires, in his way of living, is connected with the horror we feel before those actions and the remorse we feel in retrospect when these actions are our own. And these feelings themselves spring from what those actions are directed to, namely the being and welfare of something we cherish, someone special to us in a way that has nothing to do with what needs he satisfies in us—except in the case where we take the needs he satisfies in us as an expression of his goodness for which we feel gratitude, as in the case of a child's love for his parents when it is pure. Obviously we cherish the things we cherish because of what we see in them, we feel concern or compassion for others in their particular plight because of the way we think of them—for example as sharing a common fate with us. These are two sides of the same coin: the feeling and its object stand in intelligible relation to each other, and the intelligibility of their relation comes from our moral perspective.

We may feel shame for a great variety of things—failures, humiliations, blemishes, and so forth—and some of these have little or nothing to do with our conceptions of our moral worth. Vices and moral failures which may be called evils in this sense vary from one morality to another. But only those which give rise to actions and modes of existence which inspire horror in others and remorse in oneself in circumstances such as I indicated are *evil* from the perspective of a morality of love; and they are not considered 'evils' in the plural. They are seen as expressions of the evil in the person.

When one speaks of evil in *this* sense one is speaking from the perspective of a morality of love and one has in mind such things as malice, greed unrestrained by any moral consideration, envy, lusts of various kinds which compete with a consideration of others, indifference to the fate of others, incapacity to feel remorse and gratitude, the inability to forgive others such as we

find in vindictiveness. If I am asked what is evil about these things I can only tell someone if we agree on what goodness is. It is only in its light, only from the perspective of a morality of love in which goodness has its identity, that these things are evil.

Goodness, too, like evil, in the particular sense which interests us here, is unique to moralities of love. It is true that we call 'good' those things which we approve of, morally and otherwise. This stretches even as far as to include things we simply like. But putting aside such examples as those in which we speak of 'the goodness contained in orange juice' or 'the goodness of fresh air', the noun *goodness* signifies a virtue which belongs to love and which can only be apprehended by it. Indeed, it signifies something to be found in all the virtues of moralities of love—honesty, compassion, generosity, loyalty, faith, forgiveness, trustworthiness. It signifies something that unites them. Bravery or courage may also come from goodness and what is called 'true courage' within a morality of love perhaps is a form of goodness.[2] But what is regarded as an act of courage or bravery in a heroic morality would not be seen as an expression of goodness *there*, however much it is praised. Such a brave man may be praised as a 'good man', of course, but here the word 'good' is no more than an adjective of commendation in the light of the values which belong to the morality in question: 'He is a good man, he has guts, you can rely on him as a fighter.' What he possesses is courage, not goodness. The latter is not something which has reality within a heroic morality. Indeed, what comes into focus for us in the use of this term may well be seen there as a form of weakness, and in an extreme case even as something to be despised—thus Callicles *vis à vis* Socrates's conception of 'philosophic virtue'.

7.4 GOOD AND EVIL IN A DIVERSITY OF CULTURES

I said earlier that what belongs to our nature and the conditions in their lives to which human beings adapt constitute the soil from which the values and moralities which have developed amongst men have grown in their *multiplicity*. Like religions, moralities can

[2] See Socrates's discussion of courage and 'philosophical virtue' in the *Phaedo*.

grow from different roots in us and develop in response to differ-
ent conditions of life. There is *one group* of moralities, I pointed
out, whose main root is the kind of love and concern for others we
are capable of developing in ourselves. I called them 'moralities of
love'. The love in question varies, of course, in its range from
being directed to family, friends and larger groups of individuals
knit together in various forms of relationships, and common inter-
ests and loyalties, to outsiders in every sense except in being fellow
human beings—that is directed to total strangers in need of help.
When it is pure we speak of the *goodness* of the person who has it
and acts on it.

Such goodness is rare when sustained, for it is in conflict and
competition with much else within and outside us. It is rarely trans-
parent, often translucent with the impurities it contains; but, even
when it is unmarked by words, it can appear in diverse cultures in
rare moments of magnanimity and generosity. It is not the privilege
of any one culture. Of course, moral attitudes towards it vary and
some of these may work to stifle it. This claim, so far, is not contro-
versial. For since the forms of goodness in question are moral qual-
ities they can only appear within a moral perspective and they will
be seen in their particular moral identity by those to whom the
moral perspective in question is available and accessible.

My claim, however, is that we, in our culture, do not have a
monopoly over it. Thus the goodness that finds expression in an
act of generosity and magnanimity can strike a chord and awaken
a response in its recipient, a response of gratitude which is itself an
expression of its recognition. The word for gratitude in French is
'reconnaissance' which means recognition, the recognition of
goodness, and the word for ungrateful in Turkish, 'namkör',
means 'blind to the bread given to one', that is to the giver's good-
ness, blindness to it in the recipient's feelings. Such recognition is
rooted in the love that belongs to our nature and, as such, is not
the exclusive property of any particular culture. Thus what we call
'goodness' can have a reality for individuals, at least on certain
occasions, who have not been brought up in our culture, do not
share our morality, and who may not have a word for it.

This is equally true of evil. An act of what we call treachery,
even when it is motivated by the most punctilious of party loyalties,
may be seen by the person so betrayed under the aspect of evil—
much in the way we do—irrespective of the culture and morality to

which he belongs. If he is knowingly delivering the person, who has put his trust in him, to torture and certain death without batting an eye-lid, then he is taking part in an evil practice and is himself soiled by this evil. This is what *we* would say, certainly, but we would be articulating something to which its recipient may well himself be responsive, whatever the culture or morality to which he belongs. It is in his disregard for the bond of trust that ties him to the man he is delivering to such a fate, in the way he treats trust, that he is seen as having become evil. It is being the recipient of such an act that opens the eyes of its recipient to its character.

It is because trust is something the recipient in my example is capable of, which he understands, and hence to which he attaches a special significance that he finds its betrayal so abhorrent. I suggest that trust itself is not a mere predictive belief that may be disappointed, but a form of love that can be wounded and hurt. The pain contained in such wounding is an expression of the perception or recognition of evil. I do not wish to deny that different 'moral' reactions are possible to the betrayal of trust. All I am saying is that the possibility of trust transcends the limits of any culture and that there are reactions to its betrayal which are not wholly circumscribed by the moral frameworks available in a particular culture.

Forms of relationships and their obligations certainly vary from culture to culture and with the moralities belonging to these. There are, of course, in every culture, relationships of power in which fear and self-interest play an important role. This is equally true, in a modified sense, of what may be called purely 'working relationships' where the partnership is wholly pragmatic. But wherever there are relationships in which people count for each other— and they exist, I imagine, in most cultures—then trust, affection, respect, and loyalty are part of these relationships. And there are certain perceptions and obligations which are internal to trust, affection and respect. They may, of course, clash on particular occasions with those obligations that are specific to a particular culture. But even if, in that culture, they are kept in the background and disregarded in the case of a clash, the fact remains that they exist and cut across the boundaries of any particular culture.

A person whose trust is betrayed, whatever the justification he is given and however valid it is considered in the culture to which he belongs, will feel betrayed. Similarly, if he is the one who does

the betraying, he will feel the impact of his action in the form of guilt and remorse, unless he is deceived by the justification he gives himself. It is a person's responsiveness to such things which opens 'the eyes of his feelings' to the perception of good and evil. Let me link this with what I said in the previous section by noting that the remorse that is felt for an act of evil done to others is independent of values that are specific to a culture in a way that the shame felt for a disgrace is not.

The perspective in which good and evil have reality for the individual, I submit, belongs to the way people can count for each other in personal, and then by extension in 'impersonal', relationships as individuals. The first context in which people, as children, are initiated into such a way of regarding others is the context of the family, whatever its form in the culture to which he belongs—and if not the family then whatever else takes its place. It is here that the young child's capacity for love and affection comes into play and develops. The perspective in which good and evil have reality is a way of regarding others and oneself in relation to them, and it belongs to love in its different varieties. The kind of fellow-feeling one may feel for a total stranger in distress belongs to compassion, which is an extension of such love. The impersonal character of the relationship—for instance attending to a perfect stranger from whom one has nothing to gain—becomes a test of the purity of such love, although even here it may be sullied by what one may receive from such an act in the form of self-congratulation.

I am suggesting that the source of such actions is love, just as it is the source of trust and forgiveness too. I further suggest that what I called initiation to love, for which human beings have an innate capacity, a capacity which belongs to our nature as human beings, is an initiation to a particular perspective, one in which others are seen as counting as individuals. The initiation is the bringing out and development of that for which we have a capacity. This capacity to love develops through experiences which provide it with the opportunity for its exercise and by the individual's surmounting of obstacles which threaten to impede such development. These obstacles are provided by situations which rouse the individual's ego-centric impulses—such as greed and hatred—or call up defensive measures meant to protect the individual in his ego-centric identity, such as when he responds to a slight or humil-

iation with an angry impulse to redress the balance, tit for tat, tilted unfavourably relative to the ego.

Let me note here that what belongs to the loving, caring side of man's nature gives him the capacity to tolerate pain, fear, privation and frustration, to bear abuse without feeling demeaned and so wanting to retaliate. It is the source of his ability to give, forgive, and to be grateful for the good he receives. It is through what belongs to this side of his nature that a child or adult grows out of what is ego-centric in him. Indeed it has a great deal to contribute to a child's coming to a 'normal sense of self'—in other words the lack of doubt in his own existence for others. For such a sense of self is built in the formation of relationships of trust and affection. A person comes to it in feeling that there are others, originally his parents, for whom he counts and on whom he can depend, and in wanting to be worthy of their trust in him. One who lacks such a sense of self doubts whether he has anything to give to others. It is often in a person who has a weak sense of self that ego-centricity thrives.

I said that we find the responses which are expressions of regard for the values of a morality of love in cultures where there is no explicit recognition and acknowledgement of these values. But how can we speak of these responses—for instance, the horror that stays the hand of a native in a ritual which involves taking someone's life—as expressions of regard for values which do not exist in the culture in question? How can we take the response in question as an acknowledgement of values which are not available in the culture?

I would say that what the native I have imagined finds out when he cannot take the life of someone he is expected to take is comparable to a soldier at war when he finds he cannot bring himself to kill an enemy soldier. There is a difference, of course, and it lies in the way that in our culture such responses can be integrated together with various others. It is our relation to the framework of values which belong to our culture, with its particular moral heritage, that enables us to do so in ourselves.

Indeed, we can compare the native in my example with someone within our culture in whom such spontaneous responses remain unintegrated—for instance, Raskolnikov in Dostoyevsky's novel who gives his last twenty copecks to save a young girl from sexual molestation and then calls after the policeman he asked to take her home and tells him to let them be (*Crime and Punishment*, p. 68). The difference lies in what it would take for such an inte-

gration to come about. Raskolnikov, Dostoyevsky tells us, was brought up in his mother's religion, namely Christianity. He has to go through the fire of remorse for the crime he has committed before he can make his own the beliefs in which he was brought up. Only then does the goodness in him which finds expression in sporadic impulses become part of his settled personality. The native, on the other hand, needs to be *converted* to a framework of beliefs which is alien to his culture before this can be true of him. The point I am making is that the humanity in us, that is our capacity for compassion, forgiveness, and gratitude, is not the product of a specific culture, although the possibility of its existence presupposes some form of culture or other.

The *potential* for goodness exists in most people at the start of their lives. There are, however, cultures in which it is not nurtured and developed, but is instead stunted so that mostly it perishes. That is what makes its survival in particular cases so remarkable. In our culture it mostly reaches an average height in personalities which don't give it much head room, and co-exists with what, given its head, would make for evil—much of this under a blanket of moral conformity and finding expression in terms of such conformity.

What is not confined to a particular culture and is thus 'universal' in its appearance may still be something very rare. Obviously there is a great distance to be covered by anyone if he is to move from the capacity for love which most people are born with to the kind of love which, in Simone Weil's language, constitutes a 'supernatural virtue'. Very few people travel that distance; the obstacles to it in the soul which she points out prove insurmountable for most people. It is one thing to risk one's life to save the life of another, for instance, another thing to be a saint. One is a spontaneously generous action, a genuine expression of goodness, the other takes the consolidation of such actions in a life of self-denial.

7.5 Ego-centric Pursuit of Evil: Self-Stultifying?

Now evil, which is a notion specific to moralities of love, is ego-centric. It attacks or ignores what other people cherish. It is destruc-

tive of what others hold dear and at the same time it impoverishes the life in which it thrives. It desiccates it of the kind of sense in which only a person can come to himself.

Professor Phillips has argued (1997) that particular vices alienate people from *particular* moralities, and that the evil person and the good man stand in symmetrical relations to what each is alienated from in his life: what the evil person is alienated from is what the good man engages with and similarly the other way around, what the evil man engages with is what the good man is alienated from. Therefore if the evil person is limited in his life then so is the good man. What is called a limitation or impoverishment is relative to the speaker's perspective, and there is nothing self-stultifying about what is a limitation from a perspective which a person does not share. For it to be self-stultifying he must *himself* consider the life he wants to live to be limiting and so feel deprived of something he wants or cares for while living it. So if there is anything self-stultifying about such a life its source must lie in particular features of the personality of the person who lives it: he must stand in his own way, live a life which excludes what he, himself, needs or values. There is nothing self-stultifying about mere indifference or non-engagement. Such a person has, therefore, to be contrasted with the man who has an insatiable ego-hunger and who has been likened by Socrates to someone who tries to fill a leaky vessel with a sieve. In *his* case there is a tension between his self-importance which reduces others to mere shadows in his feelings and the way he needs them to be real so that he can have his own importance confirmed in their eyes.

I agree that the ego-centric desire to put oneself first is primitive. It has its roots in the ego-centricity which belongs to early life. Most people outgrow it to various degrees as they engage in relationships in which their capacity to care and put themselves out for others comes into play. Thus it need not be a desire for compensation for the lack of importance one feels in oneself. Yet if, someone who has been unable to outgrow his early ego-centricity puts himself first to a degree where others take on a shadowy existence in his affective life, his engagements with them will be very tenuous. So they will not be able to sustain his conviction of existing in his own right. This may then give rise to a *secondary* need for compensation so that he seeks to acquire status and be somebody in their eyes. That is he comes to seek to make up for what he has

been deprived of in his primary or primitive ego-centricity. But this dependence on others may, in turn, further undermine his inner confidence in himself and lead to a reaction-formation: 'I need nobody; I am self-sufficient.' This further reinforces his ego-centricity. Both the need for compensation and the reaction-formation against it, his ego-centric self-sufficiency, are thus secondary formations. They have their source in the person's primitive or primary ego-centricity and its consequences. These constitute a vicious circle in which the person is further anchored in his ego-centricity.

Still, an ego-centric person's self-sufficiency may not be a secondary formation in this way; it does not have to be. A person who has been badly spoiled in his early childhood may gain the conviction that he can have anything he wants and that others are there to provide it for him. He will then come to expect it as his due, feel no gratitude for what he gets, and consider that nothing that constitutes a frustration is to be tolerated. If such a person continues to be successful in having his own way in life his conviction that he owes nothing to anyone and that he is the source of his success and good fortune will be reinforced. This is a perfectly genuine conviction in him and such a person will not find his ego-centric self-sufficiently stultifying. Can *we* nevertheless still say that it is self-stultifying?

Yes we can; and I believe Socrates does. When he used the simile of the leaky vessel and the sieve used to fill it he was thinking of ego-centricity as such; not a particular form of it. What he had in mind, as I understand it, may be expressed as follows: the more the ego is fed the more it expands and the more it expands the more it needs. The ego-centric person thus cannot catch up with his needs. As for the sieve: what the ego grabs to feed its needs is automatically devalued; its sustenance is lost in the way the ego-centric person appropriates it. It is devalued because he is incapable of any genuine regard or appreciation. What looks desirable, when appropriated loses its value. What I am referring to is well known in the case of envy: the grass is always greener on the other side of the fence.

I am suggesting that the ego's way of feeding itself, namely by appropriation, is itself destructive of the value of what it wants. It expands the ego but leaves the person forever unfed and hungry, without sustenance and dependent on the ego. There is a big

difference between the arrogant self-satisfaction of the ego and the self-fulfilment a person finds in forgetting himself and getting on with something outside that interests him, something to which he gives himself. To so forget himself and be open and responsive to the call of things and people on him, a person has to have accepted himself. It is only then that the ego leaves him alone and shrinks. The inner peace and freedom that comes from this belongs to self-acceptance, and in the give and take which this allows the person finds enrichment.

If a person, successful in his ego-centric pursuits, in the sense of attaining his immediate goals, says that he doesn't care for any of this, it is because he has no conception of it. He cannot compare what he has with what he misses. He cannot have a conception of it while he is driven by the needs of the ego.

So, yes, there need be no tension in him, no conflict between what he craves for and what his pursuits exclude, since he doesn't know what he thus misses and, therefore, cannot want it. It remains true, however, that in feeding his ego he starves himself and that this increases the hunger he feels in the ego. He is a person *driven* by the ego with which he is at one in his ego-centricity. He is driven by the ultimate unattainability of what he craves for and the way this increases his craving. In the words Alcibiades uses in the *Symposium* we could say that the ego-centric person 'neglects his own true interests' in pursuing the goals set for him by the ego. Socrates would say that he thus neglects his soul. In doing so, I am arguing, he neglects himself—the self from which he has strayed. His pursuits stand in the way of its growth and flourishing. It is in this sense that what is pursued ego-centrically is self-stultifying.

The self, its growth and flourishing, are of course invisible from the ego's perspective and so to the person who has adopted that perspective. When, therefore, I speak of what such a person *needs* to come to himself I am not speaking of what he, in his ego-centricity, wants. The need belongs to a self from which he has strayed and so to which he has not come. The 'self-sufficient' ego-centric person lives a life that is stultifying to this self—'self' in this sense. In his identification with the ego he cannot, of course, find that life stultifying. It is, therefore, true that what I claim is meant to be a comment on how *others* see him.

Tolstoy is in the same situation when in his story *The Death of Ivan Ilytch* he suggests that Ivan Ilytch is self-deceived, a judgement

which Ivan Ilytch could not himself have made without coming to a perspective from which the deception can be appreciated—a perspective which belongs to a new self. Similarly for Socrates's judgement in the *Gorgias* that Archelaus is an unhappy man when Archelaus himself has no reservation about the pursuits which characterize his life. For he could not have acknowledge Socrates's judgement without departing from the life judged.

My judgement that the ego-centric person's life is self-stultify-ing is a similar judgement, one made from the same perspective as the two other judgements, Tolstoy's and Socrates's. The self that is stultified here is the same self as the one deceived in Tolstoy's story and the one Socrates pities in Archelaus. Ilytch had strayed from the self he finds just before his death. In thus straying from it he was deceived *in* the self from which he had strayed. Similarly, the 'self-sufficient' ego-centric person lives a life which stands in the way of his coming to a self in which he would be disgusted or hor-rified by the life he lives. The self stultified is outside his concep-tion: he is 'all ego'. He is thus alienated from *himself* in being alienated from a life in which other people's separate or indepen-dent existence is acknowledged and respected, a life of give and take with them as such. For my claim is that it is only in such a life, whatever form it takes in the culture to which it belongs, that a per-son finds himself.

7.6 Ego-centric Pursuit of Evil: Self-Alienating?

Someone criticizing my argument may express scepticism about this notion of the self in which a person is said not to have come to himself even though, in full identification with his ego, he is behind his actions—as in the case of Archelaus. My critic may say that if Archelaus is behind his evil actions then he is himself: he is the evil person that he really is. To say that even then he is not him-self, that evil alienates a person from himself, is simply to court confusion. My critic may doubt that there is any benefit in speak-ing this way.

In response to such scepticism let me point out that I am not applying to Archelaus a way of speaking I have invented. In Ibsen's

play Peer Gynt is represented as having strayed from his 'true self'.
When this finally catches up with him he is terrified that he is
going to be melted down in the casting ladle of the button moul-
der who has come to claim his soul. In other words his fear is that
he is going to be cast into the non-entity that he has become in the
life he has lived and that he will never be able to redeem himself.[3]
Yet Peer Gynt's self-alienation does not consist in wanting one
thing and doing another and consequently living a life which
involves inner tension. It consists in living a life of dissipation and
rootlessness in which he fails to come together. He pursues his
desires, follows impulses of the moment, but he cannot be said to
know what he wants. It is not so much that he is not behind his
actions as that he has not come to a self with which to be behind
what he does.

There are many forms of character or modes of being which
represent what a person is really like, that is in which he is what he
is, and not false or phoney, but in which nevertheless he is said not
to have come to himself. Rootlessness is one, an impulsiveness
which fragments a person's life into a series of disconnected
moments is another. Ego-centricity is yet another. There are many
different forms of self-alienation. What Archelaus has not found is
the kind of unity of self that belongs to moral integrity of one kind
or another. He is alienated from any kind of moral concern in
what, from the perspective of a morality of love, is seen as the evil
which has entered his soul. He pursues what he wants for himself
without considering himself accountable to anything or anyone for
what he does. The only considerations that weigh with him are
instrumental: under the present circumstances what is the best way
of getting what I want, the most efficient? When those circum-
stances change some other line of action becomes the best way to
what he wants. He has nothing to be loyal to and no one, therefore,
can trust *him* or depend on *him*. Others can assess his character and
depend on *that* for their judgement of what he would do, how he
would act in certain circumstances. But that is very different from
trusting or depending on *him*—counting on his word for instance.

He has not thus come to a self which has anything dependable
about it; there is nothing in him to make him trustworthy. Such a

[3] Compare with Ivan Ilytch's terror when he realizes that he is going to die.

person may, as I said, be behind his actions moment by moment, he does what he wants at the time. But he has not come to a self to be true to. Rather it is what he wants that calls the tune in his life and the question of being true to any conviction does not arise for him. In thus having nothing to be loyal to he has no self to be true to. It is in this sense that he has not come to himself.

7.7 THE MATURITY OF GOODNESS AND THE KIND OF CONTACT WHICH EVIL EXCLUDES

The notion of individual development which has played such an important role in psycho-analysis is a *moral* notion; it cannot be understood in terms of a biological model or in purely psychological terms. Thus maturity, which is a developmental concept, cannot be understood in morally neutral terms. It follows that there is not one concept of maturity. What Fromm calls 'humanistic ethics' represents his attempt to spell out the moral ethos that belongs to psycho-analysis. It is from its perspective that Fromm argues (i) that evil is a form of *immaturity*, that it comes from an immature part of the self, and (ii) that to come to goodness, in the humanistic sense, a person has to grow in maturity and move towards authenticity: find himself and in doing so put greater honesty into his relationships.

I tried to spell out what truth there is in this claim in the last chapter. But I argued that while Fromm's humanistic ethics may give an accurate representation of the morality implicit in the psycho-analytic outlook, it is not to be identified with the moral perspective in which Christianity, in the broad sense, is continuous with Platonic morality, and where good and evil have their unique reality. It differs, for instance, insofar at least as it is partly an 'ethics of self-realization'. Thus I contrast Fromm and Plato's Socrates in this respect—Socrates whose notion of the 'care and cure of the soul' has sometimes been misunderstood in just this way. I am critical of Fromm's attempts to elevate 'humanistic ethics' to the objective status of the only true or authentic morality.

So what *kind* of maturity does it take to come to goodness in the Christian and Platonic sense in one's life and actions? My short answer is: the kind in which a person outgrows the ego-centricity that belongs to his early life so that the love and care with which

he is able to respond to others is freed from any trace of ego-centricity it had contained. What is *distinctive* about such a morality, which I characterize as a 'morality of love', is the distinction it makes between the ego and the self, and the way coming to goodness is conceived in it as a turning away from the ego. The kind of maturity that is in focus here involves an emotional independence which permits a person to respond to others in their 'separate' existence—an independence which is not a reaction-formation to a dependency which survives unconsciously, one therefore in which he remains closed to others in wanting to hide his vulnerabilities. It has sometimes been called 'mature dependence' (Fairbairn) because it takes the kind of inner security which belongs to the maturity in question to accept one's dependence on others, not to try to deny it. Moving towards such maturity is thus moving towards greater openness towards others and so greater honesty with them as well as with oneself. This makes for greater contact with the life around one and so for increased opportunities for emotional learning in one's interactions with others.

Indeed, when a person is open with others in his personal relationships it will in many instances change the character of the relationship towards greater honesty, even if initially this awakens discomfort in the person. One will thus learn greater honesty, modesty and patience in such a relationship and develop the ability for greater warmth and sympathy.

Contact with another person involves reciprocity of one kind or another (see Dilman 1984, Chapter 8). For there to be reciprocity each person must be 'there' for the other person to respond to him. Trust is only *one* way in which a person can be 'there' for me. For my enemy or adversary to be 'there' for me in our conflict I must respect him—I must find something in him that calls for my respect. More than this, *he* must recognize and acknowledge my respect, he must see *me* so to speak. Otherwise 'though I come in contact with a side of him that is real, I do not make contact with *him* since he does not see me. In such a case, therefore, although I do see him, and not simply as a witness through a one-way screen, *I do not see him seeing me*: our eyes do not meet so to speak' (*ibid.*, p. 158, italics not in the original). If I am right then this rules out contact with an evil man, and the evil man making contact with his victims as well as his allies.

Of course we can make contact with people belonging to different cultures. But to do so we have to find something common between us—for instance the exchange of gifts and the good feelings that go with such an exchange. As for the respect that we may feel for our enemy in the way, for instance, he remains true to his convictions, obviously what in him inspires such respect will vary with the moral perspective we take on him as an enemy. Obviously contact with others is not the privilege of those belonging to a morality of love. But I would like to stress that although that in which people make contact with one another varies from people to people and from culture to culture, 'contact' means the same thing in these different cases.

I repeat. A man immersed in a life of evil cannot make contact with either the allies he uses or with the enemies he is intent on harming or plundering. He sees neither as individuals; they do not have a reality for him in their own right. The evil which 'limits' his affective perspective and determines what he can see with the eyes of his feelings in this way comes from the ego-centricity which he has not outgrown and which has taken roots in his personality. As such it prevents the kind of interaction with others which involves give and take and the learning and growth which that makes possible.

7.8 Asymmetry between Good and Evil

In my description of the poverty of the evil person's life in the last chapter, I had in mind the thug who cares for no one and nothing except himself. At any rate he cares for things only insofar as they are of use to him in enhancing his ego and satisfying its cravings. Hence his greed for material things and craving for power, his determination to get his own back and 'punish' those who cross him, to get the better of his rivals by one means or another, his meanness towards those in need, his contempt for the weak, his need to make an impression on those who speak his language. I pointed out that the majority of people have in common with him something of what emanates from the ego. It is reflected in different cultures in different ways—in ways that can be characterized as 'culture syntonic'. It thus pervades the world we all live in as human beings, the human world—not surprisingly, since ego-cen-

tric reactions form part of human nature and few people outgrow
them completely.

The thug who has no morality understands the moral lan-
guage of those around him, though it means little to him in the
sense that it does not speak to him personally, and does not
engage him affectively. He lives thus in a limited world and has
shallow relationships. But that does not mean that he is cut off
from human life altogether. He engages with certain aspects of the
life and culture to which he belongs. These are those aspects
which take up what is ego-centric in human beings, legitimize and
institutionalize it—forms of relationships and activities, the com-
mon interests and identities they promote, types of jokes and even
rituals.

Evil is, of course, part of human life and, therefore, belongs to
the human world; it is part of the human scene. What emanates
from it is thus taken into and made part of human cultures and so
characterises the meanings of many of our words and the identity
and significance of the things we describe in terms of these
words—for instance many slang expressions for sexual intercourse
and other human acts and for types of human character. Indeed,
evil has a way of seeping into many of our moral attitudes to things
and into the meanings of the words in which we express such atti-
tudes. The evil person shares some of these attitudes and speaks
this language and so enters into the activities which they charac-
terize. But he cannot see these from the perspective of the good
man. The good man, on the other hand, can see them as those
who enter into them see them, because he knows how they look
from the perspective of those who engage in them.

The good man is thus not someone 'alienated' or cut off from
vice but someone 'who has not been corrupted by vice', someone
who has resisted such corruption. He is not cut off from those
aspects of human life in which vice and corruption flourishes. He
may himself have experienced the temptations of vice and over-
come them in himself. As such he will be in touch with the way evil
marks human life everywhere. He may have been the victim of
such evil, or may have felt and even suffered for those who have
been hurt by it. The mere fact of having loved ones and caring
enough about the injustices in one's immediate surroundings is
sufficient to keep him in touch with the ways in which evil works in
human life.

Imagine a good man who comes to be corrupted by some vice. He may well remember what he once knew. But that doesn't mean that he still knows it, that he is in touch with goodness as he once was. He no longer has the feelings he had. Things that horrified or disgusted him no longer do so; he no longer sees what horrified or disgusted him in them as horrifying or disgusting. He no longer understands what goodness means to those who are pure at heart. He has lost sight of what they see in it, what makes it attractive to those who find it attractive.

In contrast, the man who overcomes actual vices in which he indulged or, at any rate, their temptations, does not lose touch with them. He would have to become smug for this to be so. But then he would not really have come to goodness; he would have succumbed to a different vice. He knows from experience what makes them tempting. Indeed, the vices he has overcome do not lose their reality for him in the attraction they once held for him. Rather they become repugnant to him in that very attraction. It is to this that the goodness he finds opens his eyes, the eyes of his feelings.

It is true that in the case of the man who loses his innocence, succumbs to vice and is corrupted, there is a corresponding opening of the eyes to a world of pleasure, to a world of swaggering, a world of power and its ruthlessness, but one to which the man who overcomes these vices and comes to be repulsed by them does not become blind. Indeed, the very repugnance the latter feels for them now contains an acknowledgement of the attractiveness which people are susceptible to in them. This attractiveness is part of what makes them repugnant to him now.

The asymmetry between them lies in this. The man who overcomes vice is not blind to the pleasure he once found in it. He retains his understanding of the pleasure he once found in or at least expected from it, and which others do. Whereas the man who succumbs to vice becomes blinded to the repugnance which the very idea of such pleasures once inspired in him. He *loses* his understanding of what once made them repugnant to him and still makes them so to others. To put it succinctly, one can be innocent of moral knowledge, as Adam and Eve are portrayed as being in their original state in the Bible, but one cannot know goodness or even have a conception of it without knowledge of evil. Whereas, in contrast, as Plato says, those who are evil do not know they are.

They do not know evil and are not aware of it in their own actions and pursuits, for they are cut off from goodness and are, therefore, deprived of its illumination.

There is another side to this asymmetry. The man who is corrupted is one who succumbs, gives in to something in himself, whatever its source. He may struggle against it, but he is corrupted in that he lets go. There is complicity, but it takes the form of giving in. Furthermore, the response to what corrupts comes from within, it contains what lies within one. That is why I speak of complicity. This is often represented as entering into a pact with the Devil. In contrast, the man who comes to goodness is someone who overcomes something in himself and what he comes to is something he attains, even though he is thankful and doesn't take any credit for it. The pride which taking credit for it and thinking of it as an achievement would contain is, of course, incompatible with what he comes to being goodness. Still the fact remains that there is a radical difference between the way a person is corrupted and the way he comes to goodness. As Simone Weil puts it: one doesn't fall into goodness: 'on ne tombe pas dans le bien' (1948, p. 82). To come to goodness one has to 'rise' against what she calls the force of 'moral gravity' in the soul, exercised by our ego-centricity. The person who comes to goodness comes to something he is not; for he has to be awakened to the love to which the goodness he comes to belongs. And even if that love is already in him, it has to be purified so that in the process he changes in himself and finds a new mode of being. In the goodness towards which he thus moves he finds the inspiration to work and make it his. Such inspiration thus comes from without. That is what is contrasted with 'a fall into evil'.

It is true that the man of whom we say that he has been corrupted may himself say that he has freed himself from the hold which what he once called 'goodness' had on him. He may even say that he had to fight for such freedom; he may say that it took guts and that it was not an easy thing. He may describe where he has got to as an attainment. He may also speak of the life it has opened up for him as being a richer and more rewarding life than the one from which he has thus been liberated. He may even say that in it at last he has found himself.

He may, of course, not have been himself in his previous life. His earlier morality may have been something external to him

and, as such, a constraint. This would justify him in speaking the way he does: he has thrown away a shackle. But in that case it was not goodness that moved him in his former life; it was the fear of others—the fear of losing their approbation and all that hung on it for him or of gaining their disapprobation.

However, this need not have been the case: what he describes as 'bondage' may be the genuine hold which what we call goodness had on him. Such a person was torn between the pull of the good and the temptation of evil. He identified himself with the temptation and so now speaks of the attraction of the good as a snare. He has rejected it and turned to evil. He now uses the language I have used and says that he has made the evil he has embraced his own and in doing so he has risen to it. He denies that this is a fall. In doing so he is using moral language, not the language of moral alienation; he is saying, 'evil, be my good'. If these are not mere empty words, then he is trying to put evil in the place which previously goodness occupied in his soul.

Looking at him in a slightly different way *we* could say that he has given himself to a form of evil which houses itself in a morality and which, as such, engages something of the good in him. Such a person is not simply taken over by evil; the good in him is tricked into making this possible. It is made to work for the devil until it ends up by being taken over. He is thus deceived in the way that a person who falls in love with someone worthless out to exploit him is deceived.

I have argued that the good man's life is not limited and impoverished in the way the ego-centric thugs's life is. For he is not cut off from evil in the way that the ego-centric thug is cut off from goodness. But does this asymmetry hold in the case of the good man who is converted to evil in the way I have imagined? I have argued, in his case, that not being totally ego-centric he has the capacity to give himself to something outside himself—at any rate to begin with. It is this capacity that he puts into action when he is tricked to give his love to something that appeals to his ego-centricity. While he uses moral language to express his relation to it— a language he uses misguidedly but not vacuously—he has not lost touch completely with his earlier life. That language still contains echoes of what he was in touch with earlier. There is in him still, even if tricked, that with which he is in touch in what that language echoes. If the evil which he is tricked into embracing gets hold of

him totally—and that is the direction in which he is changing—
then he will lose touch with his earlier life and will turn into some-
one ego-centric in his affective orientation. All that will remain of
his past life then will be the memory of something from which he
is totally dissociated. In this transformation he will lose touch with
everything which the goodness he had in him illuminated.

So my claim that the good man is in touch with what is evil in
human life, whereas a man whose life is steeped in evil has no con-
tact with and no understanding of what the good man sees and is
moved by, stands.

7.9 SUMMING UP

I argued that though we find our individuality as *human beings* in
the culture in which we grow up and to which we belong, it never-
theless makes sense to talk of a *human nature* which cuts across cul-
tural boundaries. Since, however, our nature as human beings is
not something that exits independently of one form of culture or
another what belongs to it cannot be distinguished in any simple
way from what comes to us from the particular culture to which we
belong.

Next, I argued that moralities grow from human responses to
the particular conditions of life to which human beings have to
adapt in their struggle to make a life for themselves. They have
their roots in both human nature and the particular culture in
which these conditions have their significance for those who have
to adapt to them.

I then tried to make clear what is meant by good and evil and
the way the reality of these is unique to a morality of love—that is
a morality that has its source in the love, in the broad sense, which
belongs to our nature as human beings in its primitive form.
Within the framework of such a morality this love is purified of all
traces of ego-centricity and developed and, as such, made into an
ideal in which those who give themselves to it find inspiration. I
argued that in the primitive reactions of such love we find expres-
sions of a recognition of good and evil, one that is not confined to
any particular culture. It is in this sense that there is something
universal about moralities of love.

In such moralities human nature is seen as having two poles: one in which human beings have the capacity to come out of themselves and respond to others in their separateness and individual identity, and the other in which they are ego-centric in their primitive reactions. Such a morality enjoins those who give themselves to it to purify their love from all ego-centricity. The notion of *coming to oneself* presupposes the contrast between the self and the ego which is specific to moralities of love, and it is what such purification makes possible that enables a person to come to himself in his interest in and concern for what exists independently of him.

The notions of self-alienation and self-stultification I employed go with this. I have tried to make clear why I say that 'there is something self-stultifying about making oneself the centre of one's concern'. This is equally true of the self-satisfied person. In his ego-centricity such a person has no idea that his pursuits are self-stultifying. He has no conception of a self distinct from the ego. The fact that such a person is really ego-centric, ego-centric in his very mode of being, does not in any way preclude his not having found himself, and so his not being himself in that ego-centricity.

Part of the reason for saying that the ego-centric person is someone who has not found himself is that in his ego-centricity such a person remains rooted in something that belongs to his early life and which he has failed to outgrow. In his failure to do so his life remains impoverished. He is deprived of what relationships of genuine give and take, and an interest in things outside him for their own sake, can bring into a person's life. He is deprived of the wisdom and understanding that a person can come to through this.

Finally I maintained that there is a certain asymmetry between good and evil. Evil is not alien to the life in which a good man participates and this is something with which the good man is in touch. Goodness, on the other hand, is alien to a life shaped by evil. The good and the evil man lead different lives, of course, but in its horizons the life of the good man is not limited in the way that the life of the evil man is. The good man does not participate in practices which he sees to contain evil, but he sees those practices to be a part of the life to which he belongs. The evil man, on the other hand, does not, in the same way, see the practices and restraints in which the good man's regard for and loyalty to good-

ness finds expression as part of the life to which he belongs, except as aberrations rooted in men's foolishness. He cannot understand how any man can have regard for goodness itself. For goodness means nothing to him. The good man, in contrast, is not in *this* way alienated from evil. He understands it and knows only too well the reality of the attraction it exercises on men. He could not be good in the full sense of the word if he was innocent of that reality; he could only be naïve.

8 Love and Hate: Are They Opposites?

8.1 MATURE AND IMMATURE LOVE

Michael Balint describes a woman, a patient of his, whose 'whole life', as he puts it, had been 'an endless repetition of the same pattern' (Balint 1952).

She had always been terribly in need of love and affection. In her relationships with men, she had repeatedly 'thrown herself away at the first signs of some slight attention'. The person in question became an angel in her mind and for a short while she lived in blissful expectation. Then, because the other person had a separate existence from her, he could not satisfy her absolute demands. She interpreted this as heartlessness and cruel neglect and the result was a painful disappointment. This then turned into hatred and the person was discarded as bad, heartless, rotten, and cruel. She was then overcome with anxiety.

Was the love for the person she came to hate genuine? Balint argues that it was, but that it was a primitive, immature sort of love. In contrast, he says, his patient's hate cannot be called either mature or infantile, or primitive; but then immediately after having said this he adds: 'anxiety, and to some extent hate, exist only in primitive forms'. At first he concentrates on love: what is the difference between a primitive and an adult love? He gives seven characteristics of immature, primitive love which distinguish it from mature love.

(i) The person has a weak sense of self and feels insecure in herself. As a result she needs the reassurance of love, affection, and attention. When, in the separateness of his existence the other cannot meet the absolute demands she makes on him the

result is cataclysmic. Anything other than fusion is felt by her as a let-down, a betrayal. She feels abandoned and condemned to nothingness for having been denied the confirmation of love and affection.

(ii) The more desperate her need for confirmation the less she is able to be realistic both in her expectations and in her assessment of the other's response to her. She expects from the other something he cannot give her, or at least something he cannot sustain, and her disappointment is out of all proportion to reality: her idealization turns into an equally unrealistic disappointment followed by denigration.

(iii) Given her weak sense of self and feeling of inner deprivation she cannot avoid envying those who feel at home and secure in their own skin, and is therefore charged with the destructiveness which belongs to her envy. 'Such people', Balint writes, can only have ambivalent relations . . .' and their love is 'easily smothered by their destructive tendencies'.

(iv) She cannot form a realistic picture of the other and tends to split him into two: the loving, caring person who will fulfil all her expectations and the selfish, feckless person who is unable to care. He thus tends to oscillate in her apprehension between these two irreconcilable aspects. Similarly so do her feelings towards him oscillate between love and anxiety, and at times, a defensive hatred. She cannot feel at home with him, nor with herself in her need for confirmation.

(v) Balint points out the possibility of strong narcissistic tendencies in such a person which she has failed to outgrow. She loves herself in him. This makes her intolerant of any fault or blemish in him and also makes her demanding: he must be perfect in his love and attention towards her.

(vi) A sixth possibility is what Balint, after Freud, calls 'oral greed'. She looks for sustenance in the love she expects and demands, and she can never have enough of it. Such greed is rooted in her absolute dependence that goes back to her very early childhood—indeed babyhood. This is dependence which she has been unable to grow out of and which in the way she has approached personal relationships she has perpetuated. On the one hand it makes the other person all-important to her and, on the other hand, it stands in the way of her considering his interests, needs, sensitivities and well-being. He is seen as being there to cater to her needs.

(vii) A seventh characteristic of this primitive, immature love relationship from which she cannot escape is her need to control it unconditionally. This need to control the relationship, to impose her own terms on it, is a defence against her own helplessness.

What Balint gives here is a characterization of the only kind of love his patient is capable of and of the kind of person she is. It is the kind of person she is which confines her to this kind of love and its consequences. Some of these characteristics are to be found in most love relationships, to a certain degree, on one side or the other. The love in question is a very early form of love, the love of a young child for his or her mother, where the child's sense of herself is precarious, she is dependent on her mother for the satisfaction of her needs, her world is limited and only marginally coincides with the world of the adult members of the community in which she will grow up. It is a world defined by significances determined to a large extent by the child's emotions and phantasies. To the extent that she fails to outgrow these emotions and grow up affectively her contact with the adult world remains precarious—especially in situations which bring such emotions into play.

Adults, on their part, who have lost touch with such emotions in themselves, either because they defend themselves against these or because their imagination has remained stunted, will have only a tenuous contact with the world of the young child. Yet because so often this is a world which intrudes into the relationships of adults they will be helpless and impotent when faced with it in others. They will be unable to help their loved ones and only exacerbate their anxieties.

Let me emphasize: to outgrow such a world is not to lose touch with it. It is often people who fail to outgrow it and cannot tolerate facing it in themselves who lose touch with it. Consequently their contact with others come to be limited and their life is impoverished. These are the two sides of the same coin: on the one side we have the woman who is incapable of adult love, on the other side the person who has not outgrown what she lives. He moves within a well-mapped pattern which at best sterilizes their give and take and impoverishes their life together.

To return to the kind of person exemplified by Balint's patient: she lacks self-reliance, she needs confirmation, in any intimate relationship she cannot tolerate the other person's separate exis-

tence; it poses a threat to her. She cannot appreciate the other person in his independent existence: she cannot allow him an independent existence and what he lives independently of her she takes to be neglect or treachery and hates him for it. Her love is thus narcissistic or possessive (not the same thing); it is demanding and draining. What she is capable of giving she gives on her own terms; it is therefore conditional on his being just the way she wants him to be.

Her love is thus to be contrasted with a love where care and giving is unconditional and directed to the person in his separate existence. It is a love that is considerate, one that is capable of appreciating the other's pains and difficulties and responding to these. It is capable of appreciating his differences and tolerating his foibles and, indeed, his defects. It is mature in the sense that what makes the person capable of it is his having outgrown the very features of her early love which stand in its way. Those features—patience, tolerance and respect of the other, unconditional care, appreciation and active concern, the ability to give emotional support, to bear his pains and share his sorrows, to forego thinking of oneself—are themselves a mark of *moral* maturity. A person comes to a love characterized by such features in growing out of what belongs to his early affective life and through inner work. Just as a plant needs time to mature, in a very different way these qualities are qualities that need and take time to develop. Just as, it has been said, one cannot fall into goodness, so similarly one cannot be granted these qualities at one go with the wave of a magic wand. It takes time, inner work, letting go, and a certain kind of faith for a person to be able to move, to grow, so as to come to them.

8.2 ASYMMETRY BETWEEN LOVE AND HATE

What is philosophically interesting is the asymmetry there is between love and hate in this respect, which Balint himself points out. I should like to develop this point and, indeed, to point out that while love certainly comes from the heart, it is not an emotion, whereas hate is.

We have already seen that Balint says that the distinction between infantile and mature which applies to love does not apply to hate. But then he adds that to some extent at least hate exists

only in primitive forms. Let me first help to resolve this contradiction and explain what it is that makes Balint waver.

Fear is certainly an emotion. There is such a thing as phobic and irrational fear and also what one may call a realistic fear. I would not wish to speak of mature and immature fears, even though phobic fears are, I believe, rooted in unresolved conflicts that go back to one's childhood. What is mature in the case of a realistic fear is the courage one exhibits in the face of it. It is the mark of a mature personality. I spoke of patience as a mark of moral maturity; I would put courage together with patience in this respect. Courage is a quality of character and not an emotion, of course.

Similarly, hate is an emotion. But unlike fear I would not speak of a realistic hate. Fear is generally directed to danger. It is difficult to give a general characterization of the object of hate. But I would distinguish between a hatred charged with animus and an impersonal hate. Thus I may come to hate someone who constantly treads on my tail, humiliates and ridicules me in a sneaky way without giving me a chance to defend myself. That is, he may do it in such a way that any proper response to it would aggravate the situation into which he puts me. It is the pain of having my tail trodden on and having to take it that turns into hatred. If I could, I would bite him. I have to swallow the pain; therein lies the animus of the hatred I feel for him. Such hatred may be understandable, but it is neither realistic nor unrealistic, neither rational not irrational. I would use none of these terms to characterize it.

Now, in contrast, I might say, 'I hate corruption and the person who takes bribes'. This applies to any person who takes bribes. It is not because I have had to pay bribes or because my refusal to do so has cost me dear that I hate anyone who takes bribes. It is because of the moral significance I find in it that I hate bribe-taking. I might say, 'it nauseates me'. Here the hate is *impersonal*. The distinction I have in mind is similar to the one between revenge, which is personal, and retribution, which need not be. This is something which people who discuss the rationale of punishment don't always appreciate.

Now to return to my first example—the person who treads on my tail. Here my hatred is not impersonal; indeed its source lies in my inability to take revenge which I characterized as personal. If I can get my own back on him in such a way that he stops, my hatred

may go, evaporate. Here my hatred stops, but I don't change in myself. If he stops of his own accord and says he is sorry, I may forgive him. Here I change towards him. But it may so happen that although he continues, my perspective changes; his constant needling me or ridiculing me no longer matters to me. I say to myself, 'that is the kind of person he is; I must be touching some sore spot or vulnerability in him because of the way I am'. I may even be more specific about this. We find what I am trying to depict in Spinoza. He calls it detachment. Now the detachment he has in mind is a mark of maturity.

We find the same kind of maturity in the person who wants the punishment of a criminal without any sense of vengeance. Thus Socrates in the *Gorgias* when he speaks about punishment. When I say that bribe-taking nauseates me and that I hate the bribe-taker my hate may be similarly empty of my ego, devoid of ego-centricity. Having outgrown one's ego-centricity is the other face of the detachment of which Spinoza speaks: they are the two sides of the same coin.

In the former example hatred is something I suffer; it is what Spinoza calls a 'passive emotion'. I am passive in receiving it; I *yield* to it. In the case of the bribe-taker my hate is not an emotion to which I yield. I own it; it does not own me. It is an affective, moral response to bribe-taking in which I am myself. By contrast I am not myself in my hatred of the person who treads on my tail and forces me to swallow the pain and humiliation without being able to do anything about it. It is precisely in my passivity that I hate him. When I can detach myself from it I am myself and exhibit what Plato calls 'self-mastery'.

8.3 RICHNESS OF LOVE AND POVERTY OF HATE

It is precisely this kind of self-mastery which Balint's patient lacks. In Socrates's language from the *Phaedo* her love is a form of 'self-indulgence'. Put it like this: she gives her heart to someone whom she expects to satisfy her needs—needs that she has because she has failed to come to herself, because she has been starved emotionally in one way or another or has been unable to accept or assimilate what she has been given, because she has been unable to outgrow her narcissism, and so on, . . . She gives her heart con-

ditionally; she has unrealistic expectations. Her giving is qualified; her love is a qualified giving. Spinoza's distinction between 'active' and 'passive' is applicable here.

The more active a person's love for another the more her love is a mode of being—one in which the person is herself. No doubt it is an affective mode of being, one in which a person is affectively directed towards the loved one. Loving a person is not being in an affective state. Perhaps one is in such a state when one is *in* love. The person in love is attracted, consumed, 'starstruck'. She is in the grip of an emotion. The person in love can think of nothing but the beloved, wants nothing better than to be with the beloved. She glows with the reciprocation of her feelings. But though she can think of nothing but the beloved, she finds a great deal of pleasure in thinking of him. She lives as in a dream; the lover and the beloved share this dream; they indulge themselves in the dream they share.

It is only when they can pass the test of coming to know each other and bearing each other's difficulties, entering into each other's problems constructively, learning to give each other a space in which they can be themselves, have independent interests, that they will come to love each other. They will no longer be *in* love, though not because they have fallen out of love. Their love for each other will be transformed into an active love—that is into care and devotion. They will be free to think of all sorts of other things, but in what they do they will always consider each other. Here 'thinking of the other' takes on a different meaning; it is not pleasurably dwelling on the other in one's thoughts.

A love that is devotion to another, one that finds expression in the way one cares for the other, in one's warmth, in the friendship one gives to the beloved, the support and protection when it is needed, and the unspoken loyalty, is not a state; it is not an emotion. It cannot be compared with hate to be its opposite: they are not in the same grammar.

One may hate another person, resent the way he has been towards one—even for the rest of one's life. This is something one feeds or sustains; at least one is unable to let go of it in forgiveness. In some ways it is like being in love; it is a form of passivity. It is something one suffers; and what one suffers has 'genuine duration' to use an expression of Wittgenstein. An intention, or knowing something, he said, does not have genuine duration; it has no

substance of its own. This is equally true of active love, of care, loy-
alty and devotion. If I love her I certainly will have feelings for her;
but my love itself is not a feeling or an emotion.

Compare loving someone with liking him or her. Liking some-
one is finding him agreeable, enjoying his company, finding in
him qualities that give one pleasure or which one admires. If I like
him I would seek his company and, of course, he would inspire
warmth and friendship in me. If I spend time with him and the
give and take between us increases we may become friends.
Friendship is a bond which involves loyalty and trust.

I like him because he is the kind of person I enjoy spending
some time with—talking, joking, doing together something we
both enjoy. We may have common hobbies or common interests.
Enjoying someone's company is one of the innocent pleasures of
life. When one simply likes someone one is detached from him or
her, which doesn't mean that one is indifferent. Love by contrast
engages one's emotions without itself being an emotion.

If I love someone I shall be attuned to his or her pains and
pleasures. Her pains will be mine; her pleasures, successes will give
me pleasure: I shall be pleased for her. The more mature I am in
my love the more selflessly will I enjoy her pleasures: that is, I shall
be pleased for her. My pleasure will not be the vicarious pleasure
of identification. That is, I shall accept her separateness, her inde-
pendent existence. This is not detachment; it characterizes the
form of my attachment. I am thinking of personal love, such as the
love of a man for a woman, of a parent for his or her son or daugh-
ter and *vice versa*, of love between brothers and sisters, etc, as
opposed to compassion which is impersonal in the sense that any-
body can be the object of my compassion.

I was speaking of the way the beloved's pains are mine and the
way I share her pleasures and her good fortune. Thus I will defend
her, protect her, support her, put myself out for her, remain loyal
and faithful to her during periods of trial—when my love is tried
or tested. I shall also trust her, forgive her, accept things from her
which I could not accept from others, and even ask things which I
would not ask from others. All this engages me affectively, in my
whole being. But I must be whole in my being to be so engaged.
As it is put colloquially, I have given her my heart. This is itself an
act of trust and faith which exposes me in my vulnerability: it is up
to her whether she cherishes it or breaks it. If she breaks it then it

will pierce me to the core. This is one reason why people often shun love and are afraid of it. It takes a certain courage to love someone, to commit oneself to another. I am speaking especially of sexual love, the kind of love there is between man and woman. How I shall respond in such an eventuality will be a measure of my love for her. Forgiveness certainly, but compassion too, have a role to play even in such a personal matter. They are a part of love.

This is all part of the complexity and richness of love. It has many dimensions, and the primitiveness and maturity which Balint was speaking of are a pair of poles which define one of its dimensions. It has been said, 'each kind of person loves in his own way; what he is, his love is'. This cannot be said of hate, nor of fear. And while it is true that what a person is his love is; it is equally true that a person can grow and come to himself in love. This too cannot be said of hate, nor of fear.

Certainly hate or fear can change a person; but this can never amount to growth—unless a person learns to turn away from his hate through forgiveness or detachment, or finds courage and overcomes his fear. But in either case it is something he values or loves that makes this possible; it is through love and faith that he is able to forgive, to let go of resentment, finds courage in himself to conquer fear.

Thus in love one finds sustainment and growth, though not when one seeks them, makes love a means to them. Indeed the sustainment people seek in love and the sustainment they find gratuitously when they genuinely forget themselves are not the same thing at all. The sustainment they seek is the sustainment of the ego. As Florida Scott-Maxwell puts it in a little book entitled *Women and Sometimes Men*:

> The longing for love that both men and women feel, the clamour and grasping for love, obviously does not come from full hearts that must give; full hearts usually overflow quite simply and with little fuss. The great do about love is more like the starveling bay set up by hunger. Our emptiness must be filled, our nothingness must be denied. We thirst for love's denial that we are small, we want its reversal of truth, its enhancement of value, its turning of aloneness into uniqueness. We crave to be given ourselves. (p. 185)

This is precisely what Balint characterizes as primitive, immature love.

By contrast the sustainment which love gives comes through the way we learn to forget ourselves in it and put the loved one first. In losing our ego we find ourselves; we can no longer then need to be given ourselves; our smallness ceases to matter; our emptiness is not filled, it disappears.

In love, I said, we grow to greater maturity. Hate, on the other hand, immobilizes; it arrests us: we hold on to things, we repeat the same pattern. This itself may bring a change: bitterness, isolation, withdrawal. Hardly anyone would characterize this as growth or development. It is what I would call a deterioration of the person—a deterioration that comes from the starvation of isolation and withdrawal. In *this* respect one can say that love and hate are the opposite of each other; but they are *not* opposites in the sense that black and white are opposites—opposite colours, opposite emotions.

8.4 LOVE AND HATE: GOODNESS AND EVIL

I want to finish by linking love and hate with goodness and evil. I shall be brief and only indicate the link.

We are familiar with goodness as a virtue; we know what it means to speak of the goodness of a person. A person who possesses goodness is kind and considerate towards others. He treats them with justice and respects their rights. He would not lie to them, cheat them, use or exploit them. When they need help he helps them if he can. He is ready to put himself out for others. He is forgiving. In the face of provocation he controls himself; he is not easily provoked. He shows courage when he has to defend what he cares for and values. These virtues—compassion or charity, justice, honesty, generosity, forgiveness, courage, patience and self-mastery—form a unity and together belong to or constitute goodness.

Goodness is an ideal, a value and virtue at the centre of a kind of morality we find in Plato's ethic as well as in Christian morality. The virtues it unites all have their source in the loving side of our nature. We come to them, or move towards them, through the purification of the love of which we are capable—its purification from all ego-centricity. The purer our love, the more we are able to consider others, to put ourselves out for them unconditionally

and without the expectation of any return. Our justice towards them springs from our ability to put ourselves in their place. The same is true of our honesty towards them of which our trustworthiness is a part. The courage it takes to remain loyal to the trust others put in us is also made possible by our selfless concern for them. Finally our ability to surmount the grief others may cause us and to forgive them for the harm or injury they inflict on us, instead of returning it in revenge, is again made possible by the degree of selflessness we have reached.

Not all love is selfless of course, but there can be no selflessness without love. It is by means of the purification of our love that we become selfless; it is in our love for others that we find selflessness. It is to the degree to which the other becomes important to us *in himself*, in his own independent existence, regardless of any way in which he may serve us, that is in what Plato calls 'decent indifference for ourselves', that we become selfless, turn away from our ego in such a way that it withers. The other, however, can become important to us in this way only in the kind of care, concern for, and interest in him which belong to love. Indeed his importance in this sense is internal to the object of our love and compassion in its purity.

What is of interest is that the development towards the capability of a mature love, in Balint's sense, coincides with its purification from all ego-centricity. The development in question is thus at once towards greater goodness and towards greater self-knowledge and self-mastery. What unites them is the purification of the soul from the kind of ego-centricity which inevitably characterizes all infantile modes of being and orientations. If such ego-centricity is equally prevalent in adult life, that is because it is so tenacious; indeed so much so that ego-centricity can be said to be one of the poles of the human soul.

Just as all the virtues that are part of or, indeed, constitute goodness are characterized by their purity in selflessness, by the degree of selflessness which the person has reached in the love and concern he is capable of for others, so, on the other side, everything which by contrast is considered evil in a morality of love is characterized by ego-centricity. The evil person thus is someone who only thinks of himself and for whom others are either obstacles to his schemes or instruments to be used to further them. They are to be exploited, preyed on, discarded. If they enhance

the ego they are sought; if they make him feel small in the ego in any way or stand in the way of its expansion they are hated and 'punished', 'taught a lesson' whenever this is possible.

In one word evil is the total disregard of others; it is an aggressive form of ego-centricity—such as is to be found in malice, greed unrestrained by any moral consideration, envy, strong lust, vindictiveness. Such disregard is the opposite, the very antithesis of love. Hate in this context is the ego's response to any threat to its expansion and to the boundless sovereignty for which it craves. It wishes and seeks the pain and destruction of anyone and anything that stands in its way. But in such hate the ego already finds compensation for its sense of diminishment in having been ignored, obstructed, or insulted. For in hatred it finds a sense of power and being.

It is worth repeating that what I have described as constituting evil has that character, significance, and identity from the perspective of a morality of love. If asked, 'What is evil about these things?', I can only tell the person who asks me if we agree on what goodness is. It is only from the perspective of a morality of love in which goodness has its identity that the things I mentioned, such as malice, vanity, unrestrained greed, and a lust that rides rough shod over the other are evil.

9 Must Psycho-analysis Explain Religion Away?

9.1 FREUD'S CONCEPTION OF RELIGION AND THE GOD HE REJECTS

What can psycho-analysis make of religion? Can psycho-analysis help a patient in his religious, spiritual problems? In Professor Phillips's words: can it regard gods or demons as ultimate—as 'last things?' (see Phillips 1993, p. 188).

I want to begin by summarizing Freud's view of ethics, in its negative character, and compare it with his view of religion. Human beings in their very nature are selfish and aggressive; morality is a product of culture alien to human nature and opposed to it. It is imposed on us in opposition to our nature. It has the advantage of making communal life and co-operation possible, but at a cost to the individual. Even when it is no longer externally imposed, it is still imposed on the individual by a part of him which sides with it: the super-ego. It is thus a force of repression and any belief to the contrary—that is, the idea that moral qualities are to be admired for what they are in themselves—is a deception. For morality prevents us from being ourselves. Since, however, it is nevertheless beneficial in that it regulates human conduct in community life, the only way to be moral without self-deception is to see through the pretentions of morality and accept its strictures voluntarily. This then is an enlightened choice as opposed to a surrender.

Freud thus allows the possibility of being both moral and one-self at the same time. But he makes morality into something one at best tolerates. He can see nothing in its values—theoretically, not personally—to which one can give one's heart without being

163

duped. I have argued in Chapter 6 that Melanie Klein and other psycho-analysts, some of them influenced by her writings, have broken part of this mould in which morality is regarded as alien to human nature and have argued that there are forms of morality which contain something much more positive than Freud was able to allow.

Freud's views on religion are in many ways similar to his views on morality, except that he does not find in religion even the redeeming features he finds in morality. The most he can find there is that religious belief helps to 'make tolerable the helplessness of man' (Freud 1949a, p. 32) and 'succeeds in saving many people from individual neuroses' (Freud 1949b, p. 42). Religions may have evolved from totemism to monotheism, Freud points out, but they remain rooted in infantile fears and needs. To hold religious beliefs is thus to be deceived in a double sense. It is to hold beliefs which at best cannot be substantiated; it is to give credence and allegiance to something for which there is no rational support. Secondly, it is to give in to wishful thinking and remain wedded to infantile fears and insecurities and to infantile ways of dealing with them. So if one is to grow up, shoulder responsibility for one's life, and be oneself, one has to see through one's religious beliefs, if one has any; one has to shed one's religion. There is no reason for reaching a willing accommodation with religion, as there is in the case of morality, for religion can only serve the irrational and infantile side of one's personality.

Thus the only kind of sense Freud can see in any religion is the kind he sees in the obsessional behaviour of his neurotic patients. When he speaks of the 'hidden significance of obsessive neurotic practices' he means their role in the individual's mental and emotional balance, maintained in the face of various psychological strains and stresses. They serve a purpose there, though they are otherwise a nuisance and an encumbrance. The aim of psycho-analytic treatment here is to make what constitutes the strains and stresses in question accessible to the patient, so that he can face them and work on them. When they are lessened he will be able to dispense with his neurotic obsessional acts and so be free of the handicap they constitute. They have thus a role, a purpose, in his mental economy, that is in his ability to maintain a balance with a minimum degree of pain. But they have no sense or significance *in themselves.* Similarly Freud sees no sense in religious beliefs and

practices which he compares with neurotic practices, speaking of religion as a mass neurosis, a 'universal obsessional neurosis' (Freud 1950, vol II, p. 34). Their sense in religious terms is for Freud a cover-up. The difference between the two is that neuroses are individual elaborations whereas religions are cultural products. They are taken up by individuals because they respond to existing needs in them, widely shared.

This is the general picture and I see little point in going into further detail. It follows that the ultimate explanations of the religious practices and beliefs, the religious fears, anxieties and self-criticisms of religious patients in analysis will be in non-religious terms—in terms of what they do for the patient, including what they help him avoid facing in himself, and so what they are a response to in him.

Now it is perfectly true that any part of the patient's conduct and beliefs, however genuine, can be so treated in analysis, and legitimately so treated. For instance, an analysand whose politeness is perfectly genuine may nevertheless help him avoid certain forms of confrontation with people in the face of which he may feel helpless. It may be important for the analysand to confront this helplessness in his analysis in order to work on what lies behind it and deal with it. When, therefore, his analyst points out that his politeness serves him to evade it he may think that his analyst is suggesting that his politeness is not genuine, that it is a defensive posture. But this need not be the case. He may be genuinely polite, yet his politeness may serve a purpose which is not *his* purpose, not even unconsciously, though he benefits from it in terms of his mental economy. In such a case he will not lose his politeness in analysis; all he will lose will be what makes for his lack of confidence in standing up for what he believes in certain circumstances. Indeed, he will now be able to do so firmly, straightforwardly, but still with politeness.

The trouble with the patient's religious convictions and the actions which come from them is that no such possibility exists for them in Freud's view. They *cannot* be genuine without the analysand being duped. So in the course of an analysis that is progressing, they have to be analysed away—given Freud's conceptual orientation. My question is whether there is something about psycho-analysis, which after all is Freud's brain-child, which makes this impossible. I will argue for a negative answer; psycho-analysis

does not have to analyse away a patient's religious beliefs—not when they are genuine.

Before doing so, however, let me point out by way of a relative mitigation, that there is a certain amount of truth in what Freud says about religious belief. What he says does not have to be true. On that score he is wrong and displays a mind closed to the possibilities of sense in religions. Indeed, he is blinded by his professional preoccupations to what religions are in their variety, to the way they represent and emphasize the significance of, express and enable believers to respond to, what is important to them as human beings in the life of their culture. This said, there is a share of truth in what he says: people do give their allegiances to their religion—say to Christianity—out of non-religious needs. It is well known in Christianity that many people's attachment to its beliefs have their source, at least partly, in the compensations and consolations they find there—very much as Freud describes these. It is also true that for some people the objects of their religious beliefs become a focus for their infantile feelings and attitudes.

Many recognize this fact. Bonhoeffer, for instance, responds to it as follows: 'The only way to be honest is to recognize that we have to live in the world even if God is not "there". Like children outgrowing the secure religious, moral and intellectual framework of the home, in which "Daddy" is always there in the background, "God is teaching us that we must live as men who can get along very well without him" (Quoted by John Robinson in his book *Honest to God*, pp. 38–39). Freud teaches us that 'abandoning religion must take place with the fateful inexorability of a process of growth' (1949a, p. 76).

The religion to be abandoned is the one Bonhoeffer also rejects: 'we have to live in the world even if God is not "there".' Simone Weil puts this by saying that the God she believes in manifests Himself in the world by His absence. Freud's God encourages infantile dependence; that is why Freud thinks that such a God must be abandoned if people are to grow up. But Bonhoeffer's and Simone Weil's God cannot be faulted in this way. The dependence which the believer in such a God accepts as part of his belief has nothing infantile about it. It is interesting to note that this prejudice of Freud's is matched in those who think that psycho-analytic therapy encourages a childish attitude in the patient and that the mature attitude towards one's problems is to

deal with them oneself *instead* of seeking psycho-analytic help. What such a view fails to recognize is that what the analyst helps the patient to learn in analysis is precisely to shoulder responsibility for his problems. Thus those who take such a view of psycho-analytic therapy are as blind to the possibilities within it as Freud was to the possibilities within the Christian religion.

I am suggesting that Freud's interest in the 'pathological' in a broad sense, made him see it where it exists unseen, but equally where it does not exist. His perception was Janus-faced: he saw what others missed seeing, but it made him lose sight of distinctions which in his position it was important for him to be sensitive to.

I said that there is a share of truth in Freud's view of religion. We could say that he was rejecting a certain view of Christianity, on personal as well as intellectual grounds, without however being able to see the possibility of alternative views to which his objections might not have applied. He was rejecting a scientific or meta-physical view of Christianity, at least partly on intellectual grounds. He was rejecting a religion of compensation and consolation and advocated the courage to face reality without reliance on crutches. He did not see that Christianity does not have to be opposed to his values—at any rate not to all of them. I should like to note in this connection that Freud's ideal of independence, towards which he believed psycho-analysis must work, was in part itself a reaction-formation to the kind of dependence he disliked. It has given way for many analysts to what Fairbairn calls 'mature dependence'. This is obviously more in tune with the Christian belief of our dependence on God.

9.2 An Alternative Conception by a Psycho-Analyst: Rycroft's God

I now turn to the question of whether psycho-analysis has to remain wedded to Freud's view and estimate of religious belief and religious truth. My answer is that it does not have to, and various psycho-analytic writers have tried to disengage it from those views. I want to consider one such attempt in a paper by Charles Rycroft. I shall take my start from what he says.

Rycroft was originally given the title 'The God I Want'. He explains that in these words he was invited to speak about the God he can make sense of, give his heart to, believe in, and thus to

speak *personally*—to speak for himself as a person who has been trained as a psycho-analyst. In this sense, we shall remember, there was no God that Freud wanted, since the only God he could think of was one from which he turned away in disdain. Rycroft says: 'the God I want will have to be someone who never came into Freud's field of vision—at least when he was writing about religion' (p. 283–84). 'I do not want Him as a father-figure (he writes), nor as a mother-figure . . . And even if I did want a God who restored me to childhood, my professional conscience would not allow me to endorse such a wish' (p. 283). On this point Rycroft is in moral agreement with Freud.

Rycroft also says: 'I do not want Him to explain the universe for me or to invoke Him as a First Cause or Prime Mover . . . I do not . . . want a God who will provide me with a cosmology, and I am, therefore, dispensing with Him in the role for which until recently he was most often wanted' (p. 282). Rycroft takes 'cosmology' in the sense in which the cosmology of Christianity in the middle ages has since been superseded by scientific astronomy. 'In the cosmological sense', he writes, 'God is, to my mind, dead' (p. 282). But this is not the only sense in which some of the claims Rycroft has in mind can be grasped. For instance, understood in a spiritual sense, there need be no conflict between the claim that God created the universe and the so-called 'big bang theory of the universe'. It is clear that Rycroft is here rejecting a metaphysical conception of God.

So far what Rycroft says is negative: 'the God I do not want'. His positive statements are, to my mind, too general and ambiguous. The God they portray is rather pale; his features are too general to be able to sustain the depth of spirituality of which the Christian God can be the focus. Still I think we can agree on this much, namely that Rycroft is looking for Him in the right direction insofar as it is one which is diametrically opposed to the direction in which Freud found the God he rejected. What he says is that belief in God can be an 'affirmation of love' and he identifies the God he wants with love.

Such a God is not an object, in the widest sense of the term, nor is He a foil for the projection of the believer's fears and wishes. He does not offer consolations for the believer's weaknesses or compensations for his pains and frustrations. Rycroft sees a certain parallel between the idea of God as an object, a God whose attrib-

utes are the properties of such an object, and the ideas of the mind as a substance and of Freud's unconscious as a region in that substance. In such a conception the unconscious is invested with causal powers whose operations by-pass the individual as an 'intentional agent'. 'There is . . . a growing body of literature which suggests that there may be something intrinsically paradoxical about the enterprise of applying the scientific method to human beings . . . and that the point of psycho-analysis may lie not in its capacity to elucidate the causes of human behaviour but in making sense of it' (p. 286). This is a point he has developed in a paper (in the same collection) entitled 'Causes and Meaning'. In the present paper he suggests, similarly, that the existence of God is not, or at any rate need not be, an hypothesis about the existence of an object for the believer, one which is causally responsible for what befalls us as well as everything else we find in life. Rather a belief in God, at least the one that makes sense to him helps the believer to make *sense* of life—of what is to be met there, of the pains, frustrations and deprivations to be found there, of the good and evil that is part of that life which ends in death—a sense, not an explanation, one which calls for a certain kind of *response*.

Rycroft does not elucidate the character of the response, but he says that it comes from that side of the believer which gives him the capacity to give himself to others, to attend to them in their distress, to forgive them their trespasses, to share their joys in gladness. For belief in his God, he says, is the affirmation of just such a love. When this kind of religious belief in someone in analysis is genuine, he says, it is not subject to analysis, for there is nothing further about it which can be analysed. It is an expression of the kind of love it affirms having become part of the person, of his having made it his own. In such a case the love in question does not exist in dissociation from the person's will, it is not in conflict with any ego-centric side to him, it is not used to stave off anything unwelcome. In other words, there is no inner division within the person to be made accessible through analysis for it to be healed by inner work so the analysand can come to greater wholeness.

Let me note, in passing, the parallel between this and what Melanie Klein says about the fate of the Freudian super-ego in a successful analysis. When the patient's morality has its source in the super-ego it is subject to analysis. For, she agrees with Freud, the super-ego is a part of the self divided from the rest and stand-

ing in the way of its autonomy. When, however, the patient makes
his morality his own the super-ego changes into a 'genuine con-
science' and the patient himself changes in the process, attaining
greater wholeness in himself. There is then nothing further for the
analysis to say about it.

The kind of religious belief which Rycroft tells us he can make
sense of, he says, is an expression of such wholeness, because the
kind of love of which it is an affirmation, when it is genuine, is the
very *antithesis* of what turns a person on himself, puts him at the
centre of his considerations, eclipsing from him other people's full
reality. It is in just the kind of engagements which such love makes
possible that the believer finds a meaning in life which is inde-
pendent of his own successes and failures. It is precisely this capac-
ity for love that enables him to outgrow what is ego-centric in him
and thus to find greater wholeness.

Rycroft compares Freud's God, whose attributes are what the
believer *projects* onto him, with the psycho-analyst as a transference-
figure in analysis. Projection is a form of dissociation, defensive in
character: the patient externalizes what belongs to him and relin-
quishes responsibility for it. He both expects everything from such
a figure and also feels himself under its power and so fears it.
Analysts are familiar with this attitude towards themselves in their
patients. Rycroft contrasts a God which is the focus of the believer's
projections with a God belief in whom is an 'affirmation of love', so
that one who believes in Him is, in his belief, at one with himself in
the kind of love his God stands for. Since in this oneness the
believer finds wholeness, Rycroft says that 'integrity, wholeness,
health and insight . . . may be recovered either by psychoanalysis or
by communion with God' (p. 290). By *health* he means what results
from the healing of splits or divisions that are endemic to a person's
very mode of being. The *insight* of which he speaks is, I think, the
kind of knowing of what matters to one, and so of what to do in sit-
uations which pose problems for one, a knowing of what to make
of things which affect one personally, of how to respond to them. It
is a form of knowing which involves a person in his wholeness and
which cannot be separated from the person. As such it belongs to
his affective orientation. Rycroft contrasts it with intellectual appre-
hension and scientific knowledge.

He speaks of the language of religion as 'the subjective,
metaphorical language of insight' and contrasts it with what he

calls 'the objective language we use when dealing with the impersonal'. He does not say much to clarify this contrast, but what I can extract from what he says comes to the following. In its everyday sense *insight* is not something confined to religion or psychology. It means grasping a truth directly, cutting through what commonly blurs, diffuses, or deflects thought. 'Metaphorical' is not, I think the word Rycroft wants for the language that conveys the kind of insight he has in mind. For what is expressed in metaphors can be expressed in literal terms. Some philosophers and theologians who, like Rycroft, thought of religious language as metaphorical wanted, in the name of clarity and directness, to replace metaphor with literal speech and ended with an attenuated sense of what is expressed in that language. I shall argue in the following section that Rycroft's account of the God he wants suffers from this kind of attenuation. Such 'demythologizing', as it has been called, is as unfeasible in religion as it is in poetry. What is needed for those for whom the language in question poses problems is *clarification*. Its equivalent in the case of poetry is literary criticism. What, I think, Rycroft has in mind when he characterizes the language of religion as 'metaphorical' is precisely the parallel he finds between religious language and the language of literature: the way each speaks about life and the kind of perspective it conveys which people can take into their lives.

The word 'subjective', which others have used in this connection like Rycroft, is equally misleading. It suggests a kind of 'free for all' in which anyone can understand what he likes. What, I think, Rycroft wishes to convey is that the assent to what is true here, in the insight which one comes to, must come from the person. In the case of scientific truth a person properly puts his feelings aside as irrelevant. Reason, in the sense of what counts as good reason here, and evidence, override the person. *Anyone* who understands what is in question has to go along with it. Such reason is *impersonal*, it by-passes the person so that assent to the truth is dictated by the object. Hence the term 'objectivity' used in connection with science and the kind of knowledge that belongs to it. Indeed, there is a sense in which the objective person does not affirm the truth; he simply puts himself at the disposal of what is impersonal, namely reason and evidence. The person who does so where life, art, morality, and religion are concerned has no insight and simply conveys what is second-hand. Nietzsche describes him

as 'the objective man' to which George Eliot's Causabon constitutes a very good example. As his wife Dorothea is to discover to her great disappointment, the wisdom she thought he had is a sham, and he has nothing to give or share with her.

It is in this sense that religious, in the sense of spiritual, truths are *personal*. I think 'personal' is a less misleading term than 'subjective'. One who is detached, and in that sense takes an objective stance, cannot have access to the wisdom or insight one can find in it. Here 'whether I like it or not, what it says is true' is an evasion. If my belief is a delusion or my lack of belief is a form of blindness, there can be no removal of the blindness or delusion without my changing *in myself*. What leads you to assent to a particular religious belief may be perfectly clear to me intellectually; but unless it engages me *in myself* the way it engages you, and no doubt others as well, I cannot give my assent to it, I cannot in all honesty call it 'true'.

Assent to religious truth is thus not a matter of the intellect alone. Here the intellect has to be part of the person, that is to be at one with and work through his feelings—feelings he has made his own. He cannot subordinate himself, his feelings, to the intellect, as in the sciences. Such subordination in one's responses to life would amount to a form of dissociation—to be noticed particularly in academic circles where the intellect is overvalued. T.S. Eliot praised the metaphysical poets, of which John Donne is one, by saying that they had their intellect in their finger tips. In other words their intellect was accessible to them even when they wrote about matters of passion and sensuality; it was not dissociated from their sensibility. Such a dissociation would have left their sensibility impoverished, and their response, when they brought in the intellect, would have been 'cerebral' or 'mental' in the sense in which D.H. Lawrence uses these terms. In either case it would have been fatal to their poetry.

Rycroft also mentions Eliot and argues that a religion that is in competition with the sciences, and so emulates them, encourages a dissociated conception of God. So he says that the God of such a religion is not the kind of God he personally wants. He does not want such a God for others either, he says (p. 284). He thus rejects a *rationalist* conception of God for encouraging such a dissociation; 'I am placing God in the realm of feelings,' he says, and thus in the realm of the personal (p. 284). Only such a God engages the believer as a whole.

9.3 CRITIQUE OF RYCROFT: THE PSYCHOLOGICAL AND THE INDIVIDUAL

I have tried to articulate the kind of conception of God Rycroft develops when conveying what kind of God he can make sense of personally, as someone who has been trained as a psycho-analyst—and that means as someone who has changed in himself in the course of a personal analysis and has learned from its insights. I have tried to make the best of what I have found in what he says, reading between the lines in the light of my knowledge of psycho-analysis and my acquaintance with the writings of such analysts as Melanie Klein, Winnicott, and others who have developed Freud's work and tried to rectify its various faults.

It is clear that the God Rycroft wants and speaks about is, or at any rate is meant to be, a *spiritual* as opposed to a *metaphysical* God. It is further also clear that his opposition to a metaphysical God is both conceptual and spiritual, and also, he says more than once, professional—and I take it he means psychological. He says, 'the God I want would not ordinarily be recognised as one; or, to put it . . . more honestly, I do not want a God in any sense in which that word is ordinarily understood' (p. 291). This, of course, depends on what is meant by 'ordinary' and on how what anyone's understanding amounts to is assessed. Here I remember some words by Simone Weil to the effect that if you want to know what kind of God, say a judge, believes in, look at the words he speaks when he sentences a criminal in court, not at what he says in church. Rycroft should be sympathetic to these words. He goes on: 'some kinds of God have become unavailable to me, since my professional training and conscience would compel me to interpret them as wish-fulfilling illusions' (p. 291). I guess a God who guarantees that if one is a good boy all one's sufferings will be compensated and all one's good deeds will be rewarded at some future date would be an example. Rycroft is at one with Freud about the kind of God he rejects.

I want to return, briefly, to the question why Rycroft thinks that the God he wants 'would not ordinarily be recognized as one'. Partly, I think, because Rycroft is unable to make any sense, except a metaphysical one, of the theological claims made about God, His attributes, and what He has in store for the good and the bad. As

such Rycroft rejects them. Consequently what he is left with does not seem to him to agree with the God ordinary Christians believe in as described in the traditional terms of Christian theology. This is one reason. But, in any case, and secondly, there is indeed a natural tendency to give a metaphysical twist to the sense of these traditional terms—just as there is a natural tendency to think of man's soul as a little invisible bird within that will be released and fly away into another world at death.

Such metaphysical conceptions which, as Wittgenstein said, arise when language is like an engine idling, can and I suspect have in fact become part of a tradition shaping ordinary religious consciousness in Christianity. I mean, they assume a life of their own and give Christianity a worldly twist. It is, I think, primarily from this *worldly* strand in Christianity that Rycroft tries to detach his conception of God and the God he wants. It is *this* worldly God, in metaphysical clothing, which it seems many Christians believe in, that Rycroft has in mind when he speaks of the sense in which God is 'ordinarily' understood by Christians.

What about Rycroft's God? How far does Rycroft manage to put Him in a pivotal position in a spiritual life? After all someone may sincerely say that his God is love and this may not be very different, in logic, from saying of someone that his God is power or money, in the sense that he attaches supreme importance to these things, indeed worships them in the way he lives. This is hardly what one would call a religious conception of God—not even in a worldly sense. Does he belong with people who erect an altar to power, surround it with certain rituals, have a special language in which it is given new connections and assumes a particular significance in the light of these connections? Similarly for love. Anyway, the question is: What kind of love?

To be fair to Rycroft, when he speaks of love and its affirmation, he needs to be understood in a context, by now well known in psycho-analysis, where human love is seen as subject to growth in depth and quality with the development of the individual, and where its 'mature' varieties are explicitly connected with such moral notions as remorse, forgiveness and gratitude. In what I have said I have myself taken this as understood and have made it explicit where it is implicit in what Rycroft says. I have in fact connected mature love with growth out of ego-centricity. But what is the notion of 'maturity' involved here? As Rycroft points out, 'psy-

cho-analysts do not always agree as to what is meant by maturity'
(p. 288). At any rate until that is made clear and more substance
is given to the love affirmed by indicating the position the person
affirming it gives it in his life and the connections it assumes there,
its spiritual character is bound to remain vague. Does the respect
which belongs to it give the life of those towards whom it is
directed a sacred character? After all respect on its own, though a
moral notion, is not a religious concept as such. This applies
equally to the things with which Rycroft connects love, if only
implicitly: gratitude, forgiveness, and the rest. More is needed to
turn it into a religious notion and to make its affirmation into a
religious belief.

In me Rycroft has a sympathetic critic. For I am prepared to
agree that a particular individual who doesn't speak the language
of God, of the God of Christ, may nevertheless, in the course of his
life and unknown to him as such, may have gone through the fire
of the love of God—just such a God. In him the expression and
affirmation, in particular contexts, of a love that can be seen by
others to shine in its purity, may well amount to, for those who
speak the language of Christianity, a love of and belief in God. He
can, that is, be attributed such a belief, but only by those who
speak the language in question. It is in that language that such a
belief and its object is identified. It is from such a language that
Rycroft stands too much at a distance when portraying the God he
wants. No wonder he says that his God is very different from the
Christian God as *ordinarily* understood. In trying to distance him-
self from that language as 'ordinarily understood' he distances
himself from that language altogether and so loses sight of the
connections it makes between the love affirmed and various things
in the life of the culture to which the person affirming it belongs—
seen from a particular perspective.

The result is that he finds himself confined to express these
connections, not surprisingly, in psychological terms. We have
already seen that he likens the religion he can make sense of to
psycho-analysis: in its language, its use of myths, in its placing of
the individual at the centre of its concern. It could be said that reli-
gion is palatable to him through the insights of psycho-analysis.
Thus he says, for instance, that the God he wants, both for himself
and for others, is one who would annul the dissociation of sensi-
bility which a rationalist conception of God accentuates—annuls it

by an act of synthesis (p. 284). He seems to value and want it for its therapeutic and, perhaps, also moral character. He writes, we have seen, that 'integrity, wholeness, health and insight . . . may be recovered, either by psycho-analysis or by communion with God' (p. 290). No doubt, this is true. But in psycho-analysis wholeness is, or at any rate may be, the object of the enterprise. In religion that is not so, and the wholeness which the believer finds there is a bonus. Perhaps there is a sense in which this is also true in psycho-analysis. For one of the lessons which the analysand may learn in his analysis is that wholeness, like happiness, cannot be sought directly. Having learned this lesson the analysand may be able to give himself to his analysis unconditionally and so begin to move towards the wholeness which has so far eluded him. Nevertheless there is still a sense in which the analysand may be said to be seeking the kind of wholeness which is at least one of the objects of the therapy.

In any case, is spiritual wholeness the same as the wholeness sought in therapy? Rycroft, himself, is uneasy about the identification of the one with the other. He writes that he may have laid himself open to the charge that in what he says he suggests that 'the religious quest can be restated in terms of health, depression and the manic denial of depression' (p. 282). Such an accusation would, I think, be unfair. But it still remains true that he tends to run together the spiritual and the psychological. 'Health (he writes), which is both a medical and a religious concept may be defined in terms of . . . the attainment of an inner state of wholeness' (p. 288).

I agree that 'health' is a normative concept in both connections, but that in itself does not make the medical and the religious concepts of health the same. At most one can say that just as a healthy mind can only be found or, perhaps, is normally to be found, in a healthy body (as the saying goes), so similarly, spiritual health does not exist entirely in separation from mental or psychological health. At any rate I am inclined to think that although they are not identical, the spiritual does not exist in limbo from the psychological; they interpenetrate one another.

Plato identifies spiritual health with goodness, and goodness cannot be explained in psychological terms without destroying it or giving it a corrupt aspect. What I mean is that there cannot be a psychological answer to the question, 'What makes him good?'

or 'Why is he good?' For if one thinks—as indeed Freud did—that goodness is something towards which a person's psychology disposes him then one downgrades it, one turns it into something else. If I may put it like this: what makes a person good is the goodness in him or the goodness to which he comes in his development as an individual. What makes him good is what the goodness that finds expression in his life and actions means to him. This is, of course, another way of saying that his goodness, when it is genuine, can have no psychological explanation. One may even say that it is the way that love, the concern and compassion he feels for others, work in his life. We may say that it is this that makes him good. But then there is no psychological question to be answered as to what makes him compassionate or what gives him a loving nature. At most, if it is something to which he has come, we can say how he has come to it.

It still remains true, however, that to attain goodness a man must overcome certain psychological barriers in himself and in doing so turn around in himself. A convincing portrait of goodness in a person needs to be psychologically convincing as well. This is something any great novelist knows. Some people have argued, for instance, that in Prince Myshkin Dostoyevsky has not succeeded in giving a convincing portrait of goodness or saintliness. A convincing portrait of goodness would have to be in terms of a psychology that leaves the good man open to goodness. In such a portrait we have to see a psychology that does not stand in the way of goodness engaging him at the deepest level, one which leaves him free to respond in ways that are an expression of goodness. The freedom which his psychology thus gives or allows him does not, of course, explain his goodness. Otherwise it would not be *he* who is good; whatever he would be as a result would not be genuine goodness. If he is genuinely good, that goodness must come from *him*, not from his psychology.

For Plato a person who is alienated from goodness by the evil he has done, or by his indifference, lacks spiritual health. I have argued elsewhere that the remorse such a person feels in the first case is an expression of self-division. This is not controversial. But I have also argued that the indifferent man for whom goodness holds no attraction and means nothing is someone who in his egocentricity has not come to himself. Although he may not be divided in himself, he lacks the kind of wholeness which comes

from the kind of engagement with life, and this involves other people in one way or another, which the ego-centricity of evil or of indifference to goodness prevents. If I am right, then the link between Plato's notion of spiritual health and Rycroft's notion of psychological wholeness is closer than we may at first think. Indeed it may turn out that the idea that a patient's spiritual health is of no concern to his analyst, since it falls outside the province of psycho-analytic therapy, conceived of on a medical or quasi-medical model, is a misconception.

9.4 PSYCHO-ANALYSIS, RELIGION, AND THE INDIVIDUAL

I shall return to this question presently. Rycroft agrees with what I have said about the way goodness and the spiritual lies beyond psychological explanation. He says that the God he wants 'must be immune to interpretation'—he means psycho-analytic interpretation. He says that such a God 'cannot be one who either recreates for me the blissful security of childhood or who compensates me for the bliss which I perhaps never enjoyed' (p. 283). The ideas that all religious beliefs are interpretable, that they are the product of wishful thinking, and so on, that the super-ego is the most one can find of 'what people call the "higher" things of human life' (Freud 1933, p. 82, 95), that all thinking is rationalization, all love is transference, belong to the excesses of Freudian thinking. None of these is an integral part of the psycho-analytic framework. I have called them 'philosophical froth'. This is not to deny that Freud advanced these ideas in perfect seriousness. Many psycho-analysts after him have taken them seriously enough to wish and try to rectify Freud's excesses while remaining faithful to his insights. They have also added their own insights to those of Freud while developing psycho-analytic thinking. Rycroft is one such psycho-analyst.

Thus where a patient's religious beliefs are sincere and genuine I do not see what it would be to psycho-analyse them. I do not believe that an analyst whose mind is free from prejudice and indoctrination would attempt to do so. Someone will tell me, 'but psycho-analytic training is a form of indoctrination, what else can

it be, it is bound to stand in the way of the development of wisdom'. I would remind him that the same has been said of religious training. Let us suppose that a genuinely religious patient has religious problems and he brings them to analysis. A psycho-analyst to whom the religious ideas of the patient are alien and who cannot sympathetically enter into his problems obviously cannot help the patient. If he is wise he would have the good sense to appreciate this and stand aside as far as those problems are concerned.

This is not to say that there may not be room for psycho-analytic work in investigating the psychological surroundings of these problems. Imagine a similar situation with a patient who has genuinely philosophical problems: why does he shilly-shally with them so? Why does he evade getting down to serious philosophical work on them, dramatizing his difficulties? A person may in his work face deep philosophical problems which are difficult to resolve. The way he stays with them, the way they absorb and trouble him, may be a measure of his seriousness. But, in someone else, what appears to be such seriousness may, on closer acquaintance, turn out to be something quite different. He may be an 'eternal student' with his problems, capitalizing on them by keeping them alive. This could be true even when he is genuinely interested in the matters that give rise to these problems. I give this as one example of the intermix between the genuine and the 'pathological'.

To return to the patient with genuine religious problems. If his analyst can enter into them he can be of help in discussing them with his patient in the way that a wise counsellor would. It would be enough for him to listen to and give the patient his full attention as the patient talks. It is sometimes forgotten that listening, what I am inclined to call 'active listening', that is listening to which the analyst puts himself in the attention he gives to his patient, constitutes a good part of psycho-analytic therapy. The analyst intervenes with interpretations generally when the patient is not himself in what he says, hides something, or is deceiving himself in what he says. In the case of the patient who talks about his religious problems, even where he is perfectly genuine in his religious beliefs, other aspects of his personality do not have to be excluded from the discussion or analysis. For, as I said, they may turn out to have a bearing on his religious problems.

Besides, a person's religious and moral beliefs, as I said, when they are genuine, like his love for someone when it is sincere, come from him, they are 'his' in the strong sense of that term. I mean they do not just happen to be what he believes because he was brought up that way; he has made them his own. I do not mean anything necessarily dramatic by this: in the process of his growth and development they have become his. In them his whole way of being comes to be involved. Why should we rule out *clarifying* what his love of God or his love of his friend or lover engages in him, what part of himself he gives to the loved one, with what part of himself he responds to what concerns him? Such clarification is not something alien to analysis and may even deepen the patient in his convictions and feelings. It may, of course, reveal that things are not quite what they seem, and then the scrutiny may open up problems for the patient from a consideration of which he may move one way or another in himself, changing in one direction or another.

I want to return now to a question I wanted to say more about at the end of the previous section. Rycroft writes: 'Those who have had a religious upbringing will tend to affirm [their love] in religious terms, while those who have had a secular upbringing will do so in secular terms, but I doubt whether those who affirm in one mode differ essentially from those who do so in the other' (p. 282). Here Rycroft is not taking sufficiently seriously the difference which the language one speaks makes to the way one sees things, to the significance they assume for one, and so to one's problems. He does not take sufficiently seriously the difference it makes to the feelings one can express in that language and so to the feelings one is capable of expressing in situations to the significance of which it contributes or which it shapes in the perspective it gives us on them. I have already said that whether the love someone affirms has a spiritual role in a person's life shows in how he speaks about things.

This said, it is of course possible for someone who has had a secular upbringing to have a love in him which makes such a difference to his responses to people and give him such an outlook on things that it amounts to what a Christian may call a love of God. The problems such a person may meet when he faces the ingratitude and even betrayal of those he loves and has made sacrifices for, or the suffering and death of loved ones, however he

expresses himself, are spiritual problems. He may, for instance, feel discouraged, hurt, feel on the verge of losing hope and giving up. His very vision of things may start tottering, his belief in goodness may begin losing certainty. He may wonder whether he has been a fool.

Some people will speak of these as 'psychological problems'. A psycho-analyst may classify them as such and see them as emanating from 'depression'. Yet there may be a close affinity in what he has to say about them and what a deeply religious person does. I was first struck by this a great many years ago when in *The Brothers Karamazov* I was reading a chapter in which father Zossima was exercising his healing powers. Some peasant women who understood the language of faith had come to see him. One of them—I am speaking from memory—had lost her little boy and her life had come to a standstill. Father Zossima spoke to her only a few words that addressed her emotions and went right to the root of her problem. He told her to cry and not be consoled, but to remember that her little boy was in heaven with the angels. He touched and blessed her and she, thanking him, left greatly calmed.

With the words he spoke Father Zossima led her to a position, in terms of the perspective of her feelings, to which someone else in a similar situation may be led, or herself come to, in a personal analysis. 'Do not be consoled' here means 'do not let anything—any consideration—stop you grieving or hurry you. Grieve and be patient.' 'Your little boy is in heaven with the angels' is meant to convey to her that though he has been wrenched from and taken outside her physical reach, he is being cared for, he has not been abandoned. In terms of her feelings he is not outside the reach of her care. She can think of him as flourishing; what she wants for him is being granted. 'You feel you have lost a piece of your flesh, of yourself, of your life; but you are still connected. In your grieving you think of him with love. In that love he will be restored to you: he will continue to live in your feelings. Though you will always continue to miss him you will find the wholeness you had with him and lost with his death. At present you feel you have nothing and no one to give of yourself to; but in time when you can think of your boy as well again, when your love will have healed him in your feelings, you will find other things in life to engage your love, to give yourself to. Indeed, in that engagement you will

be faithful to your boy, faithful in your very love for him. In this way you will find peace and your life will begin to move again. But now stay with your pain, it is the pain of love, and keep faith with your grief in patience.'

I have put in secular terms and without any psycho-analytic jargon what Father Zossima conveys to the peasant woman in the language of her faith and what a patient in a similar situation may find out in her personal analysis with a Kleinian psycho-analyst. I quoted Rycroft's words: 'those who have had a religious upbringing will tend to affirm [their love] in religious terms, while those who have had a secular upbringing will do so in secular terms', but what they express comes to the same thing. I was critical: not any such affirmation amounts to a belief in a spiritual God and the language of religion makes a difference to the love that a person comes to in his life. On the other hand there is something right in what Rycroft says. Grief at the loss of a loved one is a universal phenomenon and the insight which Christianity brings to it is not the unique possession of Christianity. One finds it in what psycho-analysts have written about grief, and a patient can come to it in his analysis.

Let me make it perfectly clear that I was not suggesting, in secular terms, an analysis of the religious terms used by Father Zossima in what he said to the peasant woman he spoke to—an analysis of the language of heaven and the angels. These terms have a great many connections in the language of Christianity and Father Zossima relied on only a few of these in what he said to the woman whose grief he addressed. I was only suggesting what they convey in that limited context. I agree with Rycroft that in such a particular context the insight conveyed by them is not confined to Christianity.

This is, of course, very far from Freud's view that the language of religion is the language of a mass illusion, one in which people are deceived—deceived about life or the world and deceived in and about themselves.

9.5 RELIGIONS AS PRODUCTS OF HUMAN CULTURE

The question I have been concerned with is: Are psycho-analysis and religion incompatible? Can a psycho-analyst leave his patient's

religious beliefs, when they are genuine and sincere, alone? Is there anything about psycho-analysis that would prevent the psycho-analyst from understanding his patient's religious beliefs and religious problems in their own terms. *Ultimately* do they have to be something else for him?

My answer to this question in its final version has been: for Freud they have to be something else in their *final* analysis, but not for psycho-analysis. I have tried to indicate why this had to be so for Freud and why it doesn't have to be so for psycho-analysis. I have tried to bring this out through a consideration of a paper by Rycroft, a recent psycho-analyst, imaginative and independent in his views. My consideration has been at once sympathetic and critical. In this paper he does not speak about religions in the plural but about the God he can make sense of in the religion in which he has been brought up, namely Christianity. The religion he speaks about is above all a spiritual religion and he finds no incompatibility between belief in such a religion and the psycho-analytic investigation of his personality on the part of the believer. Indeed, he finds a close parallel between the kind of insight a person can come to in religious belief and in psycho-analysis. I have been concerned to make up my mind about how far he is right.

At the beginning of this paper I subdivided the question about the *ultimate explanation* of religion in psycho-analysis into two: (i) that of a patient's or analysand's religious beliefs and (ii) those of a particular religion. I have not discussed the second question. The beliefs of a religion belong to a particular culture. Freud recognizes this and still advances a *psychological* explanation for their existence and their content. Rycroft does not touch on this question. But obviously the *clarification* of the content of the beliefs of a religion, where they raise problems of understanding, belongs to philosophy and calls for a particular kind of sympathy and imagination. Even then though there are additional problems: what are we to take to be the content of these beliefs? As held by *whom*? For Christians do not agree amongst themselves and the differences between them are not wholly differences in what they *say*, that is, differences in the accounts they give of their beliefs. Where are we to look for what may be called the tradition when those who belong to it disagree amongst themselves? I think the best thing to do is to note the various possibilities within the tradition, or at any

rate those that interest one, and to consider them individually.
This comes nearest to what I have done.

Returning to the question of explanation, I said that where
individual beliefs are genuine there can be no psychological expla-
nation of them. One can, of course, ask: how has some particular
person come to hold these beliefs? But, obviously, there must be a
special context for this question to make sense: for instance, how
did he come to hold these beliefs when he has had a specifically
secular upbringing? Sometimes the answer may be psychologically
relevant; it may throw light on the person's psychology.

Similarly for the cultural question: why did the people of Israel
come to hold such-and-such religious beliefs? Why did this kind of
religion develop at such-and-such a time among these people?
One can ask a similar question about psycho-analysis too: why did
psycho-analysis develop in Vienna at the turn of the century?
These are historical questions about cultural developments. But
the answer to them, whatever it may be, in no way undermines the
worth of the ideas in question or the truth which people find in
the beliefs they acquire within the framework of these ideas.

To touch, finally, on an idea which engenders much misun-
derstanding and raises people's hackles. To say that any particular
God, any God whom anyone believes in, belongs to a religion, and
any religion belongs to or is part of a culture and, in that sense, a
product of culture and, therefore, of complex historical, sociolog-
ical and physico-geographical circumstances, is not to say that God
is man-made, a human creation. It is not to say that the reality of
the God, for instance, sincere Christians believe in is an illusion—
as Freud says for similar reasons.

God is no more an invention than our language and our moral
values are. The world in which we live, the human world, is to a
large extent the product of the language we speak, and the reali-
ties that form part of this world, including the reality of physical
things and phenomena, are internal to this language. This does
not mean that physical things do not exist independently of us, the
speakers of that language. Our language certainly exists indepen-
dently of the individuals who speak it. Far from our language,
including the religious language or languages which people speak,
being an invention of those who speak it, it is we, its speakers, who
are what we are, human beings, in the language we speak, and we
find our individuality in that language. The reality of God and of

particular moral values, for those who believe in them, is radically different from the reality of physical things. But this is not to say that these things are in any sense less real, that their reality is a fiction or an illusion.

In any case I have neither affirmed nor denied the reality of any God. I said that the God of a particular religion has reality for those who belong to that religion and believe in him. It is not an illusion, as Freud claims. In a similar vein I said that there are many different Gods. This in no way contradicts the Christian or Muslim who says 'There is only one God'. The statement 'there are many Gods' is what one may call an *observation statement* which I made as a philosopher. A sociologist or anthropologist could have made the same statement. It has an 'objective status' in the sense I have explained. In contrast, 'there is only one God', is a *personal statement*, a 'confession', made from within a particular religion. If the person speaking it were to say to me, 'the other Gods, or so-called Gods (perhaps avoiding the capital letter), to which you refer are false Gods, illusions, again he would not have said anything that I should wish either to contradict or to affirm.

As a philosopher I am in the business of *clarifying* what I observe—for example beliefs belonging to a particular religion working in and changing the lives of those who affirm those beliefs, the lives, that is, of those speaking the language of that religion: how do they understand these beliefs and what do they mean to the believer? I am not in the business of affirming or denying any of these beliefs. These are two very different things.

10 Dostoyevsky's Raskolnikov: Psychology and the Soul

10.1 DOSTOYEVSKY'S NOVEL: A STUDY IN INDIVIDUAL PSYCHOLOGY

It is a truism that Dostoyevsky's novel *Crime and Punishment* is a study of crime and punishment. Its movement revolves around a single action, Raskolnikov's murder of a pawnbroker Alyona Ivanovna and her simple-minded and meek half-sister Lisaveta. The book is a narrative account of how Raskolnikov comes to commit such an act and then how its significance, seen from the perspective of the Christian morality in which Raskolnikov was brought up, sinks into his consciousness in the teeth of his desperate attempts to evade it. It is an account of the devastation which this single act brings to his life and the way Raskolnikov perpetuates and compounds this devastation in refusing to accept responsibility for it.

The suffering brought about by his denial, the anxiety and isolation which belongs to placing himself in the position of a hunted animal, masks a deeper suffering, bound up with his inability to give and to accept love, and with his knowing, however intermittently, how he has hurt those he loves. This is as far as the responsibility he accepts goes. Even in the first year of his life in the penitentiary he will not admit that he has committed a crime:

> 'Why does my action strike them as so hideous?' he kept saying to himself. 'Is it because it was a crime? What does "crime" mean? My conscience is clear. No doubt I have committed a criminal offence, no doubt I violated the letter of the law and blood was shed. All right, execute me for the letter of the law and have done with it!' (p. 552)

187

Raskolnikov is in the grip of an ideology, but that ideology is in collusion with an individual psychology which the book studies in depth. It is also a critique of the ideology from the perspective of the beliefs of Christianity from which it is written. As such it focuses on Raskolnikov's soul. But how is Raskolnikov's psychology responsible for the plight of his soul? This is the question at the centre of my interest.

10.2 RASKOLNIKOV'S IDEOLOGY AND DOSTOYEVSKY'S RESPONSE

I turn first to Raskolnikov's radical ideology and its role in the way Raskolnikov is led to commit murder and deny responsibility for it in its full significance.

> 'Crime? What crime?' he exclaimed in a kind of sudden frenzy. 'That I killed a nasty, harmful, wicked louse, an old hag of a money-lender, a woman who was of no use to anybody, for whose murder a score of sins should be forgiven, a woman who made the life of the poor a hell on earth—do you call that a crime? (p. 529)

This is his last conversation with his sister Dunya before giving himself up. He is defiant:

> 'I'm not thinking of wiping it out. And what do they mean by pointing their fingers at me on all sides—a crime, a crime, a crime! It is only now that I see clearly the whole absurdity of my cowardliness, now that I've made up my mind to accept this unnecessary disgrace! I've made up my mind to do it [he means to give himself up] simply because I'm a mean and second-rate fellow, and perhaps, too, because it may be in my interest—as that Porfiry puts it'. (pp. 530–31)

He means because he has lost his nerve and hasn't been able to sustain his original courage, as he sees it. He is angry with himself for that. He will give himself up to punishment, yes, but only because he has failed; he will, however, do so proudly, defiantly. As he puts it later: 'Those men—the benefactors of mankind who seized power instead of inheriting it—were successful and so *they were right*, and I was not successful and therefore I had no right to permit myself such a step.'

He wants to kick himself for his failure, as he sees it, and is prepared to let the authorities do this for him. He doesn't accept *their* punishment. That would involve humbling himself; and he doesn't have enough togetherness and inner confidence to be able to do that. At the same time he goes along with their 'absurdity' and is prepared to conform to have his sentence reduced. He thus keeps himself proudly aloof while yielding to the superior strength of the authorities and suffering his failure. In his proud dejection he envies Svidrigaylov who had the strength to blow his brains out.

His sister is shocked: 'Roddy what are you saying? It was you who shed blood, wasn't it?' she cries in despair.

> 'Which all men shed,' he put in quickly, almost in a frenzy, 'which is being shed, and has always been shed in the world, oceans of it . . . and for which people are crowned in the Capital and afterwards called the benefactors of mankind'. (p. 530)

It is of course perfectly true that oceans of blood are shed and that the strong and successful are crowned for it. Dostoyevsky writes with compassion for the victims of such a world: Mrs Marmeladov for instance, who is dying of consumption in the poverty she is suffering with her young children. Unable to pay her rent she is chased out of her lodgings and takes to the street to look for justice:

> 'Let them all see, (she cries out), the whole of Petersburg, how the children of a gentleman who served his country faithfully and loyally and who can be truly said to have died at his post have been reduced to begging in the streets.'

Mrs Marmeladov, who had by now managed to invent this fantastic tale, believed it.

> Let the miserable little General see it . . . Everyone will at once see that we're different, that we are a poor, genteel family reduced to beggary. And . . . that miserable little General will lose his job. We shall be there every day under his windows, and if the Emperor drives past, I'll go down on my knees, put the children in front of me, show them to him and say, "Father, protect them." He's the father of all orphans, he's merciful, and he will protect them . . .' (p. 442)

The Emperor, in reality, has no eyes to see them and couldn't care less. He won't protect them and he will continue to be regarded as a father figure. He will be so regarded not because he is just and compassionate but because of the position he occupies. And he will keep that position by the exercise of the power vested in him.

Raskolnikov will get no argument from Dostoyevsky on that score: there is no justice in *this* world, and perhaps there *can't* be so long as what mainly counts in it is strength or power. Where Dostoyevsky differs from Raskolnikov is in his attitude to this world where justice is a scarce commodity and people are pushed around, prey on each other, suffer, and move about, without any clear view of where they are going. The only ones who don't prey on others are the most vulnerable, the simple-minded and pure at heart, the Lisavetas and Sonias of this world. Dostoyevsky depicts all this in the novel with great compassion.

Raskolnikov, by contrast, does not have a clear attitude, he is all mixed up. But in part of himself, the part with which he identifies himself in the murder he commits, he aspires to the success of the strong. He is armed with an ideology which supports him in such an identification.

> The 'extraordinary' man [he explains to Porfiry] has a right . . . to permit his conscience to step over certain obstacles, but only if it is absolutely necessary for the fulfilment of his idea on which quite possibly the welfare of all mankind may depend . . . If for some reason or another the discoveries of the Keplers and Newtons could not be made known to people except by sacrificing the lives of one . . . or [many] more men who made these discoveries impossible, or in any way prevented them from being made, then Newton would have had the right . . . to eliminate the dozen or hundred people so as to make his discoveries known to all mankind. That, however, does not at all mean that Newton would have had the right to murder anyone he liked indiscriminately. (p. 276)

He then goes on to argue 'that all lawgivers and arbiters of mankind . . . were without exception criminals because of the very fact that they had transgressed the ancient laws handed down by their ancestors and venerated by the people. Nor, of course, did they stop short of bloodshed . . . sometimes of innocent people fighting gallantly in defence of the ancient law' (*ibid*).

Dostoyevsky's answer to this line of argument comes from Sonia who has prostituted herself and ruined her life out of compassion for Mrs Marmeladov and her little children. Luzhin, a base character and a scoundrel, has accused Sonia during her father's funeral dinner, in the presence of Raskolnikov, of stealing a hundred-rouble note from him. In fact it is he, Luzhin himself, who has hidden it in her pocket. It is a little later when Raskolnikov goes to see her in her room to tell her who killed Lisaveta that he puts the same question to her:

> 'What would have happened if they'd sent you to prison? . . . Just imagine for a moment, Sonia, that you had known Luzhin's intentions beforehand . . . and that they would have brought about Mrs Marmeladov's and her children's utter ruin . . . Suppose if all this were suddenly left to your decision— I mean, whether he or they should go on living . . . How would you decide which of the two should die? I put this question to you.
> 'Why ask me something that could never happen?' Sonia replied with reluctance.

It is in fact Luzhin's accusation that sets going the train of events that result in Mrs Marmeladov being chased out of her lodgings and which end in her death. Raskolnikov insists:

> So in your opinion it is better that Luzhin should go on living and committing his abominations. You haven't the courage to decide even that?
> But how am I to know what God's intentions may be? And why do you ask me something one should never ask? . . . How could such a thing depend on my decision? Who made me a judge to decide who is to live and who is not to live? (pp. 421–22)

Dostoyevsky means that no human being should presume he could decide such a question. To *ask* that question is an expression of the kind of pride that made Raskolnikov divide human beings into those that are ordinary and those that are extraordinary. He asked that question about Alyona Ivanovna and decided that she was a louse and that she had to go for the good of those whose blood she sucked. In the 'rehearsal' of his plan he puts himself on the receiving end and experiences the way she sucks the blood of her victims first-hand.

With a chilling realism Dostoyevsky depicts her hardnosed heartlessness when Raskolnikov goes to see her to pawn his

father's watch. When later he confesses the murder to Sonia and tries to explain why he killed the pawnbroker, he says, 'But I only killed a louse, Sonia. A useless, nasty, harmful louse.' Her response is: 'A human being—a louse?' (p. 430).

From the perspective of Raskolnikov's ideology Alyona Ivanovna is a louse, a parasite; from Dostoyevsky's perspective of a religious or spiritual morality she is first a human being, no matter what she is like. It is that which counts. And while each perspective can stand on its own feet, so to speak, and can only be criticized from within a rival perspective, there is still a difference, it seems to me, between a religious morality and an ideology—even though a religion can turn into a mere ideology for its believers. An ideology is a system of ideas which organize the perceptions and judgements of its adherents without drawing its life from the life of the people to whom its adherents belong. There is thus, it seems to me, a narrowness about an ideology which pushes its adherents to fanaticism—a form of slavery: of ideas.

Raskolnikov's radical ideology responded to his psychological needs. That is what made it attractive to him. It gave those needs a framework within which they could be 'objectified'. It gave him a purpose which compensated for his lack of coherent self. But compensation for a lack is not the same thing as actually finding what one lacks. For Raskolnikov to find the inner unity he lacks he would have to grow out of the psychology in which he is in cahoots with his radical ideology. It is to this psychology that I now turn.

10.3 RASKOLNIKOV'S PSYCHOLOGY: HIS EMOTIONAL DEPENDENCE AND LACK OF INNER UNITY

Dostoyevsky paints a vivid picture of Raskolnikov's immaturity and lack of direction, of how little he feels himself to be a person in his own right. He is a university student living in a 'little room under the very roof of a tall five-storey building . . . more like a cupboard than a living room'. He is 'up to his neck in debt to his landlady'. He feels at her mercy, much in the way he is to feel in relation to the pawnbroker. In his poverty he has dropped out of university and yet this poverty is to some extent self-imposed in that he has given up supporting himself. He is absorbed in himself, leads a

cloistered life in his coffin-like room, is 'afraid of meeting anybody
let alone his landlady', 'he forgets to eat his meals and daydreams
of getting rich all at once' (p. 47). As he puts it later, he 'wanted
something for nothing, quickly, without having to work for it' (p.
170). Here we have an expression of that side of him which he
hates in the pawnbroker.

While the idea of the murder is hatching up in his mind he
indulges in soliloquies reminiscent of Hamlet. Dostoyevsky refers
to these as 'those bitter monologues about his own impotence and
indecision' (p. 22). Clearly it is his autonomy which he feels to be
on trial. The uncontributive form of existence he is content to rest
with increases the pressure to breaking point. While the idea of
the murder is taking him over in his self-absorption, he cannot
believe that he will carry it out. Yet with every step he takes the
excitement grows stronger at the prospect of the release of those
pent-up emotions which Dostoyevsky lets us have a glimpse of in
Raskolnikov's reaction to the long letter he receives from his
mother. The letter speaks of his sister's proposed marriage to
Luzhin and tells Raskolnikov that his mother and sister are com-
ing to Petersburgh to see him and to meet Luzhin.

In it we are shown something of the subtlety with which his
mother manipulates him, the way she double-binds him by taking
on the organization of his life while at the same time making it
into an act of self-sacrifice. He resents it and yet is rendered impo-
tent with feelings of guilt. He cannot give direct expression to his
anger. She tantalizes Raskolnikov by reporting Dunya to have said
that she would gladly marry a man like Luzhin for his brother
alone and then adding that this was, of course, only said as a joke.
One minute she lets it slip for Raskolnikov to see that Luzhin is a
base man and then she immediately denies this by enumerating
his virtues. Raskolnikov's indignation is thus roused and at the
same time stifled. He cannot go along with his sister's marriage to
a man she doesn't love, a man of base character. He cannot accept
her sacrifice; nor can he agree to being put in a position that
would make him beholden to a man like Luzhin. But he does not
feel he has been man enough for his mother and sister in their
need to have the right to forbid the marriage: 'What can you
promise them in return, to lay claim on such a right?' (p. 62).

He responds in much the same way later when he tries to save
a young girl, dead drunk, from being taken advantage of by a fat

dandy. After his first generous gesture he has second thoughts: 'What the hell made me interfere? Who am I to help her? Have I any right to help anyone? . . . What business is it of mine? And what right had I to give away the twenty copecks? They weren't mine, were they?' (p. 68). His mother had just sent them to him, but he didn't feel that he had earned or deserved them and so that they were his to give. He does not own enough of the goodness within him to put himself behind his act of generosity and to sustain it.

It is not that Raskolnikov doesn't love his mother and sister; he does. But he doesn't know how to care for them without becoming vulnerable to manipulation and exploitation. He is unable to give without feeling emasculated. He enacts this conflict, blows it up, in his rehearsal for the murder when he pawns his father's watch—his father being the person to whom he owes his life and in identification with whom he must have come to his particular masculinity. Thus in the pawnbroker Raskolnikov sees not only a part of himself which he hates; he also finds in her a grotesque exaggeration of everything he hates in his mother.

Dostoyevsky tells us that the problem which his mother's letter brings to a head for Raskolnikov is one of long standing: 'All these question were not new, nor did they occur to him just at that moment; they were old, old, questions, questions that had long worried him' (p. 63). Raskolnikov's way of dealing with them had been to try and beat his mother at her own game: he complied by abdicating the management of his life, remaining dependent and thus frustrating her hopes and expectations: 'You, Roddy [she says], are all we have in the world, our only hope of a better and brighter future. If only you are happy, we shall be happy' (p. 57). He sees to it that he will not be, but he collects a lot of guilt in pursuing this goal.

He thus both complies with his mother's wishes and defies her at the same time; he accepts her offer of a dependent relationship to spite her. The result is that he cannot respect himself. In this predicament he cannot have sufficient confidence in himself to be able to admit to being in the wrong and so he cannot make any reparation for the guilt he feels. Instead his bad conscience drives him to be more defiant, his sense of worthlessness drives him to seek compensation in delusions of grandeur, his grudges keep him from forgiving his mother and all those in whom he sees her

reflection, and the rage which builds up within him seeks to lash at those he blames for this situation, including a part of himself.

The dream he has before the rehearsal prior to the murder gives expression to this in its own language. As Dostoyevsky puts it: 'when people are in a bad state of health, their dreams are often remarkable for their extraordinary distinctness and vividness as well as for their great verisimilitude (p. 72). Dostoyevsky relates the dream in vivid detail with Raskolnikov's associations to its content. Very briefly, in it Raskolnikov is a boy of seven out for a walk in the country with his father. Along the road to the cemetery where his grandmother is buried they pass a pub in front of which is a huge cart to which a small, lean mare has been harnessed. The peasant Mikolka who owns her, is flogging her brutally and invites the drunken crowd from the pub: 'Come on! I'll drive you home! This here old nag of mine is just breaking my heart . . . Doesn't earn her keep. [This is an allusion to Raskolnikov.] Come on . . . get in, all of you, . . . I'll make her gallop all the way.' But the poor mare hasn't got the strength. They all join in the beating. One of the lads shouts: 'Why don't you strike her with an axe?'—an allusion to the murder Raskolnikov is planning. 'Finish her off!' Mikolka shouts with blind rage. The little boy is beside himself, he pushes his way through the crowd and puts his arms round the dead mare's bloodstained muzzle and kisses her. Then he jumps to his feet and rushes in a rage at Mikolka with his little fists. His father then steps forward and takes the little boy away: 'They're drunk; playing the fool. It's not our business. Come along!'

'It's not our business' are the words, we have seen, with which Raskolnikov later dissociates himself from his good, generous impulses. In the dream he puts the words into his father's mouth who leads him away from his compassion and outrage. The dream places these in the scene of brutality which anticipates the murder he is himself going to commit. The old mare with which Raskolnikov identities himself in sorrow and sympathy are the Mrs Marmeladovs of this world, for which Raskolnikov gives his last bit of money, and Sonia who slaves away for her and her children, and Lisaveta too whom he is going to murder. As he is going to find out, she comes as part of a package for anyone who thinks he can achieve good by evil means. But the mare is also a part of Raskolnikov—the part who cannot earn his keep and hasn't got

the strength to carry out his obligations. With Mikolka, Raskolnikov himself thinks he deserves a beating. In his weakness and dependency as a grown-up, he feels himself to have become parasitical and wishes to eliminate what makes him so. He will try to do so where he sees it writ large, namely in the person of the blood-sucking pawnbroker. Thus the mare stands for both these sides of Raskolnikov: Alyona Ivanovna as well as Lisaveta. He rejects the identification with Alyona Ivanovna by identifying himself with Mikolka—a grotesque caricature of the superman or extraordinary man in whom Raskolnikov hopes to escape his weakness and lack of autonomy.

Raskolnikov's idealization of the extraordinary man is thus an attempt to escape his dependent and weak self. It is also a vehicle for the expression of his wounded pride gone wrong and turned ego-centric. His mother tells Dunya how much she and her brother are alike 'in face as in spirit': 'melancholy, moody and quick-tempered, proud, and generous to a fault. I can't believe', she says, 'he is an egoist' (p. 257). All this is true. Fundamentally Raskolnikov is not an egoist, he cares about others and is generous to a fault. But he lacks wholeness and stops himself exercising these good qualities. We have seen how he is indeed generous to a fault one minute and dissociates himself from his generous act the next minute. He is proud in the good sense his mother means this: he always behaves with dignity and despises anything base. But his pride has been hurt by the shame he feels at his own dependency and impotence. That is why he tries to kid himself along with the thought that he is not ordinary, which he tries to prove to himself with disastrous consequences.

Raskolnikov is not an average person; he has qualities that set him apart from the people that crowd the Hay Market. But that does not make him morally superior to them or extraordinary. Indeed no one can think this of himself without arrogance. This is pride in the bad sense. It is this arrogance in Raskolnikov which shocks Sonia more than once. When Sonia tells him to confess his crime, accept suffering and be redeemed by it, his response is:

> No, I shan't go to them . . . How am I guilty before them? They themselves are destroying people by the million and consider it a good thing. They're swindlers and blackguards . . . And what am I to say? That I murdered the

old woman and did not dare to take the money? . . . Why, they'll laugh at me
. . . and call me a fool for not taking it. A coward and a fool. They won't
understand anything. (p. 434)

He chastises himself for being a failure, but he doesn't con-
sider himself to be guilty before *them*: who are they to judge him?
This feeling of being a failure is not an expression of humbleness.
On the contrary it presupposes an expectation of higher things
from himself than from others. In his shame for having been
unable to fulfil those expectations he holds on to them: 'I ought
to have fulfilled them.' He cannot humbly accept himself for what
he is.

Sonia tells him to go and stand at the crossroads, bow down,
first kiss the earth he has defiled, then bow down to all the four
corners of the world and say to all men aloud, 'I am a murderer'
(p. 433). That is humility, humbling himself before others. This is
what Raskolnikov cannot bring himself to do. Before he goes to
confess at the police station he comes very near to it. For a
moment his proud determination grows soft: he falls to the
ground, kisses the filthy earth with joy and rapture, gets up and
bows down once more. But the people around him think he is
drunk and laugh at him, and the words 'I am a murderer' die on
his lips (p. 537).

Raskolnikov's wounded pride and arrogance accompany him
to the penitentiary. He doesn't have sufficient conviction in his
own goodness and reality to be able to submit to anything.
Submission spells humiliation and annihilation for him. He can
feel worthless in himself, kick himself for it, be prepared to suffer
ostracism for it; but he cannot humble himself willingly, from con-
viction. He cannot give up his arrogant defiance and thus expose
himself to the withering judgement of others. Just as the words 'I
am a murderer' die on his lips when others laugh at him, his heart
freezes at the prospect of his humbling himself before others. It is
of course only before others that one can humble oneself.

Consequently for a good part of his first year in the peniten-
tiary Raskolnikov cannot accept punishment and repent his
crime—for one can only accept punishment in a spirit of humility.
The transformation in which he will find wholeness, peace, and a
new life comes to him in the very last two and a half pages of the
book.

10.4 RASKOLNIKOV'S SOUL: ITS INNER TURMOIL

I now turn to Raskolnikov's struggle with good and evil and to what goes on in his soul in the course of this struggle. This is the chief focus of the book and has reality within the perspective from which Dostoyevsky writes—the one which Raskolnikov himself shares with Dostoyevsky, however much he tries to turn away from it. I begin with the way Raskolnikov enters into complicity with evil, the way he lets evil enter his soul, and is taken over by it. In colloquial parlance he 'sells his soul to the devil', that is abdicates its governance. Dostoyevsky never denies Raskolnikov's ultimate responsibility and indeed he shows that his salvation lies in reclaiming his soul by accepting that responsibility. But his seduction by evil is described as taking place almost despite himself—unknowingly and unwillingly, as Socrates would say.

He has given himself to phantasy-thinking, or day dreaming as Dostoyevsky calls it, in contrast with practical thinking. He seeks a magical solution to his problems—one that will be global, achieved without working for it, and without regard to the exigencies of the real world. He moves about almost as in a trance and this movement is sustained by a series of coincidences from which Raskolnikov takes the right cue. They seem 'pre-ordained', as if specially arranged for Raskolnikov. In reality they are sheer accidents into which Raskolnikov reads a special significance because of what is working itself out in his mind and so what he takes from them.

Thus Raskolnikov seems to be pushed inexorably towards something which in one part of him he wants to avoid. Earlier when the idea of the murder occurs to him he finds it 'horrible' and is surprised that his heart should be capable of such a 'foul thing' (p. 26). He cannot believe that he will 'really take a hatchet', hit the pawnbroker on the head and crack her skull. The thought of it makes him feel sick with horror (p. 78). 'Oh Lord', he prays, 'show me the way and I shall give up this—this damnable dream of mine!' (p. 79). Yet after the incident in the restaurant, his mind is made up: 'his casuistry was as sharp as a razor, and he could no longer find any conscious objections to his plans in his mind' (p. 89). Even then, however, 'at heart he never really took himself seriously' (p. 80).

The officer in the restaurant had asked the student whether he could kill the old woman *himself*. The student had replied: 'Of course not! I was merely discussing the question from the point of view of justice. Personally, I'd have nothing to do with it' (p. 85). As an intellectual, for Raskolnikov too the question is a theoretical one. But unlike the student he is dragged by the logic of his ideas because they lock in with his psychology. He can neither follow on nor fully disown them, and while with their support and under their protection he advances inexorably as in a dream towards the conclusion of their logic, to a large extent, consciously at least, he is a by-stander—like the student who says 'personally, I'd have nothing to do with it'. But with every incident, every accident, the idea takes a firmer hold on his soul, enslaving his will. After the incident in the restaurant he feels 'as though he had been caught in the cog of a wheel by the hem of his coat and was being drawn into it' (p. 90). When he hears that 'at exactly seven o'clock the old woman would be *entirely alone* in the house', he returns to his own room 'like a man sentenced to death . . .' He then feels 'with all his being that he no longer possessed any freedom of reasoning or of will, and that everything was suddenly and irrevocably settled' (p. 81). The murder follows soon after.

The words 'like a man sentenced to death' are prophetic. On his way to murder the old woman Dostoyevsky describes Raskolnikov's thoughts: they were like 'the thoughts of those who are led to execution' (p. 92). Raskolnikov is not only not in command of what he is doing, his will is not his own, but in killing the pawnbroker he will destroy his own life. He comes near to recognizing this in Sonia: 'Haven't you, too, done the same thing? You, too, stepped over—you had the strength to step over—you've laid hands on yourself—destroyed a life—your own life (it's the same thing)' (p. 344). He does not see that Sonia's is an act of self-sacrifice and that she has not ruined herself in the way he has—by destroying another's life. When later, upon hearing Raskolnikov's confession, she exclaims in despair: 'Oh, what have you done to yourself?' (p. 425). 'Yourself' here means 'your soul'. It is the evil he has embraced which Sonia commiserates in these words. For that is a form of death which reduces life to 'mere existence'. Raskolnikov comes to a fuller realization of this when a little later he tells Sonia:

> Was it the old hag I killed? No, I killed myself, and not the old hag. I did away
> with myself at one blow and for good. It was the devil who killed the old hag,
> not I. (p. 433)

This theme is very much at the centre of the book: loss of the life of the soul and its resurrection. After the murder when Raskolnikov finds things closing in on him he wonders whether to give himself up. But he is at a loss to find anything from which an answer can emerge. For in what he has done he has severed his relationships with all things, cut himself off from all forms of significance. As Dostoyevsky puts it: 'the whole world was dead and indifferent, like the cobblestones on which he walked—dead to him, and to him alone' (p. 194). This is what Dostoyevsky means by 'mere existence'. Life, by contrast, means engaging with people, taking part in activities of a shared life, in that life finding meaning in things, responding to them. Even in the penitentiary Raskolnikov experiences the same deadness:

> Senseless and aimless anxiety in the present, and in the future a life of self-sacrifice which would bring him nothing in return—that was what his whole life would be like . . . What had he to live for? . . . To live in order to exist? (p. 551–52)

Dostoyevsky comments: 'If fate had only sent him repentance . . . the sort . . . that is accompanied by terrible agony which makes one long for the noose or the river! Oh, how happy he would have been . . .' (p. 552). But Raskolnikov does not repent his crime.

He has rejected his own better judgement in committing murder. Having done so he resists confessing it and giving himself up; he resists admitting what he has done in its enormity and repenting it. The book follows the way the evil, that has entered his soul with the murder, now joins hands with Raskolnikov's defences against the fear of becoming a mere non-entity. For that is what admitting his guilt is tantamount to for him: it is a form of submission. In defiance he is somebody, he counts; in submission he is nothing. That is how the evil he has allied himself with was meant to save him: to make him feel he is somebody who counts. He, in his turn, serves that evil by preventing goodness taking hold of his soul. It is a perfect pact, mutually beneficial—not, however, to Raskolnikov's soul.

Raskolnikov, we have already seen, is not an evil person. Porfiry, the investigating magistrate, who understands and sympathizes with him, tells him: 'Your crime was, in truth, an aberration' (p. 470). There is much good in him, disowned, in the form of compassion. He is honest, cares for justice, and is attracted to the poor, the exploited, the cripple, and the suffering. He is one of them, but finds that identity threatening to his weak sense of self.

He has been pushed around, we have seen, and has not only allowed this to happen but colluded with those who have pushed him around. Psychologically, the crime he has planned and committed was an attempt to regain his autonomy in the teeth of being so pushed, an attempt to throw away his Marmeladov-like defensive passivity. But autonomy cannot be regained without coming together and making peace with oneself, as Raskolnikov comes to realize after much suffering. He has violated the morality which his mother has been pushing down his throat since his childhood. He has to pay for this in remorse and repentance before he can make that morality his own, is reintegrated with goodness, and finally finds the wholeness and autonomy that have been eluding him.

To do so, however, he has to give up his defences and appear in the dependency in which he feels exposed and vulnerable. Those defences, we have seen, have been taken over by evil; in them evil puts up a barrier against goodness. He also has to face the agony of remorse which will make him long for the noose or the river. Only through remorse can Raskolnikov re-admit goodness into his life. Only then can he find himself and his soul—find himself in finding his soul, and his soul in finding himself. He cannot find the one without finding the other. For to find one's soul in being re-integrated with goodness one has to be oneself. This is one side of the coin and uncontroversial. To be oneself one has to find oneness with goodness. For evil is destructive of a meaningful life and only in a meaningful life can a person be himself. This is the other side of the coin and is controversial. But I have no doubt that Dostoyevsky holds this view.

We see Raskolnikov, having committed murder and aligned himself with evil, fighting, in the rest of the book, to prevent goodness from establishing itself in his soul. His psychology is in the service of evil, not only after he confesses his crime and gives himself up, but also in the way he does so—in his motives for doing so. For

he feels angry with himself for having failed and wants to kick himself for it. He also feels guilty for having offended those who have forbidden killing. This is the kind of guilt that is rooted in fear of the anger and retaliation of those he has offended. In feeling such guilt ('persecutory guilt') Raskolnikov identifies himself in part of himself ('the super-ego') with those he has offended and becomes the object of his own anger. He is vaguely aware and afraid of acting in submission to this part of himself and so he likens himself to a moth that flies into the flame itself (p. 263).

But there is another kind of guilt, one which Raskolnikov is trying to avoid facing in his feelings. Such feelings of guilt are rooted in love and are characterized by pain—pain at having hurt or injured someone loved, something cherished. But these feelings too are working in Raskolnikov after the murder, unknown to him, very gradually gathering strength. This is the good in Raskolnikov working secretly, with allies it finds in others, ultimately to lead Raskolnikov back to life through suffering, to rise from the dead like Lazarus—a symbolism which runs through the book.

That aspect of his psychology in which Raskolnikov has allied himself with evil takes hold of him by tricking his genuine conscience. But the good in him does not employ such tricks: it does not work by deception and is naturally invisible to the person in which it resides. It is others who see it—Sonia and Porfiry. Porfiry, in his second interview of Raskolnikov, also compares him to a moth:

> Ever watched a moth before a lighted candle? Well, he, too, will be circling round and round me like a moth round a candle. He'll get sick of his freedom . . . And he'll keep on describing circles round me, smaller and smaller circles, till—bang! he'll fly straight into my mouth and I'll swallow him! (p. 355)

This is indeed what happens. But there is more in this comparison than Raskolnikov meant by it when he made it himself. The flame is also the good to which Raskolnikov, unknown to himself, is attracted—in the way, for instance, he goes to Sonia in his darkest moment. It is she who tells him to confess his crime. This flame will indeed burn his wings—the wings of his flight from reality into phantasy-thinking. It will burn the defences of his ego, ingrained in his character, the character which has been his destiny.

Porfiry recognizes this and knows that Raskolnikov can then rise from his own ashes, the ashes of his burnt ego. When in his third and last interview Raskolnikov rejects Porfiry's offer of a reduced sentence if he confesses his crime voluntarily, Porfiry says: 'Don't think lightly of life, my dear fellow. You've still plenty of it before you.' 'What is it I have plenty of before me?' Raskolnikov interjects. All he can see stretching before him is what made Svidrigaylov, Raskolnikov's alter-ego, shoot himself later on in the book. But Porfiry sees what in his despair, hidden under haughtiness, Raskolnikov is unable to see:

Life! What sort of prophet are you? How much do you know? Seek and ye shall find. Perhaps that was God's way of leading you to Him . . . How much experience have you had of life and how much do you really understand? He's invented a theory, and now he's ashamed that it has proved a failure and turned out so very unoriginal. It's turned out rotten, that's true, but you're not such a hopeless rotter, after all . . . At least you haven't been deceiving yourself long; you've reached the end of the road all at once . . . What you have long needed is a change of air. Well, suffering is not such a bad thing, either. Suffer for a bit! . . . I know that it is not so easy to believe, but don't be too clever; give yourself up to life without thinking; don't worry, life will carry you out straight on the shore and put you on your feet. (p. 471)

The last few pages of the book speak of how Raskolnikov comes back to life, rises from the dead, from the ashes of his old life. Dostoyevsky describes it as Raskolnikov's 'rebirth' and 'regeneration', his 'gradual passing from one world to another', his 'acquaintance with a new and hitherto unknown reality'. He uses more or less the same words I quoted from Porfiry to describe the change in Raskolnikov.

Now he would hardly have been able to solve any of his problems consciously; he could only feel. Life had taken the place of dialectics, and something quite different had to work itself out in his mind. (p. 558)

This is the life from which Raskolnikov had turned away and which he was prepared to throw away for good when it brought him disaster. This is the life which Porfiry tells him not to throw away, and it is Sonia who helps him to come back to it. She stays by his side through thick and thin and never abandons him. As Dostoyevsky puts it: 'It was love that brought them back to life'— the love which he contrasts with dialectics. Earlier I had said that

religion is rooted in the life of a people. Let me now add that an ideology, by contrast, is rooted in dialectics.

10.5 PHILOSOPHICAL REMARKS: PSYCHOLOGY AND THE SOUL

I want to finish with a few philosophical remarks. Dostoyevsky's novel is a deeply religious book and at the same time a subtle and perceptive psychological novel. It puts side by side, within the context of one life, that of Raskolnikov, the beliefs of Christianity and the ideology prominent among the young radical intellectuals of Russia at the time. It offers a devastating criticism of the latter from the Christian perspective which Dostoyevsky himself occupies. It does so by bringing out where that ideology would take a person who takes it seriously. It gives us a convincing study of the psychology of one such person, examining the two-way interaction between the psychology and the ideology. It studies the spiritual destiny of someone who in his psychology is vulnerable to such an ideology—the degeneration and regeneration of his soul. The regeneration comes with Raskolnikov's repentance. In the suffering this brings him Raskolnikov is re-integrated with the good in him which mitigates the evil he had allowed to enter his soul. He sheds the haughtiness and arrogance with which he has turned away from goodness and, we are led to believe, he will gradually forgive himself by paying in his future life for all the harm he has done—'the subject of a new story', Dostoyevsky tells us, a novel he never wrote.

This is *at one and the same time* a transformation in Raskolnikov's soul and in his psychology. The psychological change has two aspects: the mitigation of the hatred and anger that has built up in him and turned him against others, and the shedding of the character defences he has developed to protect himself against real and imagined exploitation and the consequent feelings of inadequacy and negligibility. What we have here is a change in Raskolnikov's feelings and so necessarily a change in his orientation towards everything that constitutes their objects and therefore in what he wants in a life in which he engages with them. It is a change in which he turns away from self-absorption towards others and finds greater autonomy with the inner confidence that comes from a growing ability to trust others.

This *same* change in affective orientation is also presented, simultaneously, by Dostoyevsky, from the Christian perspective of his spiritual morality, as a change in the direction of Raskolnikov's soul, a change in the direction of goodness—the kind of goodness that is present in relationships of *give and take* with others in the life shared with them. This is the kind of goodness to be found in generosity, compassion, trust and justice. Dostoyevsky contrasts such relationships with relationships of power and exploitation on the one hand and with those of mere mutual self-interest—'I scratch your back and you scratch mine'—on the other. He holds that the quest for power, pleasure, and self-interest as supreme goods is evil and destructive of meaning in life.

I suggested that evil enters Raskolnikov's soul through his psychology and that it takes Dostoyevsky's perspective to see the devastation it does there. It is his psychological needs that make him vulnerable to this evil which is already in the affective tendencies which are part of this psychology. In his servitude to evil Raskolnikov is not free although he is ultimately responsible for this collusion.

It is *otherwise* with his relation to goodness. This goodness is the orientation of love and its perspective—the kind of love which makes trust, generosity and forgiveness possible. The original reactions from which such love grows are natural, but a person comes to it in what he learns emotionally, that is in the way his emotions change and he grows in himself through such changes. This inevitably involves changes in the person's psychology. It is through the growth and purification of such love that goodness comes into the person's life as an individual. In this respect there is an *asymmetry* between good and evil in their relation to a person's psychology—in the way they come into his life, get established there, and in his relation to them in the way he acts.

In Raskolnikov good and evil are in conflict, indeed at war. This conflict characterizes his psychology. He can neither make his own the goodness that is in him, nor can he disown it altogether. We are given a glimpse of what would happen to a person who does so in the character of Svidrigaylov. That way points to the destruction of the possibility of finding sense in life. In the opposite direction lies the possibility of reintegration with goodness. This involves the mitigation of evil with goodness and hence the resolution of the conflict. Where, by contrast, evil takes over and a

person grows indifferent to goodness his life loses meaning. In Svidrigaylov's life of pleasure and cynicism or disbelief in goodness there is still a hunger for love. When, after Dunya's final rejection, he loses the hope that he will ever find it, he kills himself.

Where a person in goodness turns away from evil so that evil ceases to figure among the things that move him, in the love, trust and forgiveness he finds he comes together. His goodness and his psychology are then at one with one another. His psychology is 'friendly' to goodness, it does not constitute a 'barrier' to it. It is not any psychological need that makes him good; it is not what he gets out of goodness that turns him to it. The contrast I have in mind is between *friendliness* and *need*.

The evil person gets something out of his evil deeds—pleasure, self-satisfaction, self-aggrandizement, self-protection. His alliance with evil is thus explicable in terms of his psychology. That psychology predisposes him towards evil. But cannot evil be pursued with the kind of detachment from the ego in which the good man pursues goodness—though obviously without thinking of it as such? My own suspicion is that if there is such a thing as love of evil it is at the same time a love of oneself, however much a person may, in such love, be willing to sacrifice for it.

The actions of a good man must, of course, come from him. But it is what constitutes his goodness—his compassion, his honesty—that makes him what he is like, not his psychology. Thus it makes sense to ask, 'Why is he full of venom and resentment?', but not 'What makes him trusting and friendly?'. Or rather, if the latter question makes sense, it is to be answered in terms of the person's historical, psychological development which would show that there was no reason why he shouldn't be. The study of goodness by a novelist in a character, such as Dostoyevsky undertook in *The Idiot*, would have to take a different approach. It would have to depict, not a psychology which *predisposes* the character towards goodness, but one which leaves him *open* or *accessible* to it. It would have to show him as *lacking* what are normally barriers to goodness, what life is like in their absence, and how others treat such a person and look on him. Whether he is successful or not, this is precisely what Dostoyevsky does in *The Idiot*.

Bibliography

Alanen, Lilli, Sara Heinämaa, and Thomas Wallgren. 1997. *Commonality and Particularity in Ethics*. London: Macmillan.

Anderson, John. 1940. Freudianism and Society. *Australasian Journal of Psychology and Philosophy*.

Balint, Michael. 1952 [1951]. On Love and Hate. In *Primary Love and Psycho-Analytic Technique* (London: Hogarth Press).

Dilman, İlham. 1979. *Morality and the Inner Life: A Study in Plato's Gorgias*. London: Macmillan.

———. 1981. *Studies in Language and Reason*. London: Macmillan.

———. 1983. *Freud and Human Nature*. Oxford: Blackwell.

———. 1984a. Reason, Passion, and the Will. *Philosophy*.

———. 1984b. *Freud and the Mind*. Oxford: Blackwell.

———. 1984c. Our Knowledge of Other People. In *Philosophy and Life: Essays on John Wisdom*, ed. İlham Dilman (The Hague: Nijhoff).

———. 1987. *Love and Human Separateness*. Oxford: Blackwell.

———. 1988a. *Freud, Insight, and Change*. Oxford: Blackwell.

———. 1988b. *Mind, Brain, and Behaviour: Discussions of B.F. Skinner and J.R. Searle*. London: Routledge.

———. 1992. *Philosophy and the Philosophic Life: A Study in Plato's Phaedo*. London: Macmillan.

Dilman, İlham, with D.Z. Phillips. 1971. *Sense and Delusion*. London: Routledge.

Dostoyevsky, Fyodor. 1956. *Crime and Punishment*. Trans. David Magarshack. Harmondsworth: Penguin.

———. 1957. *The Brothers Karamazov*. 2 vols. Trans. Constance Garnett. New York: Everyman's Library.

Drury, M. O'C. 1973. *The Danger of Words*. London: Routledge.

Eliot, T.S. 1972. *Selected Essays*. London: Faber and Faber.

Fairbairn, W.R.D. 1952. *Psycho-analytic Studies of the Personality*. London: Tavistock Publications.

207

Freud, Sigmund, and Joseph Breuer. 1950. *Studies in Hysteria.* Trans. A.A. Brill. Boston: Beacon Press.

Freud, Sigmund. 1933. *New Introductory Lectures on Psycho-analysis.* Trans. W.J.N. Sprott. New York: Norton.

———. 1974. *The Question of Lay Analysis.* Trans. Nancy Procter-Gregg. New York: Imago.

———. 1949a. *Three Essays on the Theory of Sexuality.* Trans. James Strachey. London: The Alcuin Press.

———. 1949b. *Introductory Lectures on Psycho-analysis.* Trans. Joan Rivière. London: Allen and Unwin.

———. 1949c. *The Ego and the Id.* Trans. James Strachey. London: Hogarth Press.

———. 1949d. *The Future of an Illusion.* Trans. W.D. Robson-Scott. London: Hogarth Press.

———. 1949e. *Civilization and its Discontents.* Trans. James Strachey. London: Hogarth Press.

———. 1950. *Collected Papers.* Vols I–V trans. Joan Rivière. London: Hogarth Press.

———. 1979. *Case Histories.* Vol. II trans. James Strachey. Harmondsworth: Penguin.

Fromm, Erich. 1950. *Man for Himself.* London: Routledge.

Gaita, Raimond. 1991. *Good and Evil: An Absolute Conception.* London: Macmillan.

Guntrip, Henry. 1977. *Personality Structure and Human Interaction.* London: Hogarth Press.

Huxley, Aldous. 1950. *Brave New World.* London: Chatto and Windus.

Ibsen, Henrik. 1966. *Peer Gynt.* Harmondsworth: Penguin.

———. 1971. The Master Builder. In *The Master Builder and Other Plays* (Harmondsworth: Penguin).

James, William. 1948. *Psychology.* Abridged edn. New York: The Living Library.

Jones, Ernest. 1937. Love and Morality. *International Journal of Psycho-analysis.*

Jung, C.G. 1953. *Two Essays on Analytic Psychology.* Trans. R.F.C. Hall. London: Routledge.

———. 1966. *Modern Man in Search of a Soul.* Trans. W.S. Dell and Cary F. Baynes. London: Routledge.

Kant, Immanuel. 1959. *Fundamental Principles of the Metaphysics of Ethics.* Trans. T.K. Abbot. London: Longmans.

Klein, Melanie. 1957. *Envy and Gratitude.* London: Tavistock Publications.

———. 1948. The Early Development of Conscience in the Child. In Sandor Lorand, ed., *Psycho-analysis Today* (London: Allen and Unwin).

Mill, J.S. 1965. *On the Logic of the Moral Sciences*. From *A System of Logic*, Book VI. New York: The Library of Liberal Arts.

Miller, George. 1979. *Psychology: The Science of Mental Life*. Harmondsworth: Penguin.

Milner, Marion (pseudonym of Joanna Field). 1952. *A Life of One's Own*. Harmondsworth: Penguin.

————. 1977. *On Not Being Able to Paint*. London: Heinemann.

Mischel, Theodore, ed. 1977. *The Self: Psychological and Philosophical Issues*. Oxford: Blackwell.

Money-Kyrle, R.E. 1955. Psycho-analysis and Ethics. In M. Klein, P. Heimann, R.E. Money-Kyrle, eds., *New Directions in Psycho-analysis* (London: Tavistock).

Phillips, D.Z. 1993. Ten Questions for Psycho-analysis. *Philosophy* (April).

————. 1997. Ethics and Humanistic Ethics: A Reply to Dilman. In *Commonality and Particularity in Ethics* (London: Macmillan).

Plato. 1952. *Symposium*. Harmondsworth: Penguin.

————. 1955a. Crito. In *The Last Days of Socrates* (Harmondsworth: Penguin).

————. 1955b. Phaedo. In *The Last Days of Socrates* (Harmondswoth: Penguin).

————. 1973. *Gorgias*. Harmondsworth: Penguin.

Robinson, John A.T. 1966. *Honest to God*. London: SCM Press.

Rycroft, Charles. 1985a. Causes and Meaning. In Rycroft, *Psycho-analysis and Beyond* (London: Chatto and Windus).

————. 1985b. On Continuity. In Rycroft, *Psycho-analysis and Beyond* (London: Chatto and Windus).

Scott-Maxwell, Florida. 1957. *Women and Sometimes Men*. London: Routledge.

Skinner, B.F. 1976. *Walden Two*. London: Macmillan.

Spinoza, Benedict. 1960. *Ethics*. New York: Hafner.

Taylor, Charles. 1985. Peaceful Coexistence in Psychology. In Taylor, *Philosophical Papers, Volume I: Human Agency and Language*. (Cambridge: Cambridge University Press).

Tolstoy, Leo. 1959. The Death of Ivan Ilytch. In *The Death of Ivan Ilytch and Other Stories*. Trans. Alymer Maude (Oxford: Oxford University Press).

Weil, Simone. 1948. *La Pesanteur et la Grâce*. Paris: Librarie Plon.

————. 1949. *L'Enracinement*. Paris: Gallimard.

————. 1953. *La Connaissance Surnaturelle*. Paris: Gallimard.

————. 1960. *Attente de Dieu*. Paris: La Colombe.

————. 1959. *Waiting on God*. Trans. Emma Craufurd. London: Fontana.

Winnicott, D.W. 1957. *The Child and the Family*. London: Tavistock.

Wisdom, John. 1952. *Other Minds*. Oxford: Blackwell.

————. 1953. *Philosophy and Psycho-analysis*. Oxford: Blackwell.

————. 1965. *Paradox and Discovery.* Oxford: Blackwell.
Wittgenstein, Ludwig. 1963. *Philosophical Investigations.* Oxford: Blackwell.
————. 1967. *Zettel.* Oxford: Blackwell.
Wolf, Virginia. 1994. *To the Lighthouse.* London: Routledge.
Wright, Derek. 1971. *The Psychology of Moral Behaviour.* Harmondsworth:
 Penguin.

Index

211